Garry Trudeau

Great Comics Artists Series

M. Thomas Inge, General Editor

Garry Trudeau

Doonesbury and the
Aesthetics of Satire

Kerry D. Soper

University Press of Mississippi / Jackson

www.upress.state.ms.us

Designed by Todd Lape

The University Press of Mississippi is a member of the
Association of American University Presses.

First printing 2008
∞
Library of Congress Cataloging-in-Publication Data

Soper, Kerry.
Garry Trudeau : Doonesbury and the aesthetics of satire /
Kerry D. Soper.
p. cm. — (Great comics artists series)
Includes bibliographical references and index.
ISBN 978-1-934110-88-1 (cloth : alk. paper) — ISBN
978-1-934110-89-8 (pbk. : alk. paper) 1. Trudeau, G. B.,
1948——Criticism and interpretation. 2. Trudeau, G. B.,
1948– Doonesbury. 3. Satire, American—History and criti-
cism. I. Title.
PN6728.D653S66 2008
741.5'6973—dc22 2008003698

British Library Cataloging-in-Publication Data available

Contents

Acknowledgments

I am grateful to a number of people for their help in writing this book: Clyde Milner at Utah State University for guiding me in my first attempt (nearly twenty years ago) to write about satire in comic strips; Allen Tullos for being a wise and generous mentor during my time at Emory University; George Handley and Stan Benfell for reading early drafts of my work and offering essential advice; Carolyn Hone for helping with the logistical side of things; Van Gessel, John Rosenberg, Joe Parry, Greg Clark, Ron Woods, Mike Call, Roger MacFarlane, George Tate, and other folks at Brigham Young University for providing generous resources and support; Rachelle Koenen, Richard Peterson, Will Bishop, and Monica Simmons for their excellent work as research assistants; David Stanford and Mary Suggett for kindly shepherding the work through its final obstacles; Seetha Srinivasan, Tom Inge, Walter Biggins, Amy K. Nyberg (and the other PCA people), for their interest and faith in my work; Mom, Dad, Stan, Cammy, Holly, and David for reasons they know best; my wife, Lisa, for her good-humored support on both good and bad days; and Garry Trudeau for obvious reasons.

This book is dedicated to Lisa, Haley, Devin, Taylor, and Emmy.

Garry Trudeau

Introduction

Garry Trudeau has a knack for making people mad. He has ticked off Frank Sinatra, Donald Trump, Lee Iacocca, Dan Quayle, the entire Bush clan (inciting in the elder Bush the impulse to "kick the hell out of him"), George Will, and even God (at least according to Janet Reno, who said, "I want to be myself, and it doesn't help to have something like *Doonesbury* to start the morning. I'm sure God is at this point very angry with Garry Trudeau.") (Trudeau, *Flashbacks* 228, 288). Because Trudeau is a political satirist, you would naturally expect his primary targets—fatuous politicians and venal celebrities—to get a bit riled up; but he has also managed over the course of forty years to raise the ire of many other folks: newspaper editors, fellow comic strip artists, traditional political cartoonists, pundits, sensitive readers, cultural guardians, etc. Of course, he is also widely loved and admired—often by some of the same people in the preceding list—but it would be difficult to find another popular satirist in American cultural history that has sustained such a successful career, for so many years, while angering so many people.

From the perspective of a cultural historian who is convinced that the survival of popular, independent satire is critical to the health of an open, democratic society, Trudeau's notoriety is something to be celebrated. The controversy surrounding his strip has been a sign, perhaps, that he is actually effective at doing his job. The great satirists throughout our cultural history—Swift, Voltaire, Hogarth, Daumier, Twain—enjoyed (to varying degrees) great license to challenge leaders and criticize the social order; and if they did not annoy political leaders or irk their audiences at times while using this license, then we would not place them in that pantheon of great cultural critics. Instead, they would be remembered simply as benign

humorists who merely entertained or flattered their audiences or patrons. So in an age when many political cartoonists have been reduced to acting as innocuous cultural jesters and syndicated gagsters (or are simply losing their jobs), Trudeau has become this era's Thomas Nast: a cartoonist whose controversial work creates significant waves in the world of politics and beyond. And while Trudeau's tendency to frustrate people outside of the world of politics points in part to what some observers might consider his weaknesses (an aloof and stubborn disposition, a near self-righteous conviction in his business practices and political beliefs, and a healthy ego), it also points to what makes him an important figure on a broader cultural level: a fierce independence that allows him to create art and satire that transcends traditional genre and media boundaries, and that resists oppressive commercial and institutional mediations.

In this study I try to assess both Trudeau's significance as "the premier American political and social satirist of his time" and as a maverick or auteur in the world of cartooning and entertainment (Alter 61). Although this book principally focuses on his accomplishments on the comics page, it also looks at related aspects of his career, including business and social interaction with editors, colleagues, and readers. Only through this broad discussion of Trudeau's life, art, and business practices can one fully understand his profound influence on contemporary American culture, politics, and entertainment. The correlation, in fact, between the intensity of Trudeau's institutional battles and the integrity of his satire is so significant that a new term should be coined to describe him, that of *sateur*—a popular satirist who fights for a significant degree of economic and institutional freedom in order to engage in principled social criticism.

While this study is ultimately a celebration of Trudeau and his work, it does not shy away from discussing weaknesses in his satire and art. Trudeau would admit himself to some of these failings—the pedestrian flavor of some of his art, for example. And as a scathing critic of others' foibles, it only seems right that Trudeau should be open to similar scrutiny. In addition, because Trudeau enjoys such great privileges as a popular satirist (essentially engaging in constitutionally sanctioned near-slander), he should be held to a high standard in estimations of the ultimate fairness and accuracy of his attacks. While we love to imagine the satirist as the ever-righteous underdog, taking on the corrupt authority

figures in our society, righting injustices, and repairing the social order, we should also be able to acknowledge that the great powers of satire can be abused; as George Test suggests, they can "be used selfishly, vindictively, [and] maliciously" (Test 44). This may explain some of the ambivalence that editors and readers have felt toward Trudeau: he is admired for his chutzpah and integrity as he exerts these tremendous powers, but he also inspires fear and frustration as he occasionally appears to flirt with, or even cross, the line of misusing some of these prerogatives.

I would add that a satirist who aspires to be a responsible, progressive cultural and political watchdog ideally should avoid using comedy and satire haphazardly, irresponsibly, flippantly, or gratuitously. While one may take Trudeau to task for occasionally allowing his work to degenerate into personally motivated vendettas, he rarely makes a misstep when it comes to creating principled, consistent satire based on a coherently progressive worldview. Indeed, as I will illustrate, he stands out as one of the most principled and consistent satirists of our age. Moreover, he has even directed his watchdog impulses against other satirists, or satiric television programs, criticizing the creators when their work was scattershot, cynical, or opportunistic.

The chapters in this study of Trudeau's work are organized to touch upon each of the following aspects of his career: biography, professional practices, satire, art, and role as a social chronicler. While not an exhaustive study of any of these particular subjects, it is perhaps the first significant attempt to do justice to the sum of Trudeau's creative work. This introductory chapter will lay a foundation for achieving this goal by elaborating in broad strokes upon Trudeau's importance as a cartoonist, satirist, and cultural icon. It also previews the focus and contents of the remaining chapters.

To begin, some basic information about the unlikely popularity and staying power of Trudeau's strip is in order. Launched in 1970, *Doonesbury* was a roughly drawn college strip that from today's comic strip industry perspective would seem to have little potential to catch on in a big way. Trudeau's art was a bit shaky and static, with some strips consisting of no more than a series of talking heads; there were no cute, merchandisable animal characters featured in the cast; the humor was highly verbal (you actually had to concentrate while reading it); it was built upon complex

character development and situational irony rather than obvious sight gags or broad wordplay; finally, the subject matter was pointedly political and topical. This last quality would presumably alienate the casual comics reader, since "getting" the strip's content and humor would require a significant familiarity with current events.

Satire and politics had appeared on the comics page before. Indeed, one can cite a variety of examples: early-twentieth-century strips such as *Mutt and Jeff* or *Hogan's Alley* made references to big-city politics and used characters on the margins of society to satirize mainstream cultural values and practices; in the 1930s, Harold Gray's *Little Orphan Annie* espoused a right-wing, anti–New Deal ideology in many of its storylines; also in the 1930s, Chester Gould's detective tales in *Dick Tracy* promoted a reactionary law-and-order theme that sometimes verged on the fascistic in its vigilante view of deviance, justice, and punishment; and there was some Cold War jingoism in Milt Caniff's *Steve Canyon*. None of these strips were considered primarily satirical or topical, nevertheless. The work of Walt Kelly (*Pogo*) and Al Capp (*Li'l Abner*), on the other hand, more closely resembled Trudeau's in that these artists were celebrated primarily as satirists and often battled with editors for the right to include topical political issues on the comics page. Still, in both those cases the satire—though at times pointed and combative—was layered into fantastical environments, fronted by charming animal characters, or shadowed by slickly drawn, broadly farcical characters. So it seems reasonable to assert that Trudeau was the first to let the politics stand out unambiguously on the surface of a comic strip; unlike any comic strip in the history of the medium, he depicted everyday people, topical events, and political figures and events with little or no allegorical layering. Moreover, along with Kelly's *Pogo*, Trudeau's strip was one of the first to have a countercultural orientation.

Defying expectations, and proving that the comics page had a more varied and intelligent audience than typical syndicates and newspaper editors might have imagined, Trudeau's combative and political comic strip succeeded despite these supposed deficits. These perceived weaknesses, in fact, may have been what ensured Trudeau's success in finding an audience: it was embraced by an entire generation of baby boomers who were coming of age at a time when many college students had learned to distrust the type of slick, bland, politically "neutral" entertainment that was

associated with popular film, mainstream television programs, and the comics page. While Trudeau's strip was met with dislike and confusion by the many editors and readers who were comfortable with what the comics page had gradually become—a politics-free, "family-friendly" medium that featured fairly simplistic, comforting humor—it was enthusiastically embraced by a younger generation of politically engaged readers.

Within several years the strip reached wide syndication, making its way into as many as 1,400 daily and Sunday newspapers in the U.S. and abroad. As the strip's popularity grew, so did Trudeau's prominence as a satirist, cultural critic, and iconoclast within the comic strip business. While this combative attitude and high public profile often created friction between Trudeau and newspaper editors, the unusually fierce allegiance of Trudeau's core readers ensured the strip's survival throughout multiple controversies and battles with editors, critics, and angry comics-page readers. Equally significant markers of his relatively broad and lasting popularity are his strip collections: over sixty books that have cumulatively sold more than seven million copies worldwide.

The critical acclaim Trudeau received early in his career also helped enshrine his strip as a cultural institution. In 1975 he garnered a Pulitzer Prize for political cartooning—a controversial choice because he was not working within the traditional field of one-panel editorial cartooning. Moreover, by the mid-1970s many cultural observers were noting the social and political power of the strip. It was widely hailed as the best chronicle of the baby boomer generation, and politicos began to ask one another with an almost religious regularity, "Have you seen the latest *Doonesbury*?" This was a comic strip that mattered: it affected public debate, captured a zeitgeist, and at times shaped the news in ways usually associated with high-profile, investigative reporting. Even some of Trudeau's biggest targets, such as Henry Kissinger, acknowledged the importance of the strip; he said that "the only thing worse than being in a *Doonesbury* strip was not being in a *Doonesbury* strip" (Trudeau, *Flashbacks* 104).

This type of cultural impact by an entertainment product typically is short-lived. A film or television show captures a historical moment nicely, a stand-up comedian strikes at the heart of a particular era's inanities, or a satiric novel is the literary or political toast of the season; but the luster or novelty usually fades and another figure or program captures the

public's attention. Somehow Trudeau has avoided that flash-in-the-pan syndrome and has for more than three decades consistently prodded the national conscience, chronicled the behaviors and attitudes of a generation, and bucked trends in the entertainment industry. Indeed, that level of longevity and cultural significance is almost unprecedented in the world of politics and entertainment. *The Simpsons, The Late Show with David Letterman, Saturday Night Live*, and a few satiric novels such as *Catch-22* and *A Confederacy of Dunces* are perhaps the only other comedic-satiric creations that have shown similar staying power and lasting cultural significance.

The fact that Trudeau has achieved this feat through comic strips, one of the most abused and undervalued mediums in journalism or entertainment, is an additional marvel. In the first half of the twentieth century comic strips were a medium that mattered: they were read across racial, class, and age boundaries, and their characters and storylines were prominent in the pre-television culture's imagination. But in recent decades their profile has faded as newer mediums have captured people's attention, and as editors and syndicates have gradually undermined the merits of the comics page—reducing the size of strips, limiting the subject matter in draconian ways, and championing superficially merchandisable work at the expense of more complex characters and storylines.

Ironically, however, Trudeau's choice of venue may have also been a significant factor in allowing him to achieve his high level of notoriety and cultural power. By working within a medium that flies under the cultural radar because of neglect and its seeming insignificance, Trudeau was able to go about his business without experiencing the overexposure and seasonal, frenetic, economic pressures that can negatively affect other more prominent popular mediums. As a writer in the *New Republic* observed in 1985, "the closest thing to satire with teeth that the culture is sustaining is *Doonesbury*, and Trudeau's getting away with it because his medium is the comic strip, and ergo, not recognizable as a serious form" ("Satire Gap" 42). Moreover, in defying the traditional conventions of his medium—by effectively creating a hybrid genre of entertainment that combines investigative reporting and topical satire with a homey comic strip format and sensibility—Trudeau has been able to stand out, to matter, to create his own rules about what type of art can both entertain and inform. It is no

wonder that Trudeau has drawn the ire and jealousy of many political car-
toonists, peers who aspire to the same cultural importance but who often
are held back by the moribund state of their medium and profession.

The unique qualities of Trudeau's satire also owe a debt to the struc-
ture, aesthetics, and audience orientation of this deceptively simple
medium. Telling a joke or story through multiple panels and sometimes
day-to-day continuity, Trudeau—unlike political cartoonists working
within the one-shot limitations of the traditional editorial cartoon—was
able to couch his satire within a complex narrative, engaging character
development, irony-driven "jokes," and authentically witty dialogue. Can
one imagine Trudeau's satire attracting and retaining its devoted readers
without the help of his broad cast of endearingly flawed characters and
ongoing, engaging story lines? Satire without this type of sweetener is
like a bitter medicine that will only be taken once by most mainstream
readers.

The aesthetics of comic strips are also significant in shaping the power
of Trudeau's satire. Trudeau's limited drawing skill may have been a fail-
ing if he had been working in a more traditional highbrow or commercial
art medium, but in comic strips it is in some ways a strength. Admittedly,
even among comic strip artists Trudeau's facility with the pen is limited;
his drawings lack the dynamism of Walt Kelly's *Pogo* or the organic charm
of Charles Schulz's *Peanuts*. But for a strip that relies on deadpan irony
as a dominant comedic tone and emphasizes verbal humor over slapstick
gags, Trudeau's slickly bland lines and static character construction feels
appropriate (or at least not too much of a negative distraction). Whereas
most observers assume that the simplified, iconic construction of comic
strip images is a sign of their superficiality, comics scholars and fans have
long understood that the seemingly limited range of signs and images of
the medium give entry into an imaginative world of great power and com-
plexity. As Scott McCloud explains in *Understanding Comics,* the distilled
imagery of comic strips allows for "amplification through simplification"
and powerful reader identification (McCloud 30). Like modernist artists
who embraced "primitive" symbols or icons for their archetypal power,
comic strip artists create images that are powerful distillations of univer-
sal feelings and social types. And because the characters have simplified,
almost masklike faces, readers project themselves into the artist's char-

acters, investing these simply drawn figures with an inner life and reality perhaps as complex and rich as that experienced in their own everyday lives. The distilled imagery of the comics page, in other words, acts as a powerful portal through which readers can enter into worlds rich in emotion, humor, and even—in the case of strips like Trudeau's—politics and morality.

Finally, the composition of the audience for comic strips has also contributed to Trudeau's significance as a popular satirist. Although the size of the readership for comics is less (in proportion to the overall population) than it was in the heyday of the medium, it is still a brand of entertainment read by both children and adults and by people from a variety of class formations. No other satiric medium—with the exception of animated television sitcoms like *The Simpsons*, perhaps—can reach such a broad audience and, as a result, make such significant cultural shockwaves. (Consider the much narrower swath of readers who follow traditional political cartoons on the editorial page.) The way that editors and syndicates perceive and cater to this audience both complicates and helps Trudeau in his effort to exploit the medium's strengths and broad reach. The comic strip page has long been targeted to an idealized middle-American reader who (according to the editors and syndicates who shape the page) is easily offended, does not want to see politics taint the gentle humor of the entertainment, and is satisfied in reading simplistic gags about lasagna-loving cats or wisecracking kids. As a result, the more complex and gritty content and topically political orientation of *Doonesbury* is perpetually controversial, and many editors have been dogged in their efforts over the years to move the strip to the editorial page or to censor its content. Trudeau's popularity with a highly devoted niche audience prevents antagonistic editors from ever succeeding for long at these efforts; but there is the sense that his work is continuously embattled, that it always has to fight for its space on the funnies page.

At the same time, these controversies, and the restrictive parameters of the traditional comics page, amplify the power of Trudeau's work. His work stands out as an anomaly on the comics page; as one reads *Doonesbury* within the context of blander strips, its sophisticated, ironic sense of humor, verbal complexity, and dense references to political matters seem to take on added weight or significance. It is as if one were

listening to a series of court jesters doing safe, court-friendly gags while reading most of the page, and then a lone, trenchant truth-teller hits the stage—someone who is not afraid to bring real complexity and chaos to the court. Ironically, Trudeau's irreverence and disrespect for authority figures also benefits from the perceived restrictions placed upon this family-friendly medium. While the rest of the culture is awash with a carnivalesque vulgarity and silliness that does not allow satire to create the Freudian pleasures of seeing taboo subject matter prodded gently—or to establish a dynamic in which flexible irreverence can play off of genteel rigidity—those productive tensions are still alive and well on the stodgy comics page.

Although Trudeau does not give in to the impulse of watering down his strip for that idealized, hypersensitive reader (Trudeau's devotion is pledged essentially to a niche audience that loves and respects his relative iconoclasm), he has adjusted his strip to conform to certain crowd-pleasing qualities inherent to comic strips. For example, *Doonesbury* has an engaging storyline; endearing, sympathetic characters who engage in witty, authentic banter; a consistent delivery of comedic payoffs (though not traditional gags) with each strip; and occasionally funny visuals. Among academics and artists who still operate according to a modernist, avant-garde paradigm, any kind of catering to mainstream audiences is seen as a type of selling out or pandering that dilutes the power or purity of one's work. From a less artistically strident perspective Trudeau can be judged more generously: the pressures to make some concessions to the broad readership of comics, and to work within the pressures and conventions of the medium, can be seen as refining forces and amplifying devices in his satiric work. Specifically, they have helped him to develop the engaging qualities of the strip—such as a gently ironic narrative and quirky, endearingly flawed characters or social types. These qualities help ground the satire, pull in new readers, and retain long-term fans. All of Trudeau's good intentions and noble battles would mean little or garner scant attention if his strip was not funny and enjoyable to read.

It could be argued, in fact, that Trudeau would not even have the clout or leverage necessary to create his combative satire or take on powerful commercial interests in his industry if people did not enjoy reading his strip on a day-to-day basis. And it should be noted that this ability to both

entertain and enlighten a broad audience over decades may be a far harder task to accomplish than art that is merely avant-garde, aesthetic experimentation in a social vacuum. As Trudeau half jokingly asserts, "pandering is a lot harder than the working definition seems to imply" (Trudeau, *Flashbacks* 1).

While it is important to acknowledge the ways in which the restrictions and pressures of the comics page have improved Trudeau's work or made it more accessible to more people, in the end it is the variety of ways that he has fought or defied the traditional constraints that deserves the most attention. It should be noted that although he has made some concessions to fit in on the comics page, he has never sought or achieved the immense popularity enjoyed by earlier comic strip satirists such as Harold Gray (*Little Orphan Annie*), Walt Kelly (*Pogo*), or Al Capp (*Li'l Abner*). These artists achieved truly huge, almost universal popularity, whereas Trudeau has attracted a smaller but intensely devoted, niche audience while making the occasional splash on a larger stage when he tackled especially sensitive topics.

Has Trudeau limited the cultural or political power he could have achieved by being willing to pander even more? One could argue that Gray's, Kelly's, and Capp's strips had a broader cultural impact than Trudeau's work because their characters became vivid icons that imprinted themselves deeply on the cultural imagination. On the other hand, it could be posited that it was simply the characters, divorced from the satire, that made this imprint—that the satire did not necessarily journey with the cute character (Annie, Abner, or Pogo) into the storehouse of popular imagery. This disconnect was not necessarily the satirist's fault; it is, perhaps, simply the result of icons naturally shedding their complex, satiric codings as they get merchandised, are embraced for their cute visual qualities, or journey beyond the context of the strip. Nevertheless, these artists may have been too willing at times to satisfy editors and appeal to the broadest possible audience with their work; as a result, the satire was occasionally watered down or eclipsed by other more readily entertaining aspects of the strip. In sum, perhaps Trudeau sacrificed extreme breadth of popularity for a greater depth of precisely targeted, cultural impact—as well as a greater control over the integrity of his characters and strip.

Additionally, the focus should remain on Trudeau's resistance to commercial and institutional pressures because the controversy and notoriety that has marked Trudeau's career is an outgrowth of his success at operating as an "auteur" over the last three decades: an artist working within a popular medium who has managed—in the face of intense economic pressures and institutional mediations—to create a distinctive body of work that reflects his unique worldview. Whereas many Hollywood filmmakers, popular writers, and cartoonists are willing to compromise their work to the point that it feels as if it were following a generic formula or was created by a timid committee of marketers, Trudeau has been true to his iconoclastic political and aesthetic vision.

Beyond setting his strip apart from the rest of the comics page in tone, aesthetics, and content, this auteurship has had significant influence on other artists, the comic strip industry, newspapers, the world of punditry, and public and political debate. In other words, the things that annoy some observers so much about Trudeau—his seeming disrespect for conventions within his field and his aggressive, supremely confident criticisms of important people—are a necessary part of his status as one of the most significant and effective popular satirists of the twentieth century. To illustrate Trudeau's cultural significance, one can simply consider a sampling of some of the effects Trudeau's iconoclasm has had on his medium, the world of entertainment, and the culture at large.

By constructing a hybrid genre of popular satire—one that mixes the homey qualities of comic strips with investigative reporting and pointed political satire—Trudeau opened the door for other comic strip artists to redefine what a comic strip could be. A number of the artists who followed his lead in this respect include Berke Breathed (*Bloom County*), Scott Adams (*Dilbert*), and Lynn Johnston (*For Better or Worse*). None of these cartoonists have pushed as hard and as consistently as Trudeau against restrictions on the content of strips, but they did find narrow avenues—thanks in part to Trudeau's forging of an initial path—in which to be political, topical, or irreverent on the staid comics page.

Because Trudeau opened the door to politics on the comics page, he also deserves some credit for enabling a handful of satirists to find entry onto the comics page whose work is marketed as a rebuttal to the per-

ceived liberal politics of Doonesbury. *Mallard Fillmore* by Bruce Tinsley, for instance, was adopted for syndication by King Features because they were "looking for a conservative strip that would give conservative readers an alternative to *Doonesbury*" (Tinsley 13). Politics aside, *Mallard Fillmore* is a ponderous, second-rate strip that would not succeed in syndication if it were not for its reputation as the anti-*Doonesbury*. The search for an alternative as well as the willingness to settle for work like this attests to both the power and (in contrast) the quality of Trudeau's work.

One could also argue that countercultural cartoonists such as Matt Groening (*Life in Hell*), Tom Tomorrow (*This Modern World*), and Ruben Bolling (*Tom the Dancing Bug*), owe a debt to Trudeau. Because the alternative weekly papers that carry their work have traditionally imposed fewer restraints on cartoonists than the big daily newspapers, these cartoonists have had an easier fight than Trudeau in being topical, political, and independent; but their genre of political comic strips can trace much of its genetic DNA back to *Doonesbury*. One could say that they are perhaps the fusion of Trudeau's brand of political comic strip with the antiestablishment irreverence and experimentation of the underground comix of the 1960s.

Less obviously, traces of Trudeau's brand of popular satire—one hip to a youthful worldview that exhibits a healthy disrespect for political or corporate authority, and one that entertains while making a satiric point— can be found in more recent pop culture entities such as *The Simpsons, The Daily Show,* and *South Park*. Beyond helping invent this genre of satiric entertainment, Trudeau has policed the field, criticizing misuses of satire's democratic, reformative power, or various forms of "selling out" to commercial or corporate interests. For example, he has charged that *Saturday Night Live* has consistently misused its cultural power by being opportunistic, scattershot, and hiply cynical in its comedy (Trudeau, *The People's* 3). As an originator of a satiric tone, and as an artist remarkably consistent in his purpose and political vision, he seems to earn the right to reprimand less principled uses of the discourse.

Next, as an auteur who is especially aware of how economic and institutional pressures can shape art and satire in both positive and negative ways, Trudeau is also a mentor and model for other cartoonists, commercial artists, and popular satirists trying to navigate treacherous industry

waters. To resist institutional mediations or market pressures completely does a popular satirist little good since it negates any potential to actually become *popular*—to establish and maintain a long career based on entertaining a broad audience. At the same time, too many compromises to these pressures can water down a comic strip or work of satiric entertainment, reducing it to bland comedy and robbing it of any ideological substance. Trudeau's model of making some pragmatic concessions, while resisting the most egregious forms of commodification or censorship, offers a reliable template for other creators to follow. In particular, Trudeau's principled resistance to the following practices in the comic strip industry has inspired other cartoonists such as Bill Watterson (*Calvin and Hobbes*) and Berke Breathed (*Bloom County*) to follow his example: over-merchandising that overexposes or negates a strip's subtler, more critical codings; size reductions that limit the type of art and comedy that can thrive on the comics page; content restrictions that prevent politics, topical events, and complex, real-life issues from appearing in the comics; a self-satisfied clubbiness among the cartooning community that for many years fostered misogynistic attitudes, a jokey overfamiliarity with politicians and celebrities, and a too-ready willingness to satisfy every demand of squeamish editors or money-minded syndicates; unfair artist–syndicate contracts; and restrictions on artist rights such as access to sabbaticals or early retirement of a popular strip.

Finally, on a broader, more abstract scale, Trudeau has championed and embodied the ideal of an independent satirist as an essential political and cultural watchdog in a free, democratic society. By resisting those institutional and commercial pressures that would soften the content of his work, and by testing the limits of a satirist's right to openly attack public figures, he has promoted and protected the First Amendment rights of all satirists. A long view of Western cultural history suggests that these rights provide an essential bottom-up check on abuses of privilege and power by politicians and corporations. Powerful entities today seem to wield near-monolithic influence in our culture—constructing elaborate public relations campaigns and wielding hefty advertising or campaign budgets to promote their agendas. But they are not immune to the attacks of a popular satirist. In our society Trudeau and his fellow satiric watchdogs are given several unique privileges to level the playing field: a promi-

nent space in a broadly influential popular forum (the comics page in Trudeau's case); the appealing aura of a principled underdog, taking on corrupt Goliaths; and the extraordinary license of the satirist to attack powerful people and corporations through truthful distortion, exaggeration, and caricature. The fact that Trudeau has done this for so long, so entertainingly, and with such consistency, sets him apart as perhaps the most significant American satirist of the last forty years.

Nevertheless, despite his great popularity, and the critical consensus on his importance as a satirist, Garry Trudeau's place in the history of American comics is as yet insecure. In part, this is because of the way comics historians have canonized the field. The history of great newspaper comic strips has been defined by books like *The Smithsonian Collection of Newspaper Comics* and *The Masters of American Comics* as well as lists like *The Comics Journal*'s 100 best comics of the twentieth century. In these surveys, the golden age of comics is defined as the first half of the twentieth century, starting with *Hogan's Alley* and ending with *Peanuts* (often described as the last great comic strip). For example, in the *Journal*'s ranking of the best English-language comics, *Doonesbury* earned a spot at #37, a respectable position but well below *Krazy Kat, Peanuts,* and *Pogo,* which dominated the top of the list. According to this traditional narrative, comic strips after the 1950s were alleged to have gone into decline because of shrinking space given to strips, bland storytelling, minimalist art, and greater restrictions on artistic freedom. While some of that decline has indeed occurred—especially in relation to size and aesthetics—it both oversimplifies and shortchanges the quality of work done by a number of late-twentieth-century cartoonists including Gary Larson, Lynn Johnston, Bill Watterson, Berke Breathed, Aaron McGruder, Darby Conley, Nicole Hollander, Bill Griffiths, and, of course, Garry Trudeau.

This book argues that the successful career of Garry Trudeau challenges parts of this standard narrative of comic strip history—the golden age followed by a long fallow period—by highlighting how an auteur flourished in an era when comic strips were supposedly in decline. With his sharp-witted political satire, his character-based narratives, and his instinct for controversy, Trudeau produced a comic strip important enough to be denounced by high government officials, including presidents of the United States. This study tells how Trudeau was able to carve

out an artistic niche for himself in an unpropitious environment. At times he worked within the grain of his era, for example using minimalist art not as a weakness but as a visual correlative to his deadpan storytelling. On other occasions, Trudeau actively contested his environment, demanding greater artistic freedom and space for his stories.

In the end, Trudeau's greatest achievement has been as a satirist. Although working in a much-dismissed popular art form, he revived the tradition of moral satire, holding the wealthy and powerful to ridicule for their offenses against moral norms. He did this in a period where the mass media in general was accused of becoming ever more servile and trivial. Despite some failings and setbacks, Trudeau's story is one of triumph over adversity, proving that in the hands of the right sateur, comic strips could still be a vital cultural force well into the early twenty-first century.

In conclusion, the fact that Trudeau's notoriety or impact extends beyond the world of traditional politics—that he irks people in so many arenas—is perhaps highly significant in assessing his cultural importance. For in a contemporary American society in which one should fear the stifling social and political effects of a bland but immensely powerful commercial culture rather than the oppression of a totalitarian government, it is a good thing to have a satirist who can tick off those people intent on defanging social and political satire in the name of maintaining business as usual. From this perspective, those complaints from editors, readers, and colleagues who just want the comics to be about cute animals or little kids who unintentionally crack wise, no longer seems so mild and reasonable; instead, it sounds alarmingly like a modern type of censorship—a stifling of public debate and awareness for broad swaths of the society who need it most.

The first chapter in this study discusses Trudeau's biography and the general history of his strip. In order to understand Trudeau's motivations, the flavor of his politics and satire, and the subtext to some of his most famous feuds with political figures such as the junior and senior Bushes, it is essential to explore his upbringing and education. His peculiar brand of irreverent, vaguely left-leaning politics can be traced back, in part, to the intersection of several (at times complementary, at times competing) influences: a sense of noblesse oblige inherited from a civically minded,

but patrician New England family; a conflicted pride and embarrassment at having studied at an elite Ivy League college (Yale); and a personal identification with a generation of baby boomers who came of age in the era of countercultural politics, but who in the ensuing decades lost, to varying degrees, that movement's idealism and innocence. The resulting political worldview—a sort of self-consciously populist liberalism—continues to this day to mark the satiric, commercial, and political battles he chooses to wage. Seeing the long arc of Trudeau's career, with significant successes and controversies highlighted, also lays a foundation for discussions in later chapters having to do with the evolution of his characters, satiric methods, and business practices.

The second chapter delves into Trudeau's most significant contribution to the field of comics, as well as the culture at large: his work as a satirist. First I establish a basic profile of Trudeau's modes and philosophies: he is a popular, topical satirist who sees himself as a political watchdog and cultural critic. Then I break down the different aspects to this position, examining how Trudeau's mode fits into the history of both literary and popular (in particular, cartoon and comic) satiric modes. I conclude that Trudeau represents an amalgam between traditional notions of the satirist as a privileged, scolding cultural critic or jester, and more postmodern conceptions of the satirist as self-effacing chronicler of cultural complexities and foibles. Within this larger discussion of Trudeau's methods, a variety of sub-issues are covered, including the merits and deficits that come with engaging in topical satire; the relation between Trudeau's political convictions and the satiric methods he employs; the issue of objectivity and equal opportunity mockery when the satirist's own politics can be identified; controversies surrounding Trudeau's melding of investigative journalism with the distortions and exaggerations of satire; and comparisons between Trudeau's modes and methods and those of other contemporary cartoonists and satirists engaged in either more cosmic, open-ended philosophical commentary, or more hiply detached, scattershot postmodern mockery. The thoughtful consistency of Trudeau's methods and the principled coherency of his critical worldview make his work a powerful standard by which to judge these other contemporary figures.

The third chapter discusses the business side of Trudeau's career—his negotiations with syndicates and editors as he achieved the auteur-like clout and independence that enabled him to become such a powerful and iconoclastic satirist. It may seem odd to feature a discussion of economics and institutional negotiations so prominently in a study of a great artist; but because Trudeau is working in a popular, commercial field of entertainment, it is essential to understand how these forces and mechanisms shape his art and satire for good and ill. In other words, the politics of producing Trudeau's strip have a direct impact on the politics *in* Trudeau's strip. After establishing the importance of the concepts of the auteur and Gramscian incorporation in studying Trudeau's work, the chapter will cover his engagement with the following issues: contracts and artists' rights, merchandising, sabbaticals, size restrictions, and feuds with other creators over codes of professional conduct for comic strip artists.

The fourth chapter discusses the visual aesthetics of Trudeau's strip. While Trudeau is not widely celebrated for his artistic brilliance, the aesthetics of his strip do play a crucial role in the effectiveness of his satire. Moreover, he has contributed a handful of innovations to the art of comic stripping that, ironically, have grown in some cases out of his weaknesses. This chapter begins broadly, addressing issues peculiar to the hybrid medium of comic strip satire (all the while applying them to Trudeau's work): McCloud's theories on the minimalist power of cartoon imagery; the relationship between words and images in comic strips; and how the format and framing of comic strips shapes and determines their content. Then, looking more specifically at Trudeau, I consider the following aesthetic issues unique to his work: Trudeau's lettering style and its relation to his satire; an analysis of his line work and facial characterizations (specifically, how the undynamic, minimalist quality of his line work, and the limited range of facial expressions of his characters, match the ironic, deadpan tone of his satire); a discussion of how the text-heavy frames and repetitive imagery of the strip affect the strip's satire in both positive and negative ways; and Trudeau's use of what he calls cartooning haikus—iconic symbols to represent particular political figures (a feather for Dan Quayle, a blip for the first President Bush, a waffle for Clinton, and a cowboy hat for the younger President Bush). This last issue receives

special attention for how it emerged as a way of shortcutting his weakness for dynamic caricature, but eventually became a brilliant innovation that capitalized on the inherent power of the medium to amplify an essential truth through minimalist distillation.

The final chapter addresses an aspect of Trudeau's work that is perhaps equally as impressive as his topical, political satire: his three-decades-long documentation of American cultural history through the lives of his comic strip characters. Taken singly, his nonpolitical strips constitute isolated, comic observations on a particular interaction between his characters; but read as a continuity over weeks and years, these strips become a complex, novelistic narrative that charts shifting cultural values, a changing zeitgeist, and the particularities of everyday life in the United States during these decades. This task is aided by the reductive qualities of comic strip character construction (these figures are meant to be easily identifiable social types); but because of the sheer accumulation of storyline upon storyline, and Trudeau's own tendency to become more nuanced and compassionate in his treatment of characters the longer they stick around, Trudeau transcends the traditional limitations of the medium's storytelling and culture-chronicling abilities. Indeed, his social satire is always funny but rarely simplistic or punishing. To build upon the watchdog metaphor, Trudeau leaves behind the aggressive functions of a pit bull in the nonpolitical storylines, becoming, instead, a stern but friendly Labrador retriever, wryly barking at our collective foibles, but rarely biting. As I will illustrate, there were, of course, missteps in this project—such as his occasionally overeager impulse to update his hipster credentials as he deals with cultural fads having to do with teenagers and technology, or his self-indulgent sentimentalizing of various baby boomer rites of passage. Nevertheless, for the most part he has been accurately in tune with the spirit of the times and especially capable of giving empathetic voice to a variety worldviews and voices through his varied characters. The chapter will highlight Trudeau's achievement of this feat, using specific characters as entries into particular discussions.

In closing, this study attempts to assess the significance of Trudeau's career by providing a broad view of his activities and achievements on the comics page and beyond. It makes the case that he is, first of all, one of

the most significant comic artists in the history of the funnies page for his strengths in isolated areas: as an uneven but underappreciated artist who introduced new ways of exploiting the iconic power of cartoon imagery; as a witty comedian capable of creating consistently funny comic strips through the use of irony and situational and character-driven humor; as a sensitive social chronicler capable of great empathy, insight, and complexity in his construction of realistic characters and engaging storylines; as a courageous but often controversial satirist and social critic; and as a principled businessman. In considering all of these accomplishments together, Trudeau emerges—despite the occasional failing or blind spot—as perhaps the greatest popular satirist of the last half-century in American culture. This stature was achieved precisely because he was not content to excel merely in one aspect of his career; for him, ethical business practices and auteur-like independence were integral to the quality of his satire, and his effective social criticism was inextricably embedded in those complexly constructed characters and narratives. In sum, he represents a type of sateur that is too uncommon in an age of committee-produced comedy and blandly constructed comic strips; may his example, as elaborated in this study, inspire other cartoonists and satirists to achieve similar greatness.

Chapter One

From Walden to Iraq

A Brief History of Trudeau's Career

It is easy to think of Garry Trudeau as the Thomas Pynchon of comic strips: he is private, reticent, and enigmatic, only occasionally speaking in public, and giving interviews just three times in a four-decade career. So deep is his distaste for public exposure, that before one interview, with *Time*, he actually threw up and then canceled the interview (Weingarten W14). On another occasion he hid in his bathroom for four hours to avoid the questions of a Baltimore *Sun* reporter ("*Doonesbury*: Drawing and Quartering" 65). Trudeau is probably justified in this extreme reticence for several reasons: the media's and the public's appetite for this type of information is fairly insatiable and thus an entertainer can easily be over-exposed, resulting in loss of interest in the public's imagination, and loss of privacy and peace of mind for the artist; if an artist talks too much about his or her work, it can preempt the lively discussion and interpretation that is the pleasure of critics, highly engaged fans, and academics; the fresh qualities of the work itself can be spoiled if the artist's life begins to compete for public attention with the drama and comedy of the strip; and finally, as a satirist, Trudeau is perhaps wary of the dangers of exposing one's dirty laundry (if indeed he has any), or of revealing one's conflicted thought processes to enemies and critics. Indeed, it should be no wonder that someone who takes great liberties in exposing the skeletons in other public figures' closets keeps a tight lock on his own.

The challenge then, for the biographer, would be to make the most of this limited amount of information drawn from scant interviews and the public record. Without taking too much interpretive license, some effort

should be made to use this information to speculate about Trudeau's motivations, to make connections between his upbringing and his politics, to identify blind spots in his work and worldview, and to find traces of Trudeau in his characters. In the following pages I will attempt this broad analysis of Trudeau's life and work, then proceed to lay out in rough strokes the most significant events and milestones of his career. This biographical and career sketch should provide a foundation for the more focused discussions in subsequent chapters.

Trudeau's semi-privileged upbringing appears, at first glance, to be an unlikely seedbed for a subversive, generally populist, satirist: He was born Garretson Beekman Trudeau in New York City in 1948, and then raised in Saranac Lake, New York. Most of his ancestry on both sides were either doctors or persons involved in some sort of government service. He does point with pride, however, to a few ancestors who displayed a socially mischievous streak: a great-great-grandfather who carved satiric figurines of famous medical men from his day and was involved in some Civil War tactical fiascos; and a great-grandfather who got into trouble when he was ten years old for shooting a visiting Confederate ambassador in the back of the neck with a slingshot. Trudeau said that he sees a lot of himself in that particular ancestor (Weingarten W14).

Members of Trudeau's more recent family tree were not rabidly Republican, but their politics, perhaps because of their privileged social status, leaned to the right. As an educated, civically engaged family, they saw themselves as belonging, nevertheless, to a tradition of liberal egalitarianism. In his satire he has made the dissonance of these competing ideologies a major theme, continually returning to the ironies and hypocrisies of individuals and a society built on such conflicted ideas. In addition, having been raised at the intersection of the ethics of aristocratic gentility and liberal idealism, Trudeau seems to have adopted a sense of noblesse oblige that has fueled both his selfless devotion to promoting social justice through satire, as well as his supreme confidence in his worldview, his business ethics, and his position as social chronicler.

One may also speculate that Trudeau's populist indignation at corrupt authority, nepotism, and old-boy networks is rooted in a need to exorcise a sense of lingering guilt at having such fortunate opportunities. It has even been speculated that the depth of his intense loathing for the Bush

family comes from his need to differentiate his own privileged, WASPy persona—one that is tempered by self-criticism and a championing of social underdogs—from that of other Ivy Leaguers who, from his perspective, have seemingly used their background and connections to increase their own wealth and power. For example, those strips which mock the elder Bush for his participation in the closed Skull and Bones society at Yale (the university attended by Trudeau as well) reflect a vehemence and particularity that belies his deep-seated, especially personal dislike for this other type of New England family. (At the same time, one could argue that the Bush family's adoption of swaggering, folksy, Texan personas was an effort to distance themselves from the type of liberal New England elitism they saw in families like Trudeau's; Bush indicated as much in 1988, when he charged that Trudeau only spoke "for a bunch of Brie-tasting, Chardonnay-sipping elitists" [Alter 61].)

As a young boy Trudeau led, in his own words, "a real Christopher Robin existence," enjoying the rural setting of his home and being "well-schooled in fantasy and Beatrix Potter" ("*Doonesbury*: Drawing and Quartering" 60). He was highly interested in the world of the arts, particularly theater. At seven he created a theater troupe that performed regularly in his basement; he continued with these homemade dramatic productions well into his teens, often staging lavish performances replete with tickets, scripts, and programs (Alter 64). At the age of twelve he made the decision that instead of being a performer he would like to "be behind the scenes and write and compose and direct" (Grove D15). By acting as director, set designer, and writer for these elaborate in-family productions, he foreshadowed the incredible energy and creativity of his adult years and a lifelong penchant for operating as an independent, iconoclastic artist. This passion for theater would also continue throughout his career and find outlet in a *Doonesbury* stage production during his notorious sabbatical in 1983; in *Rap Master Ronnie*, a satirical review of the Reagan era; and in other script and screenplay writing for such acclaimed works as the political satire, *Tanner '88*.

By Trudeau's own description, he was an awkward teenager. Physically weak, athletically slow, pigeon-toed, and small for his age, he did not fit into the popular crowd. About his time at St. Paul's prep school in New Hampshire, he says, "I was not the class clown. In fact, I was pretty shy. . . .

[It was a] tortured time for me [because] I was the second or third small-est in my class" (Alter 64). As a result of being ostracized from the elite cliques at school, Trudeau's inner, imaginative life was given ample time and space to develop. He found solace in art—an interest that did not help his social life; a classmate recalls that the prep school was "an unbeliev-ably bad climate to be an artist," and as a result, "Garry took a lot of grief" ("*Doonesbury*: Drawing and Quartering" 60).

The traumas of his teen years—including seeing his parents divorce—gave him ulcers and probably contributed to his career-long sympathy for people in minority or underdog positions in society. He has little nostalgia for this awkward period in his life; for example, he stated in an interview in 1986 that "Adolescence is, I think, an unpleasant time of life no matter where you spend it and with whom you spend it. I didn't like being a teen-ager. I didn't like teenagers when I was one. And I still don't like them. It's a very selfish time of life" (Grove D15).

As Trudeau entered into his young adult years—the point at which he was expected to follow his father's lead in becoming a physician—his interest in art and theater put him at odds with his extended family. One can see how Trudeau's creative and sensitive personality did not mesh with his father's worldview, a philosophy that can best be summarized in the maxim he repeated often to his son: "Life is not something to be enjoyed, so just get on with it" (Weingarten W14). In some ways the disconnect between Trudeau's aspirations and his family's expectations was typical of many family conflicts in the late 1960s when staid lifestyles of the older generation clashed with the newly bohemian, countercultural ethics of their children. Trudeau was not a rebellious kid in any radical sense, but his affinity for the arts seemed to place him within the general parameters of this dissenting youth culture. Trudeau jokes that during his teen years his grandmother "would plead with my parents to send me to Outward Bound, because she had read in *Life* that the counselors were very good at reaching troubled teens" (Trudeau, *Flashbacks* 90). Trudeau's eventual choice of satiric cartooning as a career ultimately allowed him to be a respectable rebel, gaining the grudging respect of his family while both rejecting the aristocratic conceits of background (the popular, lowbrow associations of the medium took care of that) and ridiculing, in a vaguely

countercultural fashion, the previous generation's awe for authority and conservative, conventional wisdom (Grove D15).

In light of Trudeau's adult dedication to following politics with a wonk-like intensity, it is interesting to note that, although he had vague countercultural leanings as a youth, he did not have a deep understanding of politics or any strong convictions about particular parties or candidates during his formative years. Here he describes this teenage detachment:

> I wasn't particularly politically attuned growing up. There wasn't much debate at our dinner table. My parents were Republicans, so the GOP was my team, and Ike was our genial manager. In '60, I was too young to really respond to JFK's charisma as intuitively as I was repelled by Nixon's sleaziness, and in 1964, I was so disengaged that I actually designed placards for both parties at my high school. Later I came to admire Robert Kennedy and Martin Luther King, but more as pop figures than as visionaries who changed the world. Vietnam was the wake-up call. That's when I really started paying attention, and by then heroes were in scarce supply. Besides, who needed role models? We had the certainty of youth. (Bates 62)

After prep school, in 1966 Trudeau went to college at Yale University. The ulcers prevented him from being drafted to fight in Vietnam, so he settled down to being a college student and pursuing his artistic interests. While at the university, Trudeau emerged from his awkward adolescence and became active in school organizations, including work as the coeditor of the campus humor magazine. In his junior year (1968) he began the comic strip *Bull Tales,* for the *Yale Daily News;* it quickly became a popular fixture in the campus culture. Although it was not as political as his later strip, he did ridicule "such big men on campus as Yale's president and the star of the football team," a quarterback named Brian Dowling ("B. D.") (Woodson 104). This willingness to take on public figures with acerbic fearlessness would remain a dominant theme throughout his career. Typical of a college strip, however, *Bull Tales* was still dominated by limited, college-related themes such as football mock-heroics and male dating fantasies and humiliations. The protagonist of the strip was Michael

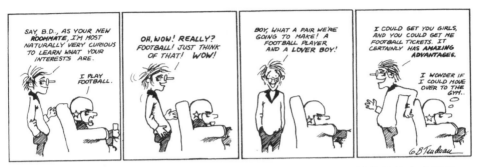

Figure 1.1. Garry Trudeau, "A Football Player and a Lover Boy," *Bull Tales*, 1968. *Bull Tales* © 1968 G. B. Trudeau. Used by permission. All rights reserved.

Doonesbury, a delusionally confident everyman whose last name was derived from the prep-school slang term for doofus, "Doone" (Weingarten W14). Figure 1.1, the first strip in *Bull Tales'* run, illustrates the typical tone and content of Trudeau's college comedy.

While most cartoonists can struggle for years to get their work syndicated, facing multiple rejections before securing a deal, Trudeau essentially found an easy entry into the field. James F. Andrews, the cofounder of Universal Press Syndicate, noticed his strip in the Yale paper, saw its potential to appeal to a youthful audience, and offered him a chance at national exposure. Trudeau describes his good fortune at being "discovered" so quickly in the following manner:

> (Question: Fluke start, right?) Pretty much. I was approached about
> syndication during my junior year in college after an arduous four-
> week apprenticeship on the school paper. Incredibly, the offer didn't
> strike me as particularly remarkable. It was the very essence of being
> in the right place at the right time, but when you're young, you don't
> understand serendipity. You feel entitled, even to your accidents.
> (Trudeau, *Flashbacks* 15)

Trudeau did not know it at the time, but he was also fortunate to align himself with a fledgling syndicate that was willing to take chances and sponsor features that were offbeat, strips that would set apart this company from its stodgy peers (Turner 42). Looking back, Trudeau now realizes that the typical syndicate would not have looked twice at his work:

The early *Doonesbury* didn't fit anyone's definition of a natural candidate for syndication. It was written on the fly, crudely executed, and ignored pretty much every convention of the business, largely because its creator didn't know any better. It took a new syndicate with no other features (and thus nothing to lose) to take a chance on a strip that wasn't really designed to reach a broad audience in the first place. In fact, I'm not sure I knew what syndication was at the time it was offered to me. I'd been cartooning for all of six weeks when Jim Andrews at UPS talked me into the job I now hold, so the stone flukiness of it can't be overemphasized. ("Trudeau is 'Amazed,'" 31)

Trudeau benefited from this naiveté and lack of awe at the comic strip industry because it allowed him to envision possibilities for his strip outside the mainstream norm. Since he did not pursue a long professional apprenticeship in which a cartoonist generally tries to "figure out" the business, he was not encumbered with the knowledge of how pressures could potentially nix his topical and combative style. Even with a distribution deal, Trudeau was unsure of his future professional path, pursuing and earning a masters degree in fine art so that he could teach or work in some capacity in the art world. In other words, he had nothing to lose by taking chances or experimenting with his strip. He was only a junior in college, had not struggled to attain this cartoonist's dream of being syndicated, and could thus safely revel in being a rebel in the field.

It should be noted here that despite Trudeau's detachment from the mainstream field of cartooning at the start of his career, he was neither ignorant of nor uninfluenced by cartoonists both traditional and alternative as he established his style. From the world of mainstream comics, he was a fan of Walt Kelly's *Pogo*—in particular, its political engagement and ability to create humor through complex storylines and character quirks (Grove D14); and he admired and tried to emulate the emotional richness of Charles Schulz's *Peanuts* with its cast of "complicated, neurotic characters speaking smart, haiku-perfect dialogue" (Begley 24). From the emerging alternative press, he admired the work of Jules Feiffer (*Sick, Sick, Sick* and *Feiffer*) and consciously or unconsciously built upon both the aesthetic and satirical strengths of this intellectual and combative satirist's work. Feiffer's influence could be seen in Trudeau's lettering, his abandon-

ment of word balloons; in the complexity of his characters' monologues and dialogues; in the melding of comic strip and editorial cartoon forms; and in some of the aesthetic peculiarities of Trudeau's work. This included the elongated, square noses, spare contextual details, the general strategy of minimalist art supporting pointed, verbal satire; and a blunt engagement with issues of race, sexuality, and politics.

After being renamed *Doonesbury*—the name of its principal character—the strip was launched in 1970. The crude drawing style of Trudeau's college work improved somewhat over the first year of syndication, but the strip was slow to find a following. The feature had only twenty-eight newspapers subscribing the first year (reason enough for quick cancellation in today's market) but began to develop a cult fan base, especially among younger readers and those who appreciated its offbeat flavor and engagement with politics and social issues—the way it resembled nothing on the comics page. In Trudeau's words, the comics page in the early 1970s ". . . was this weird parallel universe that bore very little resemblance to life as people really lived it. That's not to say that the foibles comics described weren't recognizable—it's just they were so militantly generalized and inoffensive that people my age, caught in powerful political and cultural riptides, couldn't find anything in them to identify with" ("Trudeau Is 'Amazed'" 31).

Trudeau's syndicate stuck with the strip in the hope that it could build on this niche appeal, attracting younger readers to the newspaper at a time when the blandly domestic themes of the traditional comics page held little interest for a generation of culturally disaffected college students. In turn, much the way today they desperately seek to woo Gen X and Gen Y readers, newspapers may have been initially convinced to buy the strip because it addressed this hard-to-reach, but critically important baby boomer demographic.

Throughout the 1970s the strip gradually grew in popularity, gaining syndication in over 900 newspapers and a readership of eighty million (still somewhat less than the most popular strips of the decade) ("Doonesbury's 900" 4). It effectively became the flagship feature of the Universal Press Syndicate as they took on other unconventional fare such as Cathy Guisewite's *Cathy* and Lynn Johnston's *For Better or Worse*. This popularity gained for Trudeau the clout necessary to weather the contro-

versies created by his strip; indeed, editors could rail against his topical satire and irreverent themes, but the success of the strip—and the combative devotion of his core fans—protected it from outright cancellation. For example, in 1971 the strip narrowly escaped cancellation in the *Macon Telegraph* after a reader poll resulted in the following vote: 27 in favor of keeping *Doonesbury*, and 22 against (Trudeau, *Flashbacks* 21). This type of referendum on *Doonesbury* would become common for newspapers in the ensuing years.

This gradual success of the strip also won for Trudeau some grudging praise from his family. His father offered him barbed congratulations, saying, "You're lucky you were born when you were. In my day you'd have been a loser" (Trudeau, *Flashbacks* 16). Similarly, his mother quipped after hearing that he had won the Pulitzer Prize in 1975, "I'm perfectly thrilled and delighted. I've kept my fingers crossed for fear he might end up in jail" (Trudeau, "Investigative Cartooning" C1).

Removed from its initial university setting—and the narrow range of predictable issues addressed by a college cartoon—*Doonesbury* began to tackle more ambitious topical issues such as Vietnam, Watergate, and the women's movement (see fig. 1.2). Seemingly energized by the breadth of material that he could cover as a satirist and social chronicler, Trudeau also expanded his methods and tools. His staple device—a dialogue in which the principal figure is caught in a contradiction, delusion, or pretension—gained greater weight as the subject matter shifted from young adult romance or ego-stroking fantasies to engagement with controversial, topical issues. Trudeau also added new satiric/comedic strategies to his repertoire: parodies of news reporting (most often featuring Roland Hedley) in which Trudeau brilliantly channeled the smarmy cluelessness of some reporters or commentators; interviews in which Mark Slackmeyer could entrap venal public figures in their own twisted logic; eavesdropping vignettes of White House conversations in which Trudeau created effective verbal caricatures of the president and his advisors; and a host of secondary characters that allowed Trudeau to channel voices and address issues across the cultural spectrum.

All of these strategies were linked by Trudeau's incisive grasp of complex current events; indeed, his working methods led him early in his career to develop a level of cultural and political knowledge uncommon

among comedians working in any medium. Melding the roles of cartoonist and investigative reporter, Trudeau did as much or more homework than the typical journalist, sifting through multiple newspapers, magazines, and even government documents as he constructed his early strip. He even attended political caucuses and famously accompanied President Ford to China as journalist-observer (*"Doonesbury:* Drawing and Quartering" 65). This habit of doing more homework than anyone else gave the strip its signature complexity which can be celebrated as both its greatest strength—Trudeau's confident and funny dissection of current events—as well as its greatest liabilities in some eyes: a dense topicality that alienates typical comics-page readers and blurring of roles (investigative reporter and satiric cartoonist) that has irked many editors. Indeed, the studied topicality and the irreverent flavor of Trudeau's commentary (a worldly wise liberalism) made the strip notorious among editors who had grown accustomed to seeing the comics page as a politics-free, family-friendly medium (code for generically conservative). Many of these editors were convinced—and still are—that the strip belonged on the editorial page with opinion articles and political cartoons. In 1973 one newspaper—the *Lincoln Journal*—actually moved the strip to the op-ed page, and over the years more editors followed suit (Trudeau, *Flashbacks* 45). In many cases this shift was only temporary; the strip was reinstated when it pulled away from the topical material in question or when fans griped too much. In a smaller number of cases the shift was permanent.

These ongoing debates about the appropriateness of Trudeau's satire within his medium served to highlight *Doonesbury*'s core strength: its hybrid nature, drawing qualities from political cartooning, investigative journalism, and comic strips. From political cartooning it obviously borrowed the ethic of engaging directly with topical, political events and exerting the license of the satirist-watchdog to attack powerful public figures through caricature, distortion, and exaggeration. But unlike the typical political cartoonist who takes shots from a distance, who is often "objective" or disengaged, Trudeau—like a muckraking journalist—unearthed controversial stories, exposing the details through "truthful distortion," and pursuing prolonged satirical vendettas against particular public figures.

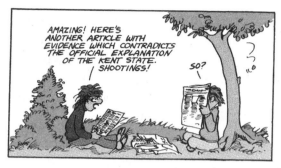
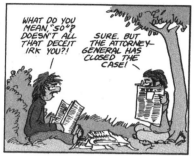
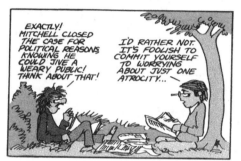
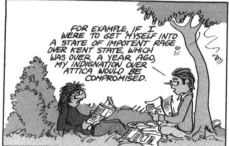
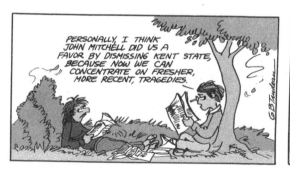
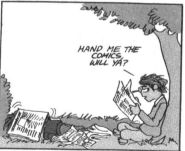

Figure 1.2. Garry Trudeau, "Hand Me the Comics," *Doonesbury*, Nov. 28, 1971. An early example of Trudeau introducing topical political issues onto the comics page. *Doonesbury* © 1971 G. B. Trudeau. Reprinted with permission of UNIVERSAL PRESS SYNDICATE. All rights reserved.

While editors have decried the pursuit of these first two objectives through the comic strip form, it is this medium that makes Trudeau's work especially powerful—that couches the topical satire in an especially appealing and complex narrative form, and amplifies its cultural reach. A traditional political cartoon is fairly limited in its ability to do more than make one satirical point or produce a simplistic gag (it has to work with

one frame, uses a limited cast of generic everyperson characters, and must move on to a new topic the next day), but a comic strip has the luxury of framing the satiric commentary within a rich, ongoing narrative, complex character development, and layered dialogue. As a result, the satiric tools available to Trudeau are greatly expanded. For example, subtle irony or layered forms of contradiction and hypocrisy can emerge or be exposed when the satirist has multiple frames, continuity, and greater space within which to work. Finally, because more people read the comics page than the editorial page—and a greater variety of politically disengaged people read the comics page (such as young people getting their first taste of satire and politics)—the comic strip form of Trudeau's work increases its potential to incite public debate, check abuses of power, or expose folly.

The comic strip format also allowed Trudeau to fulfill an additional role as a cultural chronicler. By developing an enormous cast of distinctive characters, Trudeau was able to create identifiable social types (a useful device in framing satire that could explore the breadth of American society); to chronicle the baby boomer generation through vivid personalities and complex relationships; and to give voice to competing and evolving ideologies in engagingly particularized ways. To Trudeau's credit, he has never abandoned completely that youthful idealism in the ensuing decades, but has always tempered it effectively with an unsentimental satirizing of the many ways that self-interest, life pressures, and hypocrisy can undermine the idealist's best intentions.

In the early years of the strip Trudeau cleverly grounded this cast of characters in a particular location—the Walden commune, the adult equivalent of a college dorm. This proved a handy device in simply bringing disparate characters together so that they could logically intermingle; but it also embodied some aspects of Trudeau's communitarian ethos or worldview. In addition, the communal setting gave a homey sense of identity to the strip and its characters—one that appealed to the common experience and high ideals of boomers. Within this cultural microcosm Trudeau could have it two ways: he could celebrate those characters and values that carried on the promises of 1960s liberalism, and at the same time satirize those aspects of the countercultural generation that had gone astray or become ridiculous. It was the perfect setting in which to chart a generation's transition between young adult, bohemian idealism, and the complexities and contradictions of bourgeois adulthood.

Over the decades Trudeau's cast has grown to include dozens of characters, but in the early days of the Walden commune, he focused on the interactions of a tight community of central figures. These included the following characters:

- Michael Doonesbury, a sort of contemporary "little man": well intentioned and smart, but susceptible to self-delusion, beaten up by the world, and too ready at times to compromise his principles when faced with social or economic pressures. Michael was the character through which Trudeau most directly projected his own voice and worldview; it is also the character-protagonist who gave readers imaginative entry into the world of *Doonesbury*.
- B.D., the former college football star who told readers a great deal about his personality simply by refusing to take off his football helmet in the adult, post-college world. Although he was meant to be a jocky, conservative foil to Michael's softer, more liberal persona, he has grown—inevitably—in the continuity of the strip over the years, taking on layers of poignancy and real heroism.
- Mark Slackmeyer, a political activist, radio talk-show host, and, eventually, one of the only gay characters on the comics page.
- Zonker, a hipster and pothead. Like Snoopy in *Peanuts* or Kramer in *Seinfeld*, Zonker played the role of the unrestrained id, the trickster figure, and the jester, operating outside of societal rules.
- Joanie Caucus, a homemaker in her forties who joined the women's movement and headed off to law school after having a midlife crisis.
- Boopsie, a blonde bimbo who initially serves as a target of much of Trudeau's satire of superficial, mainstream entertainment and culture, but who eventually, over the years—like B.D.—takes on more nuanced layers in her character.
- Other significant characters who joined the cast by the end of the 1970s included Duke, a parody of the "gonzo journalist" Hunter S. Thompson, and an opportunistic mercenary in his own right; Phred, the world-savvy Vietnamese soldier; Mark Slackmeyer's squarely suburban father; and Lacey Davenport, a grande dame of Washington politics.

It should be noted that although *Doonesbury* is famed for its topical satire, one cannot overemphasize how critical the construction of these characters—and the subsequent twists and turns of their lives—were to the success of the strip's satire. Without the emotional draw and specificity of these characters' life dilemmas, the satire would have been reduced

to lectures and mere polemics. And unlike most strips that freeze their characters at a particular age with unchanging habits and worldviews, Trudeau has allowed his characters to age and evolve through the strip's long run. This added to Trudeau's satire a complexity absent not only from most other comic strips (with the exception of *Gasoline Alley* and *For Better or Worse*), but also from formulaic and static sitcoms and films that can give their characters only a limited arc of development. (A more elaborate discussion of each character's significance within the strip, and a more complete charting of the evolution of each, is included in the final chapter, a discussion of Trudeau's significance as a chronicler of the cultural zeitgeist.)

Returning to the early years of the strip, one can observe that while using Walden and these central characters as a foundation or starting point, Trudeau ranged widely in topic and setting during the 1970s. A common device would be to use a particular character as a guide into a current topic: Joanie and her discovery of the women's liberation movement, B.D. and his engagement with the Vietnam war, Mark and his radio coverage of the Watergate scandal, etc. The power in combining compelling characters and engaging storylines with savvy commentary on current events and politics explains why many people—especially among the educated intelligentsia—became devoted fans of the strip. One could intellectually and morally engage with current debates and issues while being entertained with narrative comedy and familiar, endearingly flawed characters.

As the cultural profile of the strip became more prominent in the mid-1970s, and as Trudeau's satire became increasingly more political, people in Washington began to pay attention to the strip as well. Even targets or critics of the strip had to admit grudgingly that it had become an important filter of the news, source of liberal commentary, and chronicler of the zeitgeist. For example, Gerald Ford half jokingly stated that "there are only three major vehicles to keep us informed in Washington: the electronic media, the print media, and *Doonesbury*—not necessarily in that order" (Trudeau, *Flashbacks* 84).

The strip's emerging status as one of the most significant works of popular satire in any genre was cemented when Trudeau received the Pulitzer Prize for political cartooning in 1975. Some traditional political cartoonists reacted in outrage, sending a formal complaint to the prize

committee; they felt cheated and threatened because the award was given to someone outside their ranks—a comic strip artist. Others were more generous, grudgingly acknowledging the strengths of the strip and Trudeau's extraordinary abilities. For example, the political cartoonist Ben Sargent reacted by saying, "Walt Kelly and *Pogo* were satirizing politics and society thirty years ago, but nobody really got it the way they get *Doonesbury*. Garry made editorial cartooning accessible, and that's made my job a lot easier. I think we're all a little envious of him, but he has gotten to where he is strictly on his own talent" ("Trudeau, by a Jury of His Peers" 138). The mixed reactions highlighted Trudeau's ability to disrupt the cultural scene in ways beyond mere satiric commentary. Indeed, Trudeau's transgression of the boundaries between mediums and the rules within those mediums was as much a part of his subversive power as the actual content of his comic strip.

Perhaps the best way to chart the remainder of Trudeau's career—while noting significant thematic patterns, aesthetic developments, and business-related controversies along the way—is to highlight some of the most outstanding or controversial episodes in *Doonesbury*'s history. Significant runs from the early years of the strip include a series set in Vietnam with the American football hero, B.D. and the Vietcong fighter, Phred, as unlikely companions; Joanie returning to law school and falling in love with a gay male classmate; and Uncle Duke becoming the corrupt governor of American Samoa. However, two installments that best represent Trudeau in his most youthfully impulsive and rebellious mode include a Sunday strip with Zonker talking to a child about drugs, and Mark Slackmeyer's pronouncement of a guilty verdict in the Watergate case.

A Zonker strip got Trudeau into some serious controversy in 1972 (see fig. 1.3). Trudeau admitted to being a bit too full of youthful exuberance and inexperience in creating this controversial strip: ". . . I was 24. It was 1972. Someone once asked Robert Crumb why he drew his infamous incest cartoon. He replied, 'I think I was just being a punk.' There may have been some of that" (Trudeau, *Flashbacks* 34). One can perhaps see why dozens of papers, in reaction to massive reader complaints, temporarily dropped the strip for "making light of the drug problem" or for seeming to celebrate—rather than satirize—Zonker as laughable icon of a lingering hippie mentality. In this strip, Trudeau seemed to be testing,

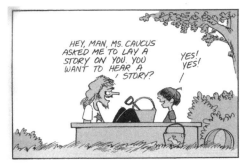
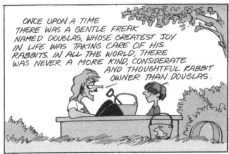

Figure 1.3. Garry Trudeau, "Turkish Hashish," *Doonesbury,* Nov. 12, 1972. *Doonesbury* © 1972 G. B. Trudeau. Reprinted with permission of UNIVERSAL PRESS SYNDICATE. All rights reserved.

albeit with some immaturity, the limits of his satiric license on the comics page and the legitimacy of his argument that topical issues and satiric commentary belong in a venue read across age boundaries. The fact that he could later reflect critically on his own motivations and methods in this early strip also indicates that he had the ability to learn from these

early missteps. Some of the scattershot and ambiguous qualities of this early strip, in fact, resemble aspects of satire that he criticized in later years (such as *Saturday Night Live*) for being opportunistic or irresponsible (Trudeau, *Flashbacks* 7).

The Slackmeyer controversy had to do with the character's coverage of the Watergate scandal in 1973. In the offending strip, Mark gleefully announces over the radio waves that John Mitchell, the attorney general under President Nixon, is "Guilty, Guilty, Guilty!!" Again, one could argue that Trudeau was poking fun, in part, at Slackmeyer's own stridently leftist political leanings; but one suspects that Trudeau also wanted an opportunity to use his character and the narrative liberties of satire to voice his own strong opinions about a case that had yet to be brought to a definitive conclusion (but which did, nevertheless, unfold with a guilty verdict). As a result of this strip more than a dozen papers dropped the feature, and the *Washington Post* told its readers, "If anyone is going to find any defendant guilty, it's going to be the due process of justice, not a comic strip artist. We cannot have one standard for the news pages and another for comics" ("Doonesbury: Drawing and Quartering" 60). While one can cheer the liberties of a satirist to make this type of emotional commentary, a bit of discomfort is felt at the way Trudeau's strong personal opinions seem to overtake the sobriety of the satire, and the problematic ways in which Trudeau's different roles (comic strip storyteller, journalistic muckraker, and political watchdog) overlap.

This pushing of the envelope of appropriateness is a part of what makes any popular satire exciting and effective at prodding readers or inciting public debate; but it is also heartening to observe that Trudeau gradually began to show in the second decade of his career some greater restraint or thoughtfulness in these satiric choices. He did not abandon his taste for controversy, but picked his battles a bit more wisely, and generally engaged in more consistent, judicious combat. He graduated, in other words, from using the youthful hipster's scattershot attacks on anything conventional or mainstream to a more consistent, politically grounded assault on authoritarian and public figures deserving of ridicule. This transition was gradual, and some of his work still occasionally exhibited a reckless quality or self-conscious 1960s boomer hipness, but

beginning in the mid-1970s, and continuing to the present day, Trudeau launched a series of highly political satires impressive in their prescience and thoughtfulness.

A few noteworthy and perhaps more mature—but still controversial, and at times, problematic—episodes from the middle of Trudeau's career include Roland Hedley's journey into Reagan's brain; George Bush putting his manhood in a blind trust; Dan Quayle's alleged drug use; attacks on anti-abortion zealots; digging through the dirty laundry of politicians and prominent public figures such as Tip O'Neill, Jerry Brown, Henry Kissinger, Frank Sinatra, and Donald Trump; the creation of "Mr. Butts," a promotional concoction of the tobacco industry; and the depiction of a character dying from AIDS. Chapter four contains a more thorough discussion of the satiric methods employed in some of these episodes, but a brief description of the contents of these strips—and the public's reaction—helps chart the arc of Trudeau's career.

Perhaps two of the most popular runs of Trudeau's career were Roland Hedley's journey in 1980 into "The Mysterious World of Reagan's Brain," and his "Return to Reagan's Brain," in 1987 (see fig. 1.4). Using his signature fatuous style, Hedley appeared in these episodes to be a television news correspondent on assignment to an exotic locale—a jungle or remote wilderness, replete with sherpas and pack animals. He explained that he was going into deep, neglected, uncharted territory—Reagan's mind, a sort of "brain of darkness." The fantastical distortions of cartooning and satire work nicely here because Reagan's foibles—his convenient lapses of memory and his hyper-cheery view of the world (a sort of delusional denial of complexity and his own contradictions)—were given vivid, figurative, but generally truthful representation in distilled, comic form. Critics of Reagan were excited by this strip because of both the sharp accuracy of the satire and the fact that it made such a broad cultural splash. The fact that the first of the two installments appeared on the eve of the 1980 election helped intensify its impact, but on its own merits it was one of the rare series of comic strips that generated lively water-cooler discussion and grassroots sharing of the run (as if it were some type of political exposé). Of course, it also elicited complaints from conservative readers and sensitive editors. Indeed, more than two dozen papers dropped the weeklong sequence. But illustrating the strength of Trudeau's popular clout—his

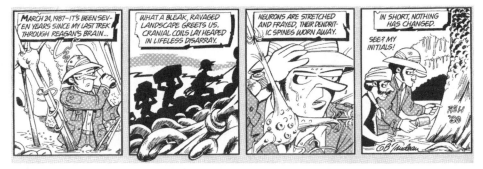

Figure 1.4. Garry Trudeau, "A Return to Reagan's Brain," *Doonesbury*, March 24, 1987. *Doonesbury ©* 1987 G. B. Trudeau. Reprinted with permission of UNIVERSAL PRESS SYNDICATE. All rights reserved.

license to be political in this highly mediated form—was the reaction of readers to the *Indianapolis Star*: when this paper dropped the run on Reagan's brain, the editors received 850 calls of protest and were forced by popular demand to reinstate the strip.

A great number of the most memorable and controversial episodes in Trudeau's career involve sustained, sometimes ruthless, attacks on specific public figures. In the tradition of Daumier, Thomas Nast, and Herblock, Trudeau identified a salient failing in the figure and then gave it vivid figurative expression through a particular symbol or comic concept. Just as Herblock identified and distilled Nixon's shady, ruthless political machinations through the symbol of a perpetual five o'clock shadow, in 1985 Trudeau encapsulated George Bush Sr.'s wimpy political opportunism by having the man's cartoon self announce that he was placing his manhood in a blind trust. But whereas these earlier cartoonists excelled at visual caricature—think of Daumier's drawings of Louis Phillippe's head as a pear, or Nast's rendering of Boss Tweed's corpulent figure as a moneybag—Trudeau's limited drafting skills were initially a handicap in his execution of these satiric attacks. One device he used to get around this weakness was to render static, repetitive images of the white house with elaborate word balloons carrying the weight of the comedy from frame to frame. These cartoons worked as excellent *verbal* caricatures (Trudeau's ability to mimic the peculiar diction of specific public figures matches that of great literary satirists) as well as lightly illustrated satiric vignettes. One could argue that a person's imagination can fill in much of the visual caricature in the strips, using the text as a starting point, but

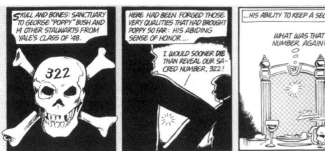

there is still something vaguely dissatisfying about so little visual information. A more successful tack was Trudeau's later representation of these public figures as simplified icons—distilled symbols of their core foible. For George Bush it was a "point o' light" (as in 1,000 points of light), a feather for Dan Quayle, a waffle for Clinton, and a cowboy hat or imperial helmet for George W. Bush. These images are such vivid and memorable reductions of each man's core character that one has to concede that in this case Trudeau's shortcomings as an artist actually led him to develop an especially effective and powerful satiric device.

Although Trudeau has proven over the course of his career to be an equal opportunity offender—taking on Clinton consistently, for example, without mercy—some of his most memorable and controversial attacks have been against the Bush family. Perhaps because of having shared similar privileges and schooling experiences (all of the men attended Yale), Trudeau seemed to be more personally invested in these critiques. Indeed, it seemed at times as if he had a driving need to shame and discredit this family—as if he were trying to take down what he perceived as his conservative alter egos. Besides the blind trust attacks, Trudeau mocked the elder Bush's clubby, old-boy network style of administration with a series about the secret Skull and Bones society at Yale in 1988 (see fig. 1.5). Trudeau could bring an insider's insights to these particular strips because he had also been tapped for membership at this club at Yale; he chose (as he continued to do later) to go in a different direction from the Bushes: he joined a rival club, the Scroll and Key society.

More recently Trudeau, like other political cartoonists, has portrayed the younger Bush as a bungling administrator and arrogant imperialist;

he elaborates that G. W. Bush "is smart but willfully ignorant, and he uses his ignorance for strategic advantage, which is appalling. He substitutes belief for thought. It protects you from self-doubt" (Weingarten W14). One could argue that rather than it being a vendetta against this family, Trudeau's shared past with the younger Bush simply made him uniquely qualified to comment in trenchant ways on the father's and son's personalities and failings. For example, recollecting Bush from his Yale days, Trudeau observed that [he was] "very good at all the tools for survival that people developed in prep school—sarcasm, and the giving of nicknames. He was extremely skilled at controlling people and outcomes in that way. Little bits of perfectly placed humiliation" (Bates 62). He continues with the following elaboration of Bush's behavior at Yale—a critique that reveals some of Trudeau's urgency to distance himself from someone who seemed to share so many of the same privileges and experiences:

> It's hard to believe, looking back, but there was a major generational chasm between the class of '68 and the class of '70. The culture had turned so radically, in such a short period of time, that we no longer identified with people only two years older than us. They were old Yale. They were closer to the values of our parents. Even those of us who went to boarding school and came from the same background as Bush felt we were part of something different. Bush felt alienated from the kinds of people I hung out with. In fact, he took my roommate aside at one point and said, "You shouldn't be hanging out with those people." He felt that what was coming behind him was threatening—an interesting thing for a twenty-year-old to feel. So that nugget of conservatism was already there. (Bates 62)

In some observers' minds Trudeau has taken this seeming vendetta against the Bush family too far by behaving, at times, like an investigative journalist in his attacks on the clan. For example, when allegations were made in 2004 that Bush had evaded service in Vietnam by doing light service in the Texas National Guard, Trudeau participated in breaking news about allegedly forged medical records. He hammered away at it too, pressing the point when other media outlets chose to treat it lightly or to move on; he even made a flamboyant personal gesture to amplify the issue—offering a ten-thousand-dollar reward (see fig. 1.6) to anyone

Figure 1.6. Garry Trudeau, "$10K," *Doonesbury*, Feb. 24, 2004. *Doonesbury* © 2004 G. B. Trudeau. Reprinted with permission of UNIVERSAL PRESS SYNDICATE. All rights reserved.

who could verify that Bush actually fulfilled his National Guard duties (Bates 62).

A fan of the strip could praise this relentless attack as an example of what great popular satire can do when the creator is politically engaged and exercises the clout of an auteur: he or she can check the abuses of public figures in ways protected from economic or institutional pressure. But to supporters of Bush this seemed more like a vendetta, driven in part by personal animosities and based on unsubstantiated claims. Moreover, other less biased critics were uncomfortable with Trudeau taking on the authority of an investigative journalist while exercising the satirist's privileges of distortion and exaggeration.

The reactions of the extended Bush family were another interesting aspect to the controversial National Guard series—as well as to other, earlier attacks leveled at the senior Bush. Whereas Reagan had deflated some of the hype around Trudeau's cartoons about him by treating the whole affair lightly (joking that Trudeau would always have a place in his *heart*, rather than his *head*), the Bushes seemed to amplify the controversy by reacting with peevish anger in public settings. Here is a sampling of things the Bushes have said in response to Trudeau's satire:

George Bush Sr.: "My first reaction was anger, testiness, getting upset. I thought, what the hell? Who is this, you know, elitist? So I had the personal feeling that I wanted to go up and kick the hell out of him, frankly." (October 14, 1987) (Trudeau, *Flashbacks* 228)

"I have gotten more composed, sure of myself. I can laugh at
Doonesbury. It doesn't bother me like it used to." (October 14, 1987)
(Trudeau, *Flashbacks* 228)

"Now I don't understand that guy . . . I read it, and half the time I don't
understand it, even when it's about me. So I don't laugh as much, but
it doesn't bother me. He does his thing, I'll do mine." (April 26, 1988)
(Trudeau, *Flashbacks* 229)

"I used to get very tense about that. My mother still does. She's 87.
She doesn't like it when people say untrue and ugly things about her
little boy. Having said that, it doesn't bother me anymore. You know
why, because we took a tremendous pounding, not just from elitists
like *Doonesbury*, coming out of the elite of the elite, but untrue allega-
tions, and you know why I don't worry about it anymore, because the
American people don't believe all this stuff. They don't believe it. So
I'm saying, why should I be all uptight, when people don't need a filter,
you know?" (May 6, 1988) (Hoffman L1)

Barbara Bush: "I feel like I need to take a bath after reading *Doonesbury*";
and "I don't think most people understand *Doonesbury*. Do I get mad?
Sort of. But not really. I go swim a mile and move on." (Trudeau,
Flashbacks 249)

George W. Bush: "My brother wanted to come up and kick Trudeau's ass all
over New York." (Trudeau, *Flashbacks* 176)

Jeb Bush (while poking a finger in Trudeau's face): "I have two words for you: Walk
softly." (Bates 62)

The senior Bush's reactions are especially interesting because of
how they reveal the inner anxieties of the target. He seemed to want to
ignore the strips—to give the impression that he was impervious to satiric
attacks—but he could not seem to resist the urge to overexplain his anxiet-
ies as he struggled to react with poise. For example, his repeated insistence

that the strips did not bother him anymore seemed to belie the fact that it did continue to irk him enough that he had to talk about it with reporters. In addition, Trudeau's core point about the senior Bush's political spinelessness is even reinforced as we see the man trying to convince himself through very public, positive affirmations that he is sure of himself and immune to criticism. His effort to assert this independence and confidence was further undermined when he later made the dramatic announcement that there were two people he would never forgive—George Will and Garry Trudeau.

Trudeau has gleefully included all of the above reactions as blurbs in his books. He knows that in an age when politicians easily absorb the attacks of political cartoonists by either ignoring their work—or asking for the original as if the attack were just another type of publicity, or a mark of honor—a great success has been achieved anytime you can get a public figure to fight back. Indeed, Trudeau has observed that "the more its [the satire's] intended target reacts, the more its practitioner gains the advantage" (Trudeau, *Flashbacks* 71). About Bush's reactions in particular, he said, "Bush senior used to say he wanted to come down and beat me up. He would lash out at me every day during campaign stops, which was a huge mistake. A comic strip isn't one of those things you want to seem too worried about" (Bates 62). The point then, is that the politician's angry reaction can serve to prolong and amplify the impact of the satire itself; and to some observers the anger can be read as a confirmation of the satirist's allegations—a sign that the satire struck uncomfortably close to the truth.

An earlier controversial series that did not target the Bush family directly, but fell within the scope of their political machine, was the run in 1991 that alleged that Dan Quayle's DEA file revealed that a federal prisoner, Brett Kimberlin, was put in solitary confinement to keep him from repeating his claim that he sold marijuana to the vice president. Because Trudeau seemed to be overstepping the bounds of satire and exercising loosely the privileges of an investigative reporter in this case, scores of newspapers and commentators denounced or dropped the series. The strip was even criticized on the floor of the U.S. Senate—a major coup, perhaps, from the perspective of any popular satirist who aspires to make an impact in the real political world. Quayle complained of Trudeau hav-

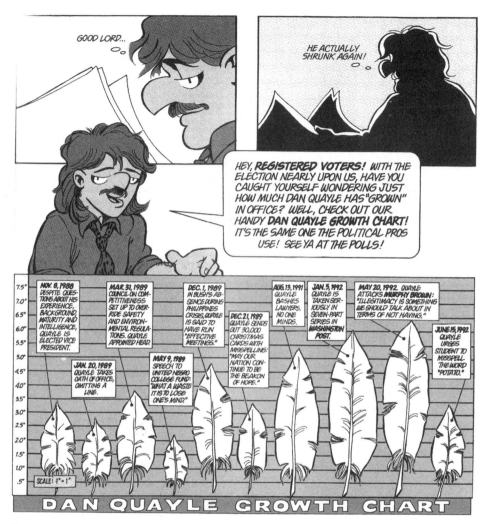

Figure 1.7. Garry Trudeau, "Quayle's Growth Chart," *Doonesbury*, Oct. 18, 1992. *Doonesbury* © 1992 G. B. Trudeau. Reprinted with permission of UNIVERSAL PRESS SYNDICATE. All rights reserved.

ing a personal vendetta against him, but his others responses, like Reagan's, was probably more effective than the touchy reactions of the Bush clan; he said, for example, "Who cares what a comic strip may or may not say about me or anyone else." Interestingly, this also highlights what is at stake for both Trudeau and his detractors in the debate over whether comic strips should contain topical political satire. Quayle seemed to be imply-

ing—or hoping to reinforce the idea—that Trudeau's work, because of its lowbrow medium, was either inappropriate or inconsequential.

A Sunday strip about Quayle from 1992 (see fig. 1.7) illustrates nicely why the vice president would feel an urgency to dismiss Trudeau's importance; on display are a variety of Trudeau's tactics in mercilessly satirizing the words and behavior of public figures: meticulously researched "investigative cartooning"; a relentless mode of attack that could make the target feel like the victim of a vendetta; and the reduction of the figure to a laughable icon. The end result is devastatingly funny and thorough in its satiric points.

One additional satiric vendetta from the strip deserves mention, if merely for the humorous reaction of the target: Trudeau's periodic dogging of Donald Trump for his flamboyantly obnoxious, and sometimes abusive, business machinations. Like Bush, Trump ends up extending the life of, or confirming the point of, the satire in his reaction. For example, in 1988 his attempt to disparage Trudeau seemed to turn back, unintentionally, on himself: "You know, I did well in school, but for the life of me, I can't understand what *Doonesbury* is all about. It's one of the most overrated strips out there. Half of it makes no sense" (Trudeau, *Flashbacks* 231). In a revival of the spat ten years later, when Trudeau took Trump to task for trying to run a family restaurant out of business to make way for a construction project, Trump was reduced to laughably juvenile ad hominem attacks, calling Trudeau a "jerk" and a "total loser." It is as if the two were back in high school: the witty class clown heroically tripping up and frustrating the most venal and arrogant of the popular jocks.

In some cases Trudeau's controversial topicality dealt with issues that were larger than specific, individual targets. In these cases Trudeau would typically allow his characters to act as entry into topics such as anti-abortion zealotry, the AIDS virus, homophobia, and the war in Iraq. This device allowed Trudeau to humanize divisive topics, borrowing his characters' sympathetic personas and complex backstories to add nuance to the discussion. Examples of this device include Mark Slackmeyer's revealing his homosexuality to his friends and family, and Mike Doonesbury's work in 1987 on condom ad campaigns to address safe-sex education issues. One especially riveting instance was a three-week run in 1989 in which Congresswoman Lacey Davenport discovered that her aide, Andy

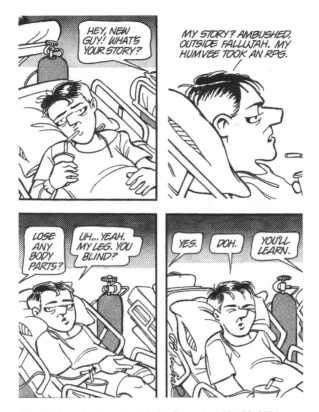

Figure 1.8. Garry Trudeau, "You Blind?" *Doonesbury*, May 20, 2004.
Doonesbury © 2004 G. B. Trudeau. Reprinted with permission of
UNIVERSAL PRESS SYNDICATE. All rights reserved.

Lippincott, was suffering from AIDS. Many editors complained about the content of the series, but perhaps because it was couched in this particularized narrative, few papers actually dropped the run. It was also celebrated by AIDS activists not only for bringing public attention to the epidemic, but also for showing that there is productive, even therapeutic humor to be mined from such tragic subject matter.

A more recent example of this grounding strategy was Trudeau's tracing of B.D.'s traumatic experiences in 2004 in the Iraq war. With almost novelistic complexity, Trudeau traced the character's day-to-day struggles in preparing, leaving, and participating in the conflict; he also depicted his debilitating injury and subsequent long recovery from the loss of a leg (see fig. 1.8). These strips were excellent in part because of their empathetic

attention to detail, and to the gritty realities of one person's experience in the war. They dealt complexly—using both humor and pathos—with B.D.'s denial, depression, and post-operative therapy for post-traumatic stress disorder. While making some observers uncomfortable (to them, the run seemed "inappropriate" for the comics page), they were celebrated by many critics and most fans. One letter to the editor suggested that "The B.D. strips are beyond cartooning. GBT is writing the first novel of the Iraq war with them, and it is heartbreaking" (Francesca).

These strips were also significant because of Trudeau's ability to be both a harsh critic of the war and a sincere supporter of the troops involved. This approach was nicely represented in this passage from a speech to Vietnam vets:

> When I talk to wounded veterans, I usually don't ask them what they think the mission was. I don't presume, because their lives are wrenching enough without the suggestion that their sacrifices may have been without meaning. Moreover, if that is so, it will become apparent to them soon enough . . . The young men and women who we've repeatedly put in harm's way are paying the price for this misbegotten mission, and as long as it continues, I, like so many of our countrymen, must walk this strange line between hating the war but honoring the warrior. I don't know how long we can keep it up. (Weingarten W14)

More succinctly, in an interview with George Stephanopoulos, he suggested about the most recent war in Iraq that: "Whether you think we belong in Iraq or not, we can't tune it out; we have to remain mindful of the terrible losses that individual soldiers are suffering in our name" (Andersen 1). These comments took on a greater depth of sincerity when reports emerged of Trudeau spending time with soldiers wounded in Iraq—as well as those in the field, acquainting himself with their daily struggles, anxieties, and successes.

It should be noted that this was not the first time that Trudeau tackled the complexities of war and soldiers' experiences within it. In 1973, *Stars and Stripes* dropped *Doonesbury* because its treatment of the Vietnam war was seen by the editors as "too political"; but after the paper received nearly 300 letters of protest, mostly from enlisted men and their families,

the strip was reinstated. Later, during the Gulf war in 1990, he devoted 250 consecutive days to exploring different facets of the struggle. His treatment of the conflict garnered him a Certificate of Achievement from the 4th Battalion 67th Armor in Kuwait City, "for significant contributions to the morale of the United States forces deployed on Operation Desert Storm."

There have been critics of his war-themed strips, nevertheless, as one would expect. Bill O'Reilly of Fox News charged that "a case can be made that Trudeau is attempting to sap the morale of Americans vis-à-vis Iraq by using a long-running, somewhat beloved cartoon character to create pathos" (Weingarten W14). This kind of carping is the exception, however; critics from both sides of the political fence, including Senator John McCain, who once held a deep antipathy for Trudeau, have praised the naturalism and apolitical compassion of these strips.

In most cases Trudeau's syndicate supported his right to engage in gritty, real-life issues, combative satire, and provocative topicality on the comics page, but in one case they convinced him that he had gone too far: In 1985 Trudeau created a run called "Silent Scream: The Prequel," that mocked an anti-abortion film. Although the core points of Trudeau's strip in this series did seem sharp, one can sympathize with the syndicate; Trudeau's flippant tone seems a bit harsh when addressing a topic that is so fraught with high moral and emotional stakes. Showing that Trudeau's cultural significance could even burst the bounds of the comics and business of syndication, the *New Republic* acquired the series and ran the cartoons in its June 10 issue.

Some of the most sophisticated episodes from *Doonesbury*'s long run satirized the media culture: journalism, entertainment, advertising. Roland Hedley's career as an opportunistic reporter, for example, allowed for ongoing shots at the gradual slide of hard news into vapid infotainment. And the innovative series on an imagined MTV persona for President Reagan—Rap Master Ronnie—also displayed a savvy understanding of the blurring lines between politics and entertainment, and the manipulative power of craftily constructed postmodern media products. Perhaps the most sustained and effective satire of media culture was Trudeau's recurring storyline (beginning in 1989) featuring Mr. Butts, a cartoon mascot for the tobacco industry. On a surface level Trudeau sim-

ply parodied the Camel cigarette company's cynical targeting of children through a cartoon character, "Joe Camel." Beyond that, by giving his character a voice—and having him speak as if he were the people plotting his campaign behind the scenes—he effectively deconstructed a variety of media manipulations.

Other comedic enterprises such as *Saturday Night Live* and *The Simpsons* over the years have created equally clever parodies of mainstream advertisements and icons. But Trudeau's is ultimately superior as a work of satire because of its consistency, longevity, and coherency, and because his auteur-like independence and developed worldview give him the license to be relentless and pointed in his satiric agenda. Those other satiric works tended toward satire that is scattershot, inconsistent, and opportunistic, because they were created by rotating committees of writers and because the point of the satire was less important, in the end, than the goal of simply getting a laugh.

There were challenges to working as a lone satirist. Although Trudeau effectively protected his privacy by remaining aloof from the media over the years, he could not escape the burnout that comes from the relentless demands of producing a daily strip. 1983 he tried to rejuvenate himself by taking a twenty-month sabbatical, explaining that "investigative cartooning is a young man's game." Although a well-established practice in fields such as academia, this was unheard-of in the world of cartooning. The traditional attitude among editors, syndicates, and cartoonists, was that you did whatever was required to make the daily deadline, year after year. Syndicate-artist contracts reinforced this notion: few artists owned the rights to their work, and in most cases syndicates were free to hire someone to replace the artist if he or she were unwilling or unable to deliver the work. While Trudeau's syndicate supported the sabbatical, editors and colleagues complained loudly, suggesting that Trudeau was behaving like a prima donna. Fans were upset too, of course, but they tended to side with Trudeau in the argument. When Trudeau returned to work after the sabbatical, he seemed both reenergized and a bit more daring when it came to the form and aesthetics of the strip. The break was also successful in bringing into relief for readers and editors the mechanisms of the comic strip industry and issues related to artists' rights.

Because of this controversy and several other industry disputes, Trudeau developed a reputation as an iconoclast. For example, over the years he has also been a vocal critic of comic strip size reductions, unfair contracts, and overly aggressive merchandising. He even criticized his own professional association—the National Cartoonists Society—for self-satisfied clubbiness and sexism. He was particularly vocal of the old-boy practices of passing around cheesecake drawings of young women and female cartoon characters at the conventions—one year even boycotting the convention for its sexist practices. As one can imagine, his colleagues did not appreciate his unwillingness to toe the industry line in all ways. Even some cartoonists in the older generation (such as Charles Schulz), who were more principled than the clubby good old boys, felt that Trudeau showed a lack of professionalism in his willingness to criticize or resist traditional industry practices (Johnson 213).

Part of Schulz's negative reaction to Trudeau's independent ways could be chalked up to generational differences since some younger cartoonists such as Breathed and Watterson applauded Trudeau and followed his lead in these actions; but much of the older generation's negative reaction can also be attributed to Trudeau's unique vision of the comics page as a lively venue for pointed public satire. Whereas his colleagues tended to go into the field imagining themselves primarily as entertainers—and having a willingness to bend and modify their products to suit the needs of advertisers and hypersensitive readers—Trudeau perceived himself first as social watchdog or investigative cartoonist and thus pushed the medium to transcend its status as ephemeral, watered-down entertainment.

After taking the high ground on so many issues within a commercial medium, it was inevitable that Trudeau would risk being perceived a hypocrite at times. For example, Trudeau has had to deal with the pressures of finding and keeping a popular audience through consistent self-promotion. While being opposed to the reckless merchandising that could rob a comic strip of its subtler qualities, Trudeau also realized that distributing his images through other media forms was an essential form of promotion—of keeping the strip alive in the culture's consciousness. His solution in 1992 was to merchandise his strip in a highly self-reflexive way by mocking the mechanisms of merchandising even as he participated in

the enterprise. For example, he titled his merchandising campaign "The Great *Doonesbury* Sellout," and created products that were parodies of earnest forms of self-promotion: "$7.95 plastic swizzle sticks adorned with 'America's cutest death monger,' Mr. Butts," fake press credentials, and a baby-blue polo shirt emblazoned with a feather icon over the breast (in tribute to Quayle)—and gave all the proceeds to charity. This was an effective way of preempting criticism by essentially deconstructing his own practices; it also transcended the status of a cynical business strategy in its execution, in large part because he donated much of his merchandising proceeds to worthy causes.

Trudeau's self-reflexivity became a common device within the strip starting in the late 1970s, further setting it apart from most of the other strips on the comics page. Beyond serving as a useful way to preempt criticism and satirize his own foibles, it embodied a new type of postmodern humor and satire. Like David Letterman's late-1970s monologues—now considered distinctively postmodern because of their self-deconstructive qualities—Trudeau was continually commenting upon what he was doing in his strip as he was doing it. In drama this is called "breaking the fourth wall"—disrupting the illusion that this creative world exists beyond the hand of the creator or the observing eyes of the audience. Instead, the self-reflexive, postmodern text continually acknowledges its own constructedness and the hand of the author in its ideology and aesthetics. By using this device Trudeau was continually present in the strip, engaging in playful commentary on the process of comic stripping, the business of the medium, and his own political agenda. It is interesting to note that this self-deconstructive approach to the craft also put him at odds with more traditional colleagues such as Schulz, who perceived it as too flippant and perhaps dissatisfying to readers expecting to be transported, without distraction, into another world.

In recent years Trudeau has also kept pace with other changes in cultural climate and technology. For example, with mixed results, he has introduced younger characters into the strip who represent the interests and foibles of Generations X and Y. At times these characters seem too hip to be real—more like walking icons for a demographic than fully imagined characters—but the storylines in which they are involved carry the same ironic nuances and twists of Trudeau's baby boomer storylines. Michael's

daughter, Alex, stands out as the best and most complex of this second generation. Her reaction to her parents' divorce and her struggles with college and career choices were especially well balanced between pathos and humor.

On the technological front, Trudeau has used the Internet to expand the reach of his strip and give fans additional, satisfying materials. While many syndicates and cartoonists saw the Internet as a threatening substitute to newspapers and the traditional comics page, Trudeau embraced it early (in 1995) and used it to give his core fans more direct and consistent access to his work. More recently, by aligning himself with the online magazine *Slate*, Trudeau has created a high profile on the Web; *Doonesbury* is a featured offering on the popular site. He has also used *Slate* as a portal for people to get access to a vast archive of previous strips; to create interactive features such as timelines and thematic compilations; to conduct straw polls on current issues; and to provide forums for feedback and discussions. In other words, he has found ways to allow new technologies to enhance his status as a "poplorist"—a popular artist able to create work that has many of the characteristics of resonant and politically engaged folk culture.

A complete assessment of Trudeau's career cannot fail to mention his occasional forays into other mediums. Most obviously, he has created a series of book compilations of his strip that are exceptional in their quality and thoroughness. While a majority of them are straightforward collections of the comic strip, a few of them are based on particular characters, thematic runs, or merchandising parodies. The *Flashbacks* collection in 1995, which celebrated the strip's twenty-fifth anniversary, was especially elaborate in its inclusion of commentary, quotes from targets, and historical trivia. One of the most recent books is a nicely focused treatment of B.D.'s entire Iraq war odyssey.

In other areas Trudeau has carried on with his childhood love of the theater. For example, working with collaborators John and Faith Hubley, Trudeau wrote and codirected an animated film based on his strip, *A Doonesbury Special*, for NBC-TV in 1977. The film was a creative success, receiving a nomination for an Academy Award and garnering the Special Jury Prize at the Cannes Film Festival. In 1983 he collaborated with composer Elizabeth Swados in creating a Broadway musical titled *Doonesbury*.

The show chronicled Mike's engagement to J.J. (Joanie's daughter) and the graduation of the denizens of Walden Commune from college. The show was nominated for two Drama Desk Awards and the cast album of the show, recorded for MCA, received a Grammy nomination.

In 1984 Trudeau also created a satirical revue based on his "Rap Master Ronnie" strips. It played Off-Broadway for four years and was continuously updated for numerous productions around the country. A filmed version of *Rap Master Ronnie* featuring Jim Morris, the Smothers Brothers, and Carol Kane was broadcast on Cinemax in 1988. That same year Trudeau wrote and coproduced, along with director Robert Altman, HBO's critically acclaimed *Tanner '88*, a satiric look at that year's presidential election campaign. The show won several awards both in the United States and abroad, including the gold medal for Best Television Series at the Cannes Television Festival, and Best Imported Program from the British Broadcasting Press Guild. *Tanner '88* also earned an Emmy, as well as four ACE award nominations. These various projects served to extend the reach of Trudeau's strip in the cultural imagination and gave him opportunities to expand his characters' complex inner lives; to exert his skills in verbal/narrative satire in more elaborate ways; and to reinforce his own status as one of the most significant satiric critics of the second half of the twentieth century.

Descriptions of all of these side projects, and accounts of the many public controversies surrounding his strip, gives one the impression that Trudeau is some sort of man of the world, attending parties and rubbing shoulders with powerful political figures and creative types. The reality, however, is that he is more of a detached observer who has created a sedate home life with his wife, the famous news anchor Jane Pauley, and their three children that is "fairly shut off from all that" (Grove D15). Trudeau explains that "I just refused to get entangled by issues of image maintenance that fame implied. I made a deliberate retreat from a publicly visible life" (Weingarten W14). He further defends this privacy by observing, "This is the only country where failure to promote yourself is widely considered arrogant" (Alter 62).

In Pynchonesque fashion, he chooses to limit his immersion in the public realm as well as the public's access to him; but in the end, he is actually a complex mix of humble reticence and professional pride, extreme

privacy and combative public engagement. Pauley describes the complexities of this dichotomous personality. "'Inside Garry, there's a little boy and a man,' Pauley says. 'And the little boy is secretive and vulnerable, and the man isn't. It would hurt him if I made a joke at his expense, but if the president of the United States says something negative about him, he puts it on the cover of his book'" (Weingarten W14). A recent interviewer adds that "he's not afraid of publicity so much as he's horrified at being perceived as the kind of person who wants publicity. He treasures his literary license to kill but feels a twinge of guilt that it isn't really a fair fight. He's a genuinely humble know-it-all" (Weingarten W14).

In interviews Trudeau occasionally displays this contradictory nature by communicating high self-regard and sincere humility in the same breath. For example, he stated that "There are certain moral values and qualities that I aspire to in my life, and my faults lie in falling short of them." If that statement were delivered with earnest pomp by a politician or other prominent public figure, it would invite a sniggering, cynical discussion of the public figure's hypocrisies and failings. But coming from Trudeau it somehow seems reasonable. The fact that Trudeau gives us so little personal data from which to discover failings and contradictions might be part of this perception, but much of it also must be a result of Trudeau's sincerity and consistency. As a principled and idealistic satirist he has to aspire to civic morality and elevated personal values because he expects it of his targets. That integrity ultimately gives his satire a gravity and power relatively unique in the postmodern media world.

In a final accounting, Trudeau is much more generous than the enigmatic Pynchon. Whereas the postmodern writer's fans have to wait for years between cryptic novels to glean interpretive clues, biographical hints, or another chance to see the world through the satirist's perceptive eyes, Trudeau's readers have a daily strip in which to revel. Within *Doonesbury* one can find access not only to Trudeau's worldview and imagination, but to a satiric chronicle unmatched in its wealth of insights into cultural trends, political foibles, and human relations.

Chapter Two

"That's Not Appropriate"

Investigative Satire on the Funnies Page

Categorizing a particular satirist's methods is tricky business because satire is so variable in its modes, tools, and genres. While a basic definition seems straightforward enough—a comedic attack upon a recognizable public figure or social practice—satire shares a score of different genres, many different tones, and a plethora of tools and devices with other comedic forms. Moreover, if the satirist's career is especially long and productive, it is difficult to reduce all of his or her work to one particular style. Trudeau is perhaps unique, however, in being especially consistent in both his methods and his worldview. While one can chart an increasing sophistication in his methods as he matured from a college cartoonist into a nationally recognized pundit and satirist, his tone and core objectives have remained remarkably consistent. Indeed, Trudeau's work is perhaps the least conflicted—in terms of methods, intentions, and core points matching up—of any created by a popular satirist in recent American cultural history. For example, a cartoonist such as Al Capp (*Li'l Abner*) occasionally dabbled in political allegories, but his satire tended to be scattershot, only vaguely clear of its targets (often settling for a blanket contempt for all politicians and urban sophisticates), and conflicted in its treatment of its main characters (alternately celebrating Abner as a wise fool, and then making him a target of simplistic mockery). Trudeau, on the other hand, seemed to have a clear idea from the earliest days of the strip about his own political convictions, what made a worthy target, and which methods would work most effectively in a popular medium. As my

earlier recounting of the strip's general history indicated, there were the occasional missteps in *Doonesbury* (Zonker extolling the virtues of hashish to a preschooler, for example), gradual shifts in aesthetic methods, and increasing sophistication in the strip's execution; but these changes were still fairly linear and coherent in their unfolding.

This chapter will chart the complexity and nuances within this progression, first by categorizing Trudeau's styles and methods in light of the definitions and history of traditional comedic modes and satiric genres. Second, I will explore Trudeau's political orientation and analyze how it is reflected in, and shapes, his satiric methods. And finally, I will discuss his methods and tools as they play out in particular strips. Along the way, I will highlight those instances where his strategies and execution seem either particularly effective on the one hand or problematic on the other.

Trudeau's Satiric Methods

To begin, we can establish that the humor in *Doonesbury* differs from that in most comic strips. It is quietly (and sometimes indignantly) ironic; it is often deadpan, giving little indication of where one should laugh or chuckle; and it is based on situational humor, witty dialogue, and complex character development rather than simplistic gags or jokes. As a result it requires a high degree of engagement from readers, while remaining generous in its humorous payoffs. Trudeau explains: "I have always tried to create a sense of the four-panel smile as opposed to the last-panel laugh. People should feel that they're simply visiting this world for a few moments. I get it from *Pogo*. Walt Kelly never told a joke in his life. It's all texture, it's all situations, and it's all characterizations" (Grove D14).

This situational humor can create a pleasant and engaging comic world with sympathetic characters whose quirky behavior and dialogue consistently provoke smiles, but longtime readers of the strip would be quick to point out that Trudeau's humor is also consistently barbed and almost always used in the service of pointed political or social satire. Indeed, the satire that Trudeau creates is of an indignant, topical, often punishing variety. While Trudeau can be very funny, he is ultimately a combative satirist rather than a gentle humorist—a social critic that just

happens to be working in medium that is normally associated with cute humor and throwaway gags.

In fact, Trudeau sees himself as a satirist first and a cartoonist second; and he takes seriously this role as social critic, continually evaluating the satiric tones and methods he employs to make his points. Here he describes the ideal powers, protections, and social uses of his particular brand of pointed satire:

> . . . satire is an ungentlemanly art. It has none of the normal rules of
> engagement. Satire picks a one-sided fight, and the more its intended
> target reacts, the more its practitioner gains the advantage. And as if
> that weren't enough, this savage, unregulated sport is protected by
> the U.S. Constitution. Unfair? You bet. But that's what makes edito-
> rial cartooning such an effective form of social control. (Trudeau,
> "Investigative" C1)

Included here are most of the essential components needed to piece together Trudeau's working philosophy and methods: his conception of his own role as a political and social watchdog; his unapologetic celebration of satire's methods of "truthful misrepresentation" or distortion; and his faith in satire's reformative or ameliorative powers. Let us explore these core ideas in greater depth.

First, although Trudeau makes it sound as if all satirists are—or at least, should be—combative watchdogs, there is actually a wide range of tones and attitudes a popular satirist can adopt. As Mark Twain and Walt Kelly illustrate, satire can be delivered through the persona of a folksy humorist—the friendly storyteller who gently lures his targets (most often the readers themselves) into recognizing the folly of their thoughts or actions. This has been described as a Horatian tone that is meant to laugh people toward good behavior and right thinking. On the other hand, other satirists can be condescending and punishing, scapegoating undeserving targets and social groups—a Hobbesian or punitive tone. Still another model is the silly court jester or wise fool who has the license from the figures in power to speak the truth or mock authority. Finally, there is the acerbic, even misanthropic critic who adopts a Juvenalian or biting tone.

Trudeau borrows many of these tones at different times, depending on his target. For example, his social satire—as executed through his core characters and their foibles—is Horatian and largely sympathetic in its flavor. Nevertheless, his primary conception of himself is the Juvenalian watchdog, a model of satirist often associated with the profession of political cartooning. As an instrument for political dissent, a critic of the free press, and a watchdog of abuses of authority in a democratic society, the political cartoonist is expected to be merciless and dogged in his or her campaign of mocking or criticizing public figures—like a "nose guard," in Trudeau's words, who has to be somewhat brutal and unfair to get the job done (Rubien 1). Moreover, a David and Goliath dynamic is often assigned to the relationship between a cartoonist and his or her principle targets: he or she is charged with representing or speaking for the weak and oppressed in society, comforting the afflicted, and afflicting the comfortable. As a result of embracing this role, Trudeau feels little obligation to apologize for the satirist's privilege of using "unfair" satiric tools as a sling against the immense power of public figures, corporations, or institutions.

Trudeau may even emphasize the combative virtues of his conception of the satirist more aggressively in interviews because of the current state of political cartooning. In the past twenty years newspapers have tried to avoid controversy that drives away advertisers or upsets sensitive readers; and thus, there has been a general trend in recent decades toward political cartooning that has little bite. Instead, many cartoonists treat only easy, national topics, while making safe, general observations and emphasizing gags more than indignant social criticism. They also sometimes get chummy with their targets, signing original cartoons for them and attending events where they can be courted and flattered. (To make this point, Trudeau relates the story of a cartoonist cutting off a press corps reporter because he thought his question was "discourteous" to President Reagan [Trudeau, "Investigative" C1].) Running counter to this trend, Trudeau likes to model himself after earlier figures such as Thomas Nast who incited public debate and upset their targets. By this conception, Trudeau probably does not think he is doing his job—being true to his calling as a righteous David figure—unless his targets get upset and controversy follows his work.

Trudeau's political work also fits nicely within a traditional literary definition of satire: he uses a manifest fiction (a comic strip universe of well-constructed characters that is meant to represent our own reality in distorted or allegorical ways) to engage in attacks on recognizable historical particulars (an academic way of saying topical figures and social practices). Indeed, although he has been seen as an iconoclast within the field of comic stripping, Trudeau's methods of using topical attacks to encourage progressive reform are actually fairly traditional. Literary and popular satire in the late twentieth century began to drift into less topical genres and away from authoritative social criticism. In Trudeau's own field, cartoonists in the 1960s such as Charles Schulz and Johnny Hart (*B.C.*) adopted a cosmic (albeit, in Schulz's case, emotionally and realistically grounded) approach to satire that had profound things to say about the psyche and the pathetic, tragic, and comic aspects of humanity but that shied away from offending anyone with pointed attacks on recognizable figures or events.

In other fields, such as the novel, a postmodern shift in cultural sensibility (recognized, generally, as beginning in the 1960s) encouraged many satirists to adopt an absurdist tone that depicted all human behavior as ridiculous, and most of the evil in the world as an outgrowth of deeply cyclical or chronic habits within human nature and societal structures. Whereas some of this satire did target institutions—such as Joseph Heller's treatment of military bureaucracy in *Catch-22*—it generally did not attack specific public figures; moreover, because of its skepticism toward the reformative power of satire—or the potential of its targets to enact their own reform—it usually did not provide hopeful prescriptions in the wake of its attacks. Indeed, beyond rebelling against the conservative, Augustan tradition of satire in which a superior commentator denounces deviations from the status quo, postmodern satire also rejected the constructive labor of liberal, Enlightenment satire's attempts to offer an "enlightened," progressive picture of society. One could label this approach to satire as cynical—a sort of defeatist mockery of malignant social ills; but another way of describing it would be deconstructive. Aware of the complex ways that people rationalize unethical behavior and even harness logic and reason to evil purposes, postmodern satire can attack or deconstruct more

foundational targets such as language, reason, or the authority of texts and arrive at open-ended (rather than categorically fatalistic) conclusions. In postmodern fashion, it is also healthily modest in its claims, often questioning its own assumptions or claims to truth; as a result, the satirist is self-effacing—or self-reflexive—and the satire itself shies away from offering authoritative prescriptions.

Trudeau has adopted some of this postmodern sensibility; for example, he can be self-reflexive at times, mocking his own persona and opinions through his main character, Michael. And the strip is mildly self-deconstructive, continually breaking down the fourth wall and acknowledging its constructedness to readers. But Trudeau differs from the cosmic satirists in remaining firmly committed to targeting evil and social ills in identifiable figures and practices. And he differs from the purely deconstructive satirists in his willingness to insist that particular values and ideologies are superior to others, and that that superiority can be proven through rigorous public debate and pointed cultural criticism. One could say that Trudeau has even inherited some of the optimism of Enlightenment-era humanism—believing in the "perfectibility of man"—as well as the confidence of a traditional, Augustan brand of satire that assumes that the best satirists have a clarity of moral sight superior to that of the common man and of most public figures (Alter 61). Like a prophet or visionary, the traditional literary satirist might stand outside the society, (supposedly) objectively denouncing foolishness and evil. Moreover, it is assumed that their work has both a reformative power (shaming the populace into better behavior and right thinking) and a punitive punch (punishing politicians if they began to abuse their power). The following quote nicely illustrates Trudeau's alignment with these righteous motivations and lofty methods. "[My work] . . . is propelled by a sense of moral indignation, which you hope doesn't turn to malice when you're executing. The critical difference is that you're not only against something, you're for something. It springs out of a sense of hope. The day I start writing from a scorched-earth viewpoint is the day I don't think I can justify my presence in the business" (Alter 61).

Nevertheless, as a product of the countercultural generation, Trudeau differs in significant ways from the conservative Augustan model. Whereas

there is a sort of conservative, top-down quality to this traditional satirist—he or she prods readers toward conventional notions of good behavior and right-thinking—Trudeau is more inclined to promote progressive ideas that are not part of what he perceives as the mainstream, conservative social order. Inheriting both the presumptions of a modernist artist (seeing the traditional social order in need of reformation, and assuming the status of visionary progressive) and the values of the countercultural movement (questioning all authority and pushing for liberal societal reforms), one could label him as a topical, modernist-liberal satirist. Complicating the designation—but making it more accurate—is that he dabbles in some of the conventions and attitudes of the postmodern satirist, while not wholly embracing the cynicism or absurdism that sometimes comes with that paradigm.

This unusual mixture of traditional assumptions about the power and lofty purposes of satire with a liberal worldview also sets Trudeau apart from other brands of popular satire that have the trappings of postmodern forms without any of the saving philosophical complexity of great deconstructive novelists such as Heller, Pynchon, or Kurt Vonnegut. These lesser postmodern, satiric works include comics such as *Red Meat* and television programs such as *Saturday Night Live, Mad TV,* or *South Park.* They can be flippantly and cynically postmodern—with a hip, ironic, even deconstructive tone—but are unable to sustain a coherent critique and are scattershot and undiscriminating in their attacks. Another way of saying this is that they are often mere parodic pastiche—a flashy, satiric shell with no substance. Trudeau distances himself from this work, saying that *Saturday Night Live* was a

> . . . magnificent missed opportunity. The reason why "SNL" ultimately doesn't matter is that the show never developed a point of view. Originally, the program produced some pretty good guerrilla theater, but with its success, it quickly evolved into a smug exercise in slash and burn humor—anarchy for its own sake. Nothing of value was ever left standing. This was a major failing, I think, because great satire has always had some sort of moral underpinnings. (Trudeau, *The People's* 3)

He elaborates on this critique in his book, *Flashbacks:*

> Mort Sahl tells the story of visiting a writer on the set of *Saturday Night Live* during its early, headier day. A skit about Henry Kissinger had been scheduled, so Sahl, who kept voluminous files about the Secretary of State, coyly asked the writer why he was attacking Kissinger. "Because he's in charge," came the self-satisfied reply. That was all. Nothing about Vietnam. Or Chile. Not a word about the criminal bombing of Cambodia. The motivation was nothing more than the banal, adolescent need to strike at someone in authority. Now this is profitable work if you can get it, and you usually can, since scorched-earth humor took off soon thereafter—spreading its spawn across the breadth of the entertainment industry. But it did seem to Sahl—and to me—a lost opportunity, that it was a pity that so much of this smart caustic, irony-driven satire didn't aim higher, didn't even try to illuminate. (8)

While effectively criticizing this hip, anti-authoritarian, slash-and-burn type of satire, these passages also highlight a key quality of Trudeau's self-conception that sets him apart from most satirists in this postmodern age: an "old-fashioned" insistence that satire have moral underpinnings and aim at enacting societal reform or individual illumination. In sum, Trudeau is an anomaly in this postmodern age: a satirist who is savvy to deconstructive forms and hiply ironic tones, but still insistent on exercising some of the privileges and powers of an Enlightenment-era humanist, Augustan satirist, or modernist critic.

Trudeau's politics

Trudeau's politics are easy enough to identify; in a broad sense, he leans to the left in his worldview. But a more nuanced discussion of his ideological convictions is required to explain the relationship between his politics and his satiric modes and tools. Along the way, a comparison to an earlier left-leaning comic strip satirist—Walt Kelly—can provide an enlightening contrast.

In order to understand Trudeau's confidence in his worldview and the direct, combativeness of his satire, it is important to identify his particular brand of liberalism—a brand that was shaped by the cultural climate of the late 1960s. Types of sixties liberalism can be better understood within a rough outline of the history of leftist politics in the twentieth century: Before World War II there were the radicals on the far left who invested faith in the world-changing power of socialism; many subscribed to *The Masses*, joined the Communist party, and embraced the concept of change through revolution. More centrist branches—such as Roosevelt Democrats—rejected such radical strategies of transforming a culture, but still placed great faith in the idea that a powerful government and grandiose social plans could transform a society for the better.

The world traumas of the 1930s and 1940s caused a ground shift, however, among American liberals. Specifically, the radical wings of the movement became discredited because people observed the dangers resulting from a large-scale embrace of radical, revolutionary ideologies (the disasters of fascism and communism, to be specific). By the late 1940s even the centrists were in retreat because of the emerging paranoia of the Cold War; a distaste developed for socialism that was so pronounced that a generalized conservatism became the default ideology of the mainstream populace. The lowest ebb of the movement was the witch hunts of the early 1950s. For two reasons, cultural leftists eschewed direct and confident critiques of the social structure during this period. First, in order to merely survive, they had to camouflage their political stripes, either pretending to be more conservative, or couching their social criticism in layered forms of satire or allegory. For example, Walt Kelly's satires of McCarthyism were certainly bold—his lampoons of the senator were obvious to the educated reader and his were the first among journalists and social critics; nevertheless, he had to play by the rules of satire in an oppressive age, couching his critiques in animal allegories and embedding them within cute characters and dense wordplay. Secondly, leftist critics were no longer inclined to place great faith in confident, revolutionary ideologies. Instead, their rallying cries were modest calls for skepticism and tolerance for ideological difference. These ideas resonated with a new generation of liberal intellectuals who had been freed from the dogma of the prewar left and had a "preference for asking questions instead of inventing answers" (Pells x).

Indeed, from their perspective European history had "disclosed the lethal consequences of utopian fixations" and thus they were "wary of messianic dogmas, apocalyptic thinking"; for them "ideology had become a dead end." Walt Kelly's *Pogo* was popular among this liberal intelligentsia, in part because they could relate to a comic realm in which "pragmatic compromise" was the operating philosophy and virtues of an ethical and cheerful engagement in "day to day living" were the chief concerns (Pells 138).

By the mid-1960s, however, a new generation of liberal thinkers and students were dissatisfied with indirect attacks and politely layered satire. As a critic in the 1970s suggested, looking back, Kelly's model of comic strip satire no longer suited the needs of these readers. He explained: "Kelly was a political spokesman of the 1950's. His work was effective because it was critical in a mannerly, or a gentle, or a whimsically veiled and non-threatening way which suited the time and place. The forces of liberal reform were entirely decent, high [sic] endearing, and in an important way markedly ineffectual. His horizontal heroes were the opposite of activists" (Berry 196).

Suggesting that Kelly's work was ineffectual goes too far—it is unfair and inaccurate, first because the measurement of effectiveness would have to differ radically between the McCarthy era and the height of the countercultural movement; second, because there is plenty of evidence in the Kelly archives and book retrospectives that he took great risks in boldly attacking McCarthyism (there was nothing gentle about his critiques); and lastly, because he played an enormous role in shaping the politics of a generation of young readers and college students (essentially laying a foundation for the countercultural movement of the next decade). (See the books edited by Bill Crouch Jr., *The Best of Pogo, Pogo Even Better,* and *Phi Beta Pogo,* for appraisals of Kelly's influence.)

But this observation does help explain why the liberal intelligentsia needed a new comic spokesperson like Trudeau who better fit the cultural zeitgeist of the late 1960s and early 1970s. Because of lessons learned from the civil rights movement in particular (that progressive goals could be achieved through direct—albeit nonviolent—action), the satirist would have to be less coded or ambiguous in his or her points. In addition, other aspects of the countercultural movement that would make an appearance in this ideal work would include the following: a respect for the more

multicultural, dialogical nature of American society coming out of the 1960s; an adoption of the maxim of questioning authority, the complacent, the status quo; a sort of postmodern respect for alternative perspectives and lifestyles (an outgrowth, in part, from those lessons learned by mid-century leftists); and an authentic representation of the interests and attitudes of the youth generation. Other cartoonists working in the underground movement in the late 1960s may have met most of these requirements (Art Spiegelman and R. Crumb, for example), but they were either unwilling to modify their controversial content for a mainstream medium or too caught up in personal fetishes to speak for collective, generational concerns.

Jules Feiffer, a cartoonist straddling the fence between the underground and mainstream, might also seem a worthy candidate for this role. A left-leaning cartoonist with a strong distaste for rigid hierarchy and oppressive institutions, Feiffer had briefly flirted with mainstream syndication in the early 1950s (a strip called *Clifford*), but ultimately found that his distaste for compromise—or censorship, in his eyes—made him a poor candidate for the funnies page. He describes his experience: "In 1960 I was courted by the Hale Syndicate for national syndication. I told them that I was worried about selling out. I was afraid of losing my status as a cult cartoonist. . . . After a year of syndication I began to see censorship not as a problem but as a form of quality control. If they didn't run me, it meant I was doing something right" (as quoted in O'Sullivan 100).

Like *Doonesbury*, Feiffer's strip *Sick, Sick, Sick* (later changed to *Feiffer*) was an innovative blending of the comic strip and editorial cartoon (borrowing some of the strengths of each medium), but may have limited its appeal by the intensity of its visual and verbal delivery: neurotic types writhing against spare backdrops while anguishing over internal struggles of conscience. It also lacked the engaging continuity of strips like *Pogo*; instead, Feiffer created isolated vignettes that had more of an intellectual than an emotional draw. In sum, he was ultimately too strident in his leftist politics, too cerebral in his satires of human psychology, and too unwilling to compromise his methods to court a popular audience. He found lasting success, nevertheless, among the liberal intelligentsia, drawing cartoons for the *Village Voice* and limited syndication for three-plus decades.

Trudeau, a fan of Feiffer's work, fit the bill for a new brand of popular, liberal satire in all respects: his willingness to "pander" in order to gain access to a broader audience allowed him to strike a balance between countercultural rebellion and pleasing entertainment; his age and identification with the antiwar movement gave him immediate legitimacy within the generational movement; his huge cast of characters allowed for a multi-voiced dissection of any ideologies that were too rigidly conservative or squarely status quo; and his direct, often combative, brand of topical satire made him an activist satirist. Just as Kelly matched his cultural zeitgeist nicely and met the emotional and ideological needs of that generation of liberal thinkers, so Trudeau did the same for his.

In closing this discussion on Trudeau's political orientation and how it is reflected in his work, it should be noted that Trudeau's brand of satire was by no means a return to pre–World War II, leftist confidence and militancy. Trudeau may have been more directly combative than mid-century critics like Kelly but was still their offspring in avoiding extreme dogmatism and unwarranted faith in revolutionary ideologies; his satire was quick to diagnose cultural ills and injustices, but he did not put forward simplistic solutions, divide individuals and groups according to ultimate rightness or righteousness, or make calls for abrupt, radical change. Moreover, he avoided the nihilism or descent into purely deconstructive absurdism that marks much postmodern satire. Instead, he forwarded the following world-wise, but hopeful worldview: there may be no revolutionary ideology or meta-narrative that will save society, and there may be something inherently, persistently foolish and selfish about humans when they acquire great power or wealth; but the worst evils of life and society can be checked if those who abuse authority in government or business are held accountable, if society-dividing dogma is kept in check, and if people can curb their own foibles through ironic self-mockery.

Satiric tools at work in *Doonesbury*

With a broad view of Trudeau's satiric and political orientation, one can engage in a more focused discussion of particular satiric tools, methods, and tones at work in the strip. These include combative attacks on

identifiable public figures; "investigative" satire; the satirizing of cultural practices through Trudeau's own gallery of laughable jerks, losers, con artists, and more sympathetic types; and a variety of postmodern strategies and tools.

The most obvious quality that sets Trudeau's satire apart from other comic strips is its combative topicality (direct engagement with current events and public figures). Like the most famous cartooning watchdogs of previous eras—Thomas Nast and Honoré Daumier—Trudeau embodies the heroic David who uses a pen rather than a sling to take on corporate and political Goliaths. While Trudeau is capable of attacking abstract social practices and cultural values as well, he is best known for targeting powerful public individuals—the figureheads of corrupt political machines, companies, or institutions. These stories receive the most attention because of the controversy they create, but they also capture readers' and critics' attention effectively because they put a face on sometimes abstract battles over virtue and corruption in the public sphere. It allows one to direct frustration or animus at a particular person, and we can cheer on the principled watchdog in the seemingly one-on-one battle.

However, Trudeau's hounding of particular figures can also be controversial and problematic. This strategy can at times seem to oversimplify a social or political problem, scapegoat an easy target, or privilege the satirist's take on the issues at hand; it can appear to be merely a vendetta that the satirist pursues because of a personal distaste for a politician of an opposing political stripe; and it can distract people from broader abuses of power or privilege that might even implicate themselves. Nevertheless, these attacks should justifiably be celebrated in most cases because of several reasons. The satirist does have the privilege in our free, democratic society to take these shots, and there is little other ammunition available elsewhere that can touch powerful politicians and corporate figures who have huge public-relations machines working to promote their image and agenda. Moreover, it does not hurt to make an example out of powerful people who do abuse power and authority. Indeed, it can serve as a cautionary tale to all who would be venal and selfish at any level of society. And finally, in a culture easily distracted by entertainment, this may be one of the only ways in which to expose what our leaders are doing with the public's monies and trust.

Let us consider some of the merits and complications of these topical attacks more closely. While Trudeau, like all good political cartoonists, aspires to be objective in his targeting of foolishness (an equal opportunity offender in the professional parlance), there is no denying that he brings a certain set of liberal convictions to his treatment of topical material. This is not necessarily a negative quality for a political watchdog, for operating without strong and coherent convictions can bring a blandness, tepidity, and haphazard quality to the satire. (For example, Jay Leno's late-night pokes at politicians have that bland, opportunistic flavor.) At the same time, acting as a partisan cheerleader would blind one to failings within one's chosen political party. (Rush Limbaugh's stabs at humor and satire tend to bear this taint.) So ideally, the satirist might have a general affiliation with an identifiable range of political positions while remaining ultimately independent of factions and movements. The other contemporary satirist who embodies this quality as nicely as Trudeau is Jon Stewart, the host of the fake news program, *The Daily Show*. While being unapologetic about his liberal leanings, Stewart freely ranges through the political spectrum, mocking with principled consistency worthy targets as they emerge.

Trudeau has achieved in his satiric methods a useful balance between an ideal, but ultimately unrealistic (and undesirable), objectivity on the one hand, and a partisan bias or cheerleading on the other. Nevertheless, there have been times when his passionate convictions or supreme confidence in the rightness of his own worldview have affected his satire, even forcing the occasional misstep. For example, as mentioned in the first chapter, Trudeau, like any writer or artist, has been saddled with familial, psychological baggage that impacts his work. Considering the following factors related to his upbringing might help chart the formation of his political worldview as well as explain the vehemence he directs toward conservatives who engage in clubby old-boy networks, nepotism, warmongering, or who seem to side with the interests of big business once elected: Trudeau inherited from his family a sense that public service is the default calling of the patrician classes; he enjoyed all of the privileges (and some of the resultant guilt perhaps) of an upper-class upbringing; he chose the career of a political cartoonist that was considered lowbrow by his parents and grandparents; he was opposed to the war in Vietnam,

but may have escaped duty because of a minor medical issue—ulcers that had not reappeared in years; and he came of age among peers that identified with the politics of the counterculture movement. One can imagine that, at the intersection of these factors, Trudeau felt a compulsion to rebel against a variety of influences and traditions—including clubby privilege, staid tradition, jingoistic patriotism, and patrician conservatism—but also wanted to please family through an elevation of his craft to the level of serious public service or commentary, and to leverage hereditary privilege toward a championing of the less fortunate.

On a less noble level, it can also explain why Trudeau's work can occasionally drift into the realm of vendetta—in particular, in his treatment of the Bush family. The depth of his antipathy to this family suggests that this battle has taken on the epic proportions in his life (and by extension, in his comic strip and the ensuing public reactions) of a mythic struggle between opposing worldviews. Linked to Bush by privilege and schooling, Trudeau can perhaps see in him his own potential to have followed a similar path in using privilege cynically or selfishly (from his perspective), and must continually affirm his own choice of a higher path by lambasting these doubles. And the deep antipathy runs both ways, apparently, if one uses the public reactions of the Bush family as a gauge.

Another tricky issue related to Trudeau's relative objectivity as a topical comic strip artist is his claim to truth-telling as an investigative satirist. The complications arise from Trudeau combining two roles—the satirist and the investigative journalist—that operate according to different conceptions and standards of truth. As a satirist, Trudeau is protected by the Constitution as he essentially misrepresents the facts of what a particular person said or did. He is protected because it is believed that a watchdog-satirist is ultimately trying to communicate distilled, essential truths through seemingly untruthful methods—distortion, exaggeration, hyperbole, etc. There is a venerable tradition to this brand of poetic honesty through rhetorical hyperbole. Aristotle, for example, argued that the tools of allegory, symbolism, and dramatic distillation allowed fictions to do a better job at communicating the way the world and human nature works than straight historical records (Aristotle 73). Satiric fictions may be especially adept, in fact, at tackling cosmic or universal targets—the unchanging foibles of human culture.

Trudeau elaborates on this defense of the "unfair" nature of his strip:

> I am frequently compelled to answer the question of whether or not
> this strip is a fair commentary on the present social scene. It does, how-
> ever, seem to me that what is lacking in such a question is a fundamen-
> tal understanding of the nature of comedy. The derivatives of humor
> on comic strips have always been based on hyperbole, exaggeration and
> overstatement. Satire has always been formulated through the expan-
> sion and refraction of truth. Cartoonists do concern themselves with
> the truth, but if they delivered it straight, they would totally fail in their
> roles as humorists. Therefore, I feel no obligation to be "fair" in any
> absolute sense to a subject simply because certain individuals are sensi-
> tive to it. (as quoted in Moritz 421)

This is an effective defense of his satiric and comedic methods, but
the issue of fairness gets more complicated because Trudeau is not content
to merely be a cosmic satirist highlighting universal failings, or a social
satirist reflecting on the current cultural scene. In truth, he is topical with
a vengeance, for he also wants to operate as an investigative reporter,
breaking scandalous stories on public figures (the Sinatra–Mob connec-
tions, for example). But our culture applies a different standard of objec-
tivity to this type of reporter. For example, unlike the satirist, an investi-
gative journalist is guilty of libel if the facts about a person are wrong or
unfairly exaggerated. Moreover, he or she is expected to support his claims
with sober, quantifiably accurate, unamplified evidence. So as a result of
Trudeau melding disparate rhetorical methods, complications can emerge
at both the execution and reception of the strip.

Chris Lamb, a contributor to *Editor & Publisher*, elaborates on
this problem in a paper entitled "*Doonesbury* and the Limits of Satire."
He points out that in battles over satiric libel, courts have consistently
ruled in favor of parody, criticism of public figures, and opinion writ-
ing. Because satire and parody are by nature "rhetorical hyperbole," they
are not required to be accurate or truthful in a literal sense (Lamb). It is
assumed, in other words, that the reader will be able to discern the differ-
ence between exaggerated satire that attempts to communicate a larger
truth without being constrained by literal accuracy, and straightforward

reporting that has the intention of accurately conveying smaller truths. If the cartoonist attacks a public figure with exaggerated ridicule, it is satire; if the reporter does the same, it is libel. So from the perspective of some editors, Trudeau has been enjoying all of the privileges and protections of the satirist without having to play by rules of a straight reporter.

From Trudeau's perspective, however, he was always a satirist and it was cowardice on the part of editors rather than confusion over shifting roles that created the controversies around his investigative cartoons: "Notwithstanding the Supreme Court ruling on the *Hustler* case [reaffirming the First Amendment protection of satire], the mere threat of costly litigation often causes editors to question the traditional consensus of what satire is meant to be—and hold it to the same standards of fairness that front page reporting must meet" (Trudeau, "Investigative" C1). To be fair to these editors—when Trudeau "breaks" a story, many of them have to scramble to respond to Trudeau's allegations, trying to help readers sort out what is fact and satire in the cartoonist's "reporting." Using these complications as a foundation, one editor at the *Providence Journal-Bulletin* even created a reasonable rationale for censoring or editing some of Trudeau's work: "I think *Doonesbury* is fine when it sticks to satire, [but if he is going to] abandon satire for an investigative reporting approach, it will be subject to the same decision-making process the *Journal-Bulletin* employs when considering whether or not to publish a reporter's investigative story" (Astor, "About" 46).

Another complication that can arise from this hybrid brand of satire is that distorted, satiric aspects of the story can become more memorable than the foundational facts. As a result, it is those distortions or exaggerations that can become the default version persisting in the cultural memory. The more nuanced, complex points Trudeau might make in supplemental editorials will not be recalled because they are not as vivid and distilled as the jokey distortions of his cartoons.

Setting aside the issue of whether Trudeau's hybrid satire-journalism is fair, one can analyze the tools and methods he implements in his muckraking efforts. For example, in these strips Trudeau has to adjust his tone, adopting the persona of an indignant editorialist rather than playful satirist. He also occasionally resorts to providing the type of concrete evidence that feels foreign to the fictional artificiality of a cartoon world.

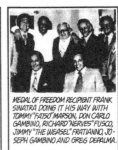

Figure 2.1. Garry Trudeau, "Did It His Way," *Doonesbury*, June 10, 1985. *Doonesbury* © 1985 G. B. Trudeau. Reprinted with permission of UNIVERSAL PRESS SYNDICATE. All rights reserved.

In Sinatra's case, this included actual photographs pasted into the strip (see fig. 2.1).

Finally, in order to fulfill readers' expectations for substance and accuracy when such claims are made, Trudeau has been forced to support his claims with supplemental information—often in the form of commentary and editorials that appear in other sections of the paper. For example, to elaborate upon and clarify his depiction of the senior George Bush as a cowardly cipher or "point o' light" in the comic strip, he provided the following editorial explanation in the *Washington Post*:

> Clearly George Bush is not a wimp in the sense of lacking physical bravery. . . . The issue is rather one of moral courage, the willingness to place oneself at risk in defense of one's principles. . . . I'm hard-pressed to think of a single instance where George Bush knowingly put himself in political jeopardy over something he believed in. On the contrary, he has a near-perfect record of trimming his sails, of steering clear of harm's way whenever a tough decision loomed ahead. (Trudeau, "Still a Wimp" A35)

After the 1991 strips about Quayle's alleged drug use, Trudeau also submitted an editorial to the *Washington Post*, supporting his claims and revealing more elaborate information about the first Bush administration's efforts to keep this potential scandal away from the media (Trudeau, "Investigative" C1). One could interpret these extracurricular editorials as a case of a satirist going beyond his or her realm of commentary, but it

also seems that dictating what a satirist can and cannot do is the start of a dangerously slippery slope in the realm of free speech. And why not allow satire itself to bleed beyond its original medium so that it can take on more nuance—and so that the satirist can have greater control over how his or her work is interpreted? The best social critics in our cultural history, such as Jonathan Swift and Mark Twain, ranged from playful satire to pointed political essaying; it seems reasonable that Trudeau should enjoy the same privilege.

Complications can also occur at the site of reception when satire and investigative journalism are melded. Because satire is already a tricky discourse for the lay reader to interpret (negotiating layers of irony, allegory, and figurative meaning), the shift in tone to earnest muckraking might be additionally confusing. Accustomed to the default tone of the strip—a satiric filtering of real news and figures through the allegorical, fictional world of his constructed characters—one might wonder whether one is meant to read Trudeau's investigative installments as playful exaggerations or as essentially truthful misrepresentation of actual events or facts. It is easy to see why some editors might feel squeamish about running those particular strips given the spotty track record of many newspaper readers who are already inclined to misunderstand and misinterpret satiric tones and intentions. And it is perhaps no small matter that the vehemence of some readers' complaints verges on the hysterical, in some cases even amounting to personal attacks.

The infamous strip in which Mark Slackmeyer seems to be prematurely pronouncing the guilt of the attorney general, John Mitchell, in the Watergate scandal (see fig. 2.2) is a good case study illustrating the complexities described above. Some background on the run of strips surrounding this particular episode will help establish a framework for the analysis: Trudeau was at the forefront of investigative reporting on the Watergate scandal in 1975. Even though his accounts of secret conversations in the White House and the other machinations of the conspirators were largely satiric, fictional exaggerations, they were plausible extrapolations of real events reported in the straight news. They thus began to carry the weight of sober reporting—and as a result made many editors and critics uncomfortable. Fortunately for Trudeau, his satiric conjectures of details such as particular White House conversations turned out to be

Figure 2.2. Garry Trudeau, "Guilty!" *Doonesbury*, May 29, 1973. *Doonesbury* © 1973 G. B. Trudeau.
Reprinted with permission of UNIVERSAL PRESS SYNDICATE. All rights reserved.

highly accurate, "truthful" exaggerations after all of the sordid facts of the scandal were revealed.

The Slackmeyer strip also proved to be a prescient guess at the guilt of John Mitchell; but the strip was widely attacked for seeming to usurp not only the privileges of serious reporters, but of the legal system as well. From many editors' perspectives, Trudeau was acting as journalist, satirist, judge, and jury ("*Doonesbury*: Drawing and Quartering" 60). A closer examination of the strip, however, suggests that this reaction was an outgrowth of misreading the strip. While Trudeau was certainly convinced of the guilt of many of those involved in the scandal, he was also making a second satiric point in the strip: a mocking of the irrational glee some media outlets took in prejudging those involved, or in fueling the hysteria surrounding the controversy. This more nuanced reading of the satiric layers of the strip may help defend Trudeau against the charge that he was intentionally misusing his satiric privileges; but it also highlights how easy it is to misinterpret satire that is at the intersection of comedy and investigative journalism. Readers and editors accustomed to reading the strip as Trudeau's muckraking pulpit incorrectly assumed that Slackmeyer was speaking *for* Trudeau. Because that idea was primarily on their minds—that Trudeau was engaged in an investigative vendetta—it was difficult to recognize the mechanisms of satire (such as persona and irony) that allow for more complex readings.

Despite the confusion that can result from this melding of satire and investigative muckraking, Trudeau's rule-breaking may ultimately enhance the power of his satire. Because Trudeau transgresses borders between

comedy and journalism, a broad readership that is generally unaware of current events is introduced to political issues they might otherwise never encounter. Like a media prankster, Trudeau disrupts the smooth flow of news and entertainment, stripping away the bland constructedness of both comics and mainstream news. The scandals surrounding these episodes, moreover, serve to amplify the issues, increasing Trudeau's chance of getting his dissenting voice heard above the media din. Indeed, this is another example of Trudeau's ability to provoke useful frustration, debate, and questioning in a social climate that can be dominated by flaccid entertainment and toe-the-line reporting.

At times Trudeau does not have to pick on identifiable public figures to make his points. Instead, he employs his own gallery of pathetic, conflicted, or reprehensible characters (in particular, Zonker, B.D., and Duke) to represent chronic human failings as well as specific cultural practices or ideologies. As with his topical attacks, there are strengths and potential weaknesses or complications to this use of characters within his own fictional construction. To explore the promise and possible pitfalls of this satiric strategy, one can go all the way back to a debate between Aristotle and Plato over the value of comedic fictions. On the positive side, Aristotle described this strategy as a "dramatic picture of the ridiculous," and argued that audiences could learn to be moral people by witnessing distilled, artistic comedy or drama that mocked the behavior or attitudes of flawed figures (Aristotle 69). Plato was less sanguine about these reformative effects, worrying that audiences were incapable of decoding irony and might actually be inclined to mimic the behavior of villainous or laughable characters (Plato 11). Evidence supporting each of these views can be found in Trudeau's use of Duke, Zonker, and B.D. as targets for his satire.

Duke is arguably the one truly villainous character in Trudeau's strip. A greedy opportunist, he has been a handy symbol for bureaucratic corruption, American imperialism, corporate exploitation of workers, media manipulation, etc. But he also functions at times as a funny antihero—a bracingly amoral libertarian modeled after the gonzo journalist Hunter F. Thompson. Duke is thus a funny villain who has a strange mix of naiveté and world-weariness in his outlook on life and society. As one reads the strip over many years, it is difficult to avoid becoming attached to even this repugnant character, smiling knowingly at his greedy antics. As a result of

Figure 2.3. Garry Trudeau, "Sir, It's Their Religion," *Doonesbury*, Oct. 5, 2003. *Doonesbury* © 2003 G. B. Trudeau. Reprinted with permission of UNIVERSAL PRESS SYNDICATE. All rights reserved.

Duke's own mixed pedigree and the tendency of readers to develop an affection for the rogue, Trudeau runs the risk of sending unstable satiric points when he uses this character as a vehicle. To explain, if Trudeau uses

Duke to satirize American ignorance and corporate opportunism in the Iraq war (see fig. 2.3), he may effectively communicate to a majority of readers his intended satiric message; but because Duke is an appealing antihero, other readers (or the same reader at a different point) may make a conflicted—or even contradictory—reading, seeing Duke's opportunism as merely funny or even heroic. It might also be possible that the reader half admires or envies Duke for his lack of conscience, his unapologetic selfishness. In this case, the reader vicariously gets to say and do politically incorrect things or allow repressed attitudes or desires to roam free. This type of psychological release may be socially useful, but it differs significantly from the ostensible purpose of Duke's character—to be a dramatic picture of evil or greed that teaches morality in reverse. In sum, then, both Aristotle's and Plato's views could be supported in the complex ways that readers interact with a character like Duke: an archetypal cad on the one hand, teaching people how *not* to behave; on the other, an appealing rogue or maverick who might inspire admiration or unconscious emulation.

Zonker's functions within his role as a satiric target in *Doonesbury* are fraught with slightly different complexities: he is used alternately as the butt of a joke and then as a sympathetic, wise fool. When acting as the target of ridicule, Zonker is usually meant to represent a brand of countercultural liberalism that has lost its moorings—that has drifted into self-serving, consumerist waters. When playing the role of the wise fool, he gets to naively (but perceptively) highlight the sophisticated ironies or inconsistencies in other characters' behaviors such as Duke, Michael, or B.D. The complexities emerge because Zonker is continually shifting between these roles, and at times Trudeau does not seem to have a good handle on what he is doing with Zonker in a particular strip.

This unstable use of Zonker is especially apparent in early strips that seem to celebrate, rather than satirize, his loopy, hippie qualities. After reading the infamous playground marijuana dialogue (see fig. 1.3) one could argue that Trudeau did not intend to celebrate drug use but to satirize the detached, demented worldview of the Zonkers of society. This point is complicated, however, by the fact that Zonker is such a lovable doofus. Moreover, for a cartoonist arguing for the legitimacy of serious satiric commentary on the comics page, Trudeau seemed to be testing the limits of his own argument. If he thinks a broad audience—including

many young people—can handle topical issues and critical satire, then the satirist's treatment of these issues has to be done with responsibility and clarity. Trudeau's point in a strip like this was unclear at best, and simply designed for shock value at worst. Indeed, the trickiness of Trudeau's satiric point (and of layered satire in general) is highlighted when one considers how different audiences might interpret this strip. For an adult reader tuned into Zonker's foibles and aware of the inappropriateness of this discourse, humor is evoked from the playful treatment of taboo material, and a reverse satiric point is made about what children should not be taught; but for a younger reader, less culturally savvy, and less able to tease out the layers of satire, the strip could merely read as a celebration of the cool carnival clown connecting with a little kid and getting the best of a stuffy authority figure. This problem of younger audiences misinterpreting satire is highlighted in other great, but trickily layered, popular satire such as *The Simpsons* and *Saturday Night Live*. In these cases, at least, Plato seems to have been right about the limits of allegory (or satire) as reliable carriers of messages to young readers in particular. In closing, however, it should be noted that this was an early strip that Trudeau himself acknowledges as problematic; over the course of his career it becomes increasingly more difficult to find such blatant examples of the satiric message of a specific strip getting short-circuited.

Postmodern satiric tools in *Doonesbury*

While Trudeau may be fairly traditional in his intentions as a topical satirist, he has also adopted or helped forge some postmodern satiric devices in comic strips. These include metafictional self-reflexivity (a continual acknowledgment of the constructedness of his satiric world and his own participation in that construction), situationist-style media pranking, and the use of a hiply ironic tone. Self-reflexivity or self-deconstruction can be seen in his regular practice of acknowledging his own participation in the construction of the strip. Another traditional way of describing this method is a breaking down of the fourth wall between creator and reader (a disruption of the pretense or illusion that the creator's fictional world is some kind of complete, insulated realm into which the reader or viewer

can imaginatively escape). From a historical perspective, there is not necessarily anything radically new about this practice; one could even argue that all satire, by its very structure, invites the reader or viewer to break down that wall, to decipher the satirist's hand in the constructedness of the work, to not get lost in the work as some sort of escapist drama or fantasy. Nevertheless, specific applications of the method in Trudeau's and others' work are either more conspicuously self-reflexive or more exclusively associated with postmodern attitudes and satiric strategies.

While most satire may seem, by the nature of its form—a layered, manifest fiction—to advertise its own constructedness, this does not necessarily mean that the satirist is actively engaged in self-reflexive practices. On a surface level there is a type of self-reflexivity that is merely healthy self-deprecation. An example of this can be found in the way that Trudeau undercuts his own importance—as in this perhaps falsely modest reflection on the amount of research he puts into his satire. How much homework does he do? He responds, "As little as I can possibly get away with. It is for this quality above all others, I think, that I am so admired by undergraduates; I know just enough to create the impression I know a lot. And, of course, being a cartoonist helps. If it weren't for the hopelessly low expectations with which people turn to my section of the newspaper, I'm sure I would have been exposed years ago" (Trudeau, *The People's* 2).

There are obvious benefits to this brand of self-deprecation: it preempts criticism and endears the creator to readers (who can warm up to an arrogant know-it-all?). In Trudeau's case it may successfully balance out his tendency to be overly zealous or self-righteous in his political convictions—or overly impressed with his own importance as a chronicler of the baby boomer generation. In addition, it is essential to the effectiveness of his commentary because it illustrates that he acknowledges the potential everyone has for evil and foolishness and allows him to avoid giving the impression that he is judging or scapegoating from a lofty position of moral superiority. Trudeau may be aware, in fact, that his work risks becoming self-righteous attacks on conservative culture and politics that flatter the liberal cognoscenti, and so he seems to work hard at being an equal-opportunity offender who sees the foibles in his own camp and in himself.

This tendency to self-deprecate can signal that the creator is rightly self-aware of his or her own foibles, contradictory opinions, and blind spots. Indeed, in some cases it can signal deeper levels of self-questioning or self-deconstruction in the work itself. In these cases the satirist may question his or her ideological assumptions and reflect critically on the ability of language, satire, or his or her particular medium to safely carry a message to readers. He or she may also engage in a consistent, self-conscious acknowledgment of his or her own foibles or blind spots within the satire. While one catches glimpses of this satiric self-deprecation in traditional literary satire such as that written by a figure like Swift or Twain, it is perhaps most closely linked to the caution of the post–World War II leftist worldview and to a postmodern strategy of continually, preemptively questioning one's own assumptions in the execution of an ideologically charged fiction.

Interestingly, in the history of comic strips there is a correlation between satirists who commonly used these metafictional devices and those who embraced what could be described as liberal, self-questioning ideologies. George Herriman's *Krazy Kat*, for example, was a sort of proto-postmodern playground of metafiction, as he continually pointed to his own hand in the strip (references to the creator by the characters, the formal elements of the frames or drawings being incorporated into the action, and a general blurring of the fictional world with self-deconstructive cartoon craft). And connected to (or growing out of) these practices in *Krazy Kat* was a worldview that emphasized respecting subjective experience, the slipperiness of language and perception, and the variability of ideological conviction. Walt Kelly continued these organically self-deconstructive practices in *Pogo*, with characters taking satiric shots at the cartoonist or messing with the words and frames that surrounded them. Kelly's worldview—summed up nicely in the maxim "We have met the enemy, and he is us"—encouraged a similar type of tolerance and respect for ideological heterogeneity. It also, obviously, prodded the satirist himself to include his own foibles in the construction of the satire.

Trudeau reintroduced these self-reflexive methods and their accompanying ideological lessons when he appeared on the comics page in the early 1970s. During this period, however, there was a staid, conservative

Figure 2.4. Garry Trudeau, "Summer Fantasy," *Doonesbury*, July 12, 1993. *Doonesbury* © 1993 G. B. Trudeau. Reprinted with permission of UNIVERSAL PRESS SYNDICATE. All rights reserved.

quality to the comics that precluded these types of self-reflexive games. The tone was set by traditional cartoonists such as Charles Schulz who had come to the consensus that it was an unprofessional practice to break the fourth wall between readers and creators. Schulz would probably insist that his disapproval was primarily about spoiling the escapist illusion for readers—and in the case of his strip, the unjaded innocence of his characters' world—but he also seemed opposed to the way Trudeau consistently used these self-reflexive moves to criticize the industry, revealing processes and practices.

In *Doonesbury* this device appears most prominently in strips in which the characters talk directly to the audience, acknowledging that they are part of a strip, situated on the comics page, and a product of a newspaper industry (see fig. 2.4). Obvious examples are the recurring sequences in which Michael and Zonker respond to reader mail or comment upon the narrative conventions of comic strips. These strips effectively reinforce Trudeau's satiric voice in the minds of readers, reminding them of his independent, critical resistance to pressures that might curtail his satire or limit his topics.

A related postmodern tool used by Trudeau is the media prank—a strategy modeled after the guerilla tactics of late-1960s situationists. These countercultural agitators, led by Guy Debord, tried to disrupt what they saw as the numbing flow of mainstream entertainment and news by appropriating media products and rebroadcasting them with subversive messages or through happenings or anti-spectacles. The term for that subversive recycling or redirecting of images or texts from the dominant culture is *détournement,* a term that does not have an exact equivalent

in English ("redirection," perhaps). The reasoning behind these types of prank-satire is that, in the crush of information in a postmodern world, traditional, genteel satire gets easily lost or absorbed into the general noise. So unusual pranks that catch readers off guard are the best ways to make a lasting satiric point—and to engage in what might pass for mind-changing, reformative work in a jaded media age. Trudeau's pranks have included asking readers to send letters of protest to specific politicians and public figures and pretending that his strip was hijacked by a monolithic corporate conglomerate.

One of the best pranks was a Sunday strip in 1994 where Mike asked, "Will you be part of the new Cognitive Elite? To find out, contact me." Thousands of readers e-mailed the address provided by Trudeau and received this response: "Regret to advise that you are unlikely to join the new cognitive elite: You have too much time on your hands. Sincerely, Mike" (*Doonesbury* 16 September 1994). While running the risk of alien-ating or offending some core readers, it was funny enough that readers could reflect critically on their arrogant assumptions or naiveté. It was also an effective way for Trudeau to make a general point about people being too immersed in popular culture and passive news-following. This type of prank addresses a common criticism made about Trudeau: that he flatters his audience or preaches to the choir. While there may be some truth to this charge—for example, Trudeau's identification with other progressively minded baby boomers is apparent in his social satire and character treatment—he is independent-minded and daring enough at times to be like Swift in a work like *A Modest Proposal*, trapping readers within their own foibles.

Another type of détournement or redirection in Trudeau's work is his appropriation of attacks on his works for use as promotional blurbs. It works this way: instead of including positive assessments of his strip's qualities or cultural importance (what one normally sees on commercial book collections), Trudeau highlights denunciations of his work. There is a generally postmodern flavor to this strategy—a type of eager self-decon-struction or preemption of the most obvious criticisms. Moreover, the blurbs act as an extension of Trudeau's satire. Because they were deliv-ered, in most cases, in a fit of partisan anger, they tend to confirm the critical points Trudeau tries to make in the strip. In effect, he allows the targets to satirize themselves. For example, by highlighting on a book

cover Barbara Bush's comment that, "I feel like I need to take a bath after reading *Doonesbury*," Trudeau is able to depict her (and by extension, her husband) as prudish, superior, and eager to wash away an awareness of complex social issues. In addition, it serves as a funny endorsement, in the end, when read by Trudeau's especially liberal-minded readers. (Any comic that annoys the First Lady this much must be manna to them.) In light of the devastating effectiveness of this redirecting strategy, it is no wonder that Trudeau relishes angry reactions to his work; as he suggests, "the more its [the satire's] intended target reacts, the more its practitioner gains the advantage" (Trudeau, *Flashbacks* 71).

While these postmodern satiric tools allow Trudeau to stand out on the traditional comics page, they are not so unusual in satiric products in other media—or in the mainstream media itself. Indeed, it is disturbing to note that in a contemporary media environment these subversive, self-deconstructive, and ironic poses have been readily adopted by large corporations. Realizing that viewers are jaded by earnest advertising pitches and are too media-savvy to buy into straight forward hype, many advertisers adopt the postmodern strategy of mimicking the voice of satire in order to preempt the viewer's derision. Indeed, from intentionally goofy insurance ads to soda and beer commercials that make fun of themselves, many advertisement pitches are now steeped in the language of skepticism and irony. This coping, co-opting strategy by commercial interests perhaps threatens the ability of a satirist working in the situationist tradition to get his or her message to stand out from the deluge of pranky, "ironic" voices and rhetorics emerging from the commercial media.

An additional problem is that many of the satiric works that use these postmodern devices have little or no political content or motivation—they are merely striking a hiply ironic, postmodern pose. A good example of this is how some alternative comic strips such as *Red Meat* and adult-oriented cartoons on channels like Cartoon Network engage in a shallow form of détournement: they borrow hokey imagery from an earlier era (earnest character types and cartoon symbols) and attach to them hiply subversive dialogue or themes. No deep satiric point is made about society, human nature, or politics; instead, readers are expected to laugh at the absurd juxtapositions and gratuitously shocking subject matter. The borrowing and collaging of imagery could be described as postmodern

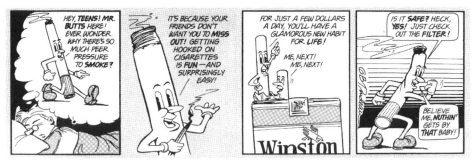

Figure 2.5. Garry Trudeau, "Mr. Butts," *Doonesbury*, April 20, 1989. *Doonesbury* © 1989 G. B. Trudeau. Reprinted with permission of UNIVERSAL PRESS SYNDICATE. All rights reserved.

pastiche and the tone as apolitical, knee-jerk irony. It should be noted that one significant exception to this judgment is Tom Tommorrow's *This Modern World*, a strip that uses Debordian détournement for consistently sharp political satire.

Trudeau stands above postmodern satiric pastiche, first because he is topically and politically engaged with a coherent, critical view of society. Second, he has interesting things to say about human nature and society that are not always cynical. Finally, his work is superior because of the careful way in which he uses a tool such as détournement. To make this point we can consider Trudeau's treatment of the tobacco industry with the caricature of Mr. Butts (see fig. 2.5). While this is a pranky appropriation of mainstream media practice (the cartoony, Joe Camel character), it is explicitly framed within Trudeau's satiric world—a parody one step removed from the seamless borrowing that many postmodern cartoons and advertisements employ. That framing helps keep the hip tone in check and allows Trudeau to make his satiric point in a more explicit and pointed way. There is no mistaking that Trudeau intends to satirize the cynical media machinations of these companies, and little chance that his creation can be reappropriated by his targets.

Some conclusions

A final assessment of Trudeau's satire must acknowledge the dynamic tensions or contradictions in his work: he is a traditionalist who believes in

the reformative power of satire and the rightness of his critiques, but also postmodern in his sensibility and strategies, engaging in self-reflexivity and rowdy media pranks through his strip. Moreover, while highly engaged with his readers in his execution of the strip and use of the Internet, he is also extremely reclusive, resisting interviews and public appearances. Again, he is a thoughtful liberal from one perspective, eschewing brands of punishing or scattershot satire; but he is also highly combative, reveling at times in vendettas and the "unfair" weapons of distortion and exaggeration. Because of these seeming contradictions, one could depict Trudeau as either a reclusive, self-righteous liberal or a poploric, self-deconstructive prankster, depending on one's interests or perspective.

In conclusion, Trudeau, like the rhetoric of satire, is hard to contain or categorize. Perhaps an analysis should not try to simplify the paradoxes or tame the unruly, contradictory qualities in his work. As Trudeau argues, these unfair, unruly qualities are simply a part of the discourse. In a recent interview in 2006 Trudeau restates these core ideas, but with a sheepish ambivalence absent from his earlier celebration of the genre's unbalanced, unregulated treatment of public figures: "Occasionally, people accuse me of courage, and that's wrong. I'm sitting on a perch of safety. Cartoonists have a tar-baby immunity. The more people react to us, and the more angrily they react, the better it is for us. So we're invulnerable. It just doesn't seem fair" (Weingarten W14).

In both celebrating and questioning the privileges of satire, Trudeau articulates a refreshingly accurate appraisal of the messiness of the discourse—as well as the complicated intentions, modes, and effects of his own work. He cuts through the lofty rhetoric of most proponents and defenders of satire who use the traditional ameliorative/persuasive model of arguing satire's noble role, and reveals that satire's greatest power and source of "effectiveness" (whether fair or not) is as an unregulated, subversive critique of powerful people and entities.

One would think that Trudeau's acknowledgment and use of this unruliest of discourses would place him within the ranks of degenerative literary satirists, such as Pynchon or Vonnegut, who harness the tools of satire to deconstruct and attack authoritarianism or any other cosmic or social philosophies which are deserving of dismantling. But unlike these satirists, Trudeau remains an idealist who admits believing in the "perfect-

ibility of man" and the reformative power of satire (Alter 61). As a result, he merely borrows the messy deconstructive tools of satire to carefully target specific figures, policies, or trends worthy of ridicule or disruption.

In sum, then, the scattershot irreverence of slash-and-burn satire and the cosmic orientation of degenerative satire (attacks on human nature in general, the inevitability of evil, and abusive uses of power and authority) are "profoundly cynical," according to Trudeau, "because categorical attacks leave no room for hope" (Trudeau, *Flashbacks* 7). And Trudeau's scathing ad hominem satire (the targeting of specific individuals) is actually idealistic and hopeful. It is hopeful because it implies, as Trudeau believes, "that there are moral choices in life, that not everyone behaves this way, and with reason"—and thus satire can play a role in promoting a foundational social morality (Trudeau, *Flashbacks* 7). This final paradox—the mingling of postmodern skepticism with unfashionable optimism—is perhaps what makes Trudeau one of the most significant and unusual satirists of the latter part of the twentieth century. It may also make him matter most to the next generation of popular satirists looking to meld the lessons of postmodernism with an old-fashioned faith in the reformative power of satiric social criticism.

Chapter 3

Artist Rights and Fights

The Business of Comic Strips

A discussion of the business side of comic strips may seem beside the point when considering great cartoons and comedy; on the contrary, it is essential to understand how institutions and economics shape the form and content of art or satire that is constructed, billed, and distributed as entertainment. But this is not merely an irksome task that detracts from the main event—the comic strip itself. Indeed, there are fascinating aspects to the business side of Trudeau's work, and after studying these issues it becomes clear that they are inextricably intertwined with the satiric and aesthetic aspects of his work. For example, although the battles Trudeau wages with public figures get the most attention in discussions of his power as a cultural critic—and are most regularly cited as a barometer of the relative health of combative satire in our popular culture—the often contentious negotiations and debates he conducts behind the scenes with editors and other cartoonists have the most *real* impact on the restrictions and freedoms enjoyed by popular satirists. A contemporary democratic society that comfortably allows satirists to mock powerful politicians and public figures should not fear for the career of a satirist who gets reprimanded by a congressman or threatened with a lawsuit by a corporate tycoon; indeed, if this occurs one should cheer the success of the satirist, since there is little those people can do to censor or limit the rights of a cultural jester such as Trudeau—and violent reactions from targets often only serve to amplify the power of the satire itself. Instead, one should fear for the satirist who is slowly beaten down by economic and institutional pressures that favor entertainment designed to offend no one—that can serve, for example, as a controversy-free backdrop to the business of satis-

fying national brand advertisers in mainstream newspapers. The self-censorship and endless compromises resulting from pressures to make satiric comedy more broadly—and in effect, more blandly—appealing, are more insidious, in the end, than some sort of governmental crackdown on a satirist's essential rights. The main point here is that this less public aspect of Trudeau's work (his critical engagement with editors, syndicates, and other cartoonists) is, in a sense, simply another facet of his work tightly connected to his more visible art and satire—and a form of cultural criticism in its own right.

Finally, there is drama and comedy to be found in peeking behind the scenes of the newspaper and comic strip industries. For a medium that has the appearance (at least in recent decades) of being a self-satisfied, slumbering giant that favors the art and comedy of bland gagsters, and caters to a sensitive but easily entertained audience, the debates about the business of the medium are surprisingly vivid and charged. And because Trudeau seems determined repeatedly to needle this sleepy industry, he is often the instigator of, or the most contrarian figure within, these debates. Following Trudeau's crusades within the industry makes one alternately smile and wince; he brings out both the best in editors and fellow cartoonists (challenging them to insist on making more of the medium) and the worst (inspiring complacent colleagues to lash out in resentment and defensiveness).

Before describing specific battles and debates, however, it is essential to couch the business side of Trudeau's career in two linked theoretical concepts: the auteur model of cultural production and Gramscian notions of the politics of production in popular art and entertainment (in particular, his notion of "incorporation"). Both ideas help establish criteria by which to judge the ethical and creative choices made by a commercial artist or entertainer, and both are sophisticated enough to acknowledge that there are things to be both lost and gained in making some commercial compromises as a popular satirist or artist.

The auteur concept

The term *auteur* was first applied to cinema by French filmmakers and theorists in the early 1960s; one of the theory's principal points was that even

"films produced under the most industrialized conditions [Hollywood] were held to bear the mark of an artist/auteur" (Turner 43). This argument allowed film scholars and fans to salvage from the cultural dustbin popular texts that had previously been tossed off as hopelessly bland and mass-produced by both highbrow and Marxist-minded critics of "mass" culture. It also allowed them to recognize the signature styles of filmmakers such as Alfred Hitchcock and John Ford who had been working within rigid genre categories (western, comedy, science fiction) that were traditionally seen as less worthy of celebration by academics—or to celebrate directors who had fought against rigid economic and institutional filters (the powerful studio system in most cases).

Since comic strips, like popular films, are a narrative literature of entertainment, categorized according to genres, and created within fairly strict institutional and industrial conditions, the auteur concept can be usefully applied to this medium as well. Moreover, whereas the auteur model has come under attack in recent years among film scholars because its emphasis on the director as artist ignores the truly complex, collaborative nature of filmmaking, it still applies nicely to the fairly solitary craft of comic strip–making. Indeed, most comic strip artists are fundamentally predisposed to be auteurs in the most general sense, because they are called upon to do almost everything in the creation of their movielike strip: to be at once the writer, set designer, comedian, director, and editor. But some cartoonists seem to deserve the designation more than others because of how closely the comic strip's aesthetics, subject matter, and worldview— the work's signature style—reflects the creator's personal aesthetic, intellectual, or political convictions. And in a few rare cases, such as Trudeau's, the artist's especially independent, iconoclastic approach to the craft and business of the creator's art or entertainment deepens the meanings of this designation.

It is possible to overfetishize the idea of pure auteurship, insisting that the creator is in complete control of every aspect of the work. Achievement of some sort of idealized, total control would carry the art out of the commercial realm and make it akin to avant-garde or modernist art—art that is supposedly pure for its distance from commercial pressures and institutional agendas. Some of the restrictions inherent in making popular art—such as genre conventions, collaboration between audience and

creator, and necessary editing for clarity and consistency—are what make this art entertaining and resonant on a broad scale. One could argue that it also makes it a more significant cultural artifact, in the end, than aesthetic experiments emerging from a cultural vacuum. And while critics celebrate a limited number of exceptional cases of popular art emerging with few heavy mediations (Orson Welles's *Citizen Kane* and George Herriman's *Krazy Kat* are famous examples), the artists behind these creations typically are unable to maintain the broad popularity needed to protect themselves from some form of cancellation. Welles famously burned too many bridges with this one masterpiece, and Herriman was able to survive chronically low syndication levels only because of William Randolph Hearst's personal crusade to protect the strip (Stewart 20).

Furthermore, while it is possible to be in charge of almost every aspect of the work in the world of comic strips, it should be acknowledged that the craft is surprisingly labor-intensive and requires the collaborative help of syndicate editors (especially in the strip's initial, gestation phase), other colleagues in the field, and at times assistants who deal with the business side of the craft, or help with time-consuming tasks such as inking or lettering. As early as 1971 Trudeau hired an inker—Don Carlton—to help him deal with the pressure of meeting daily deadlines. (After Trudeau wrote and penciled the strip, it would be sent to Carlton for final inking.) In recent years the strip has grown into such a large cultural entity that he has hired an additional assistant, David Stanford, to deal with fan mail and Internet features. There is nothing unusual or scandalous about this; both Al Capp and Walt Kelly, for example, were auteur-like satirists in the field who also relied on assistants to varying degrees. So overemphasis of the idea of pure auteurism creates ridiculous standards of independent production—often resulting in controversies such as the one that erupted when the *Wall Street Journal* and *Entertainment Weekly* falsely accused Trudeau of using Carlton as some sort of ghostwriter (Astor, "The Wall Street" 28).

Despite the risk of overemphasizing the auteur ideal, the degree to which cartoonists rely on outside assistance can still serve as an effective measure of how well a cartoonist embodies the ethic of independent auteurship. For example, a true auteur would be resistant to the idea of farming out critical aspects of his or her work to other writers, collabora-

tors, or assistants (a common practice with hugely successful strips such as *Garfield*). They would also be more likely to resist excessive pressures to censor or reshape their work to suit the needs of squeamish editors or aggressive merchandisers; and when they die their work would be less likely to be carried on by another artist, because the strip was so thoroughly a product of the original cartoonist's personal talent and vision. Finally, they might be more likely than their colleagues to use some form of satire in their strips that challenges industry conventions, prods complacent readers, and collaborates in meaning-making with core fans. This final observation can be supported by the fact that the cartoonists through the decades of the twentieth century who were most critical of draconian industry practices were also satirists of some sort: Al Capp (*Li'l Abner*), Walt Kelly (*Pogo*), Trudeau, Berke Breathed (*Bloom County*), Bill Watterson (*Calvin and Hobbes*), etc. This makes sense because these cartoonists had the most at stake in negotiations over artists' rights, merchandising, and censorship; their ability to create challenging social satire marked with an idiosyncratic worldview and aesthetic, and to satisfy audiences that came to expect a certain level of irreverence and topicality, hinged on their ability to operate with this auteur-like independence. As suggested in the introduction, these figures perhaps deserve a designation, sateur, that melds the two concepts—in effect, a popular satirist who fights for a significant degree of economic and institutional freedom in order to engage in principled social criticism.

So on one side we can celebrate the unusual autonomy that Trudeau has exerted within this popular medium over the years; at the same time, we have to acknowledge the good things that came out of Trudeau making some necessary compromises in order to satisfy the demands of a commercial medium—of "pandering," to an extent, to editors and a mainstream audience. These positive results become apparent when Trudeau is compared to Jules Feiffer, one of his role models. Feiffer was a more talented cartoonist than Trudeau, and he had similar political points to make in his satire, but he was unwilling to make the compromises necessary to establish a beachhead on the comics page (O'Sullivan 100). He perceived any control over his work by editors as censorship and thus was content to publish his work in the *Village Voice* and through some limited syndication. As a result, his work had greater integrity, perhaps, than

Trudeau's; it was an unmediated reflection of his satiric worldview and it attracted a devoted following among Beats, college students and a liberal, urban intelligentsia. Feiffer's work suffered on three counts, nevertheless, because of its marginal position in the media landscape: first, it obviously had a limited cultural reach because of the alternative venues in which it appeared; second, it put Feiffer in a precarious financial position that limited some of his independence (for three decades he was subsidized by the *Voice*, which treated him as a salaried staff cartoonist; but after being let go in the 1990s, he had to struggle to get by on the meager $20,000 provided by his limited syndication deal); and finally, his work suffered from a cerebral insularity, complexity, and stridency at times—a sign perhaps that he could have benefited from the pressures (not necessarily censorship) of entertaining a broad readership and meeting the demands of a thoughtful mainstream editor (Rall).

Gramsci's concept of cultural incorporation

A theoretical concept that provides a way of explaining and judging some of the benefits and losses of "selling out"—as well as the critical exigency of satirists achieving an auteur-like cultural clout—is Antonio Gramsci's notion of cultural incorporation. Gramsci's work is generally categorized as a type of Neo-Marxist theory—a rough designation used to describe materialist approaches more sophisticated than old-school Marxist theory, which focuses almost exclusively on the idea that mass culture is a form of bland propaganda that is used as a tool in a sort of top-down, cultural oppression. Whereas old-school views suggest that "authentic," grass-roots, politically progressive art and culture is inevitably crushed or homogenized by the commercial and institutional mechanisms of culture industries, Gramsci's concept of incorporation allows for more complexity to enter into the description of cultural negotiations. According to this theory, the dominant culture (which can, for the less paranoid among us, simply be the mechanisms of the marketplace rather than a cabal of plotting capitalist bosses) wants to achieve a political and economic hegemony (a controlling interest in the culture), and is thus willing to make compromises in order to achieve this. Because the formulaic cultural

products created within the heart of the media industry have the tendency to inspire only tepid fan devotion, entertainment companies also need to incorporate continually into their offerings new cultural movements or artists who can draw devoted fans because of the relative authenticity, unique markings, and the appealingly progressive ideas articulated in their work.

At the same time, dissenting subcultures or independent sateurs such as Trudeau need the distribution mechanisms of the dominant political and media culture in order to exert any significant cultural power, and so they are compelled to enter into talks with these institutions. In these negotiations compromises are made on both sides in order to achieve the desired benefits from each direction: the dominant media institutions are willing to let a contrarian voice into the fold because there is the potential that it will develop into a lucrative cultural product that inspires intense fan devotion; at the same time, although there may be no conscious plotting to this end, the process of commodifying a subversive work of art has the tendency to soften its roughest edges, to make it less of a real, outside threat to the hegemony of the dominant culture's art and ideology. From the artist's end concessions are made up front (surrender of ownership of the work in most cases, bowing to some editorial shaping, and perhaps some conforming to existing rules of genre, content, and form) in order to benefit from the monies and distribution that come from gaining access to the mechanisms of the entertainment industry.

There is, of course, a potential risk or downside for each side in making these deals. The artist risks having his or her work flattened and commodified to the point that it no longer reflects his or her idiosyncratic aesthetics and worldview. He or she also risks alienating—by appearing to "sell out"—whatever fan base they may have developed during the time leading up to these negotiations (an especially acute risk for punk or alternative musicians who get signed to major record labels). At the same time, the dominant cultural institutions risk letting in the door an unruly artist who will mess with the system, change rules in favor of artists, or even transform the cultural landscape in subversive or progressive ways because of the broad social reach they were granted.

The concepts of incorporation and auteurship intersect at this point, because the most interesting cases to study are those (such as Trudeau's)

where the artist is somehow able to both avoid the worst dangers that come with commodification *and* maximize the opportunities provided by participation in the mainstream entertainment industry. One could say that auteurs are artists who essentially "win" in these negotiations over the long run. They may start out their careers at a distinct disadvantage to the entertainment industry, but after building the clout that comes with broad popularity and an intensely devoted fan base, they are able to continually renegotiate the terms of their deal, protecting themselves from future mediations that would oppressively censor their views or impinge on their creativity. (In the world of pop music, bands such as U2 and R.E.M. stand out as prime examples of this arc into auteurship.) The independence exerted by these artists is irksome to many of the people in control of the culture industries because, as T. Jackson Lears describes in a discussion of Gramscian theory, the dominant culture ultimately expects subordinate segments of society (or artists such as Trudeau) to participate in the reinforcement of "values, norms, perceptions, beliefs, sentiments, and prejudices that support and define the existing distribution of goods, the institutions that decide how this distribution occurs, and the permissible range of disagreement about these processes" (Lears 568). In other words, participating artists (even the "rebellious" ones) are expected to play by the rules—rules that generally favor institutions and economics over art, that allow business as usual to proceed on sites like the comics page.

As we will see in the following pages, Trudeau has never played by the conventional rules. Over the course of his career he has challenged the following traditional industry practices: unbalanced artist–syndicate contracts, policies prohibiting artist sabbaticals, size restrictions, overmerchandising, content restrictions, and the clubby insularity and complacency of the National Cartoonists Society (the professional organization for comic strip artists). Although I made a big deal in the introduction of this study about Trudeau angering so many people frustrated with his iconoclasm, it should be noted that he has always taken on these issues in a professional way. His contrarian positions have certainly frustrated many people in the industry, but he has generally been smart enough to behave diplomatically, to couch his criticisms in calm rhetoric, and to advocate for progressive practices in ways that benefit all cartoonists—and in most cases, ultimately

the comic strip business as a whole. Indeed, his criticisms of the industry are not ultimately about killing the commerce for the sake of the art; instead, ironically, they are about rejuvenating a medium both artistically and economically—a medium that has fallen into cultural decline because of the very economic and institutional practices that were introduced to provide short-term maximization of the medium's profitability.

Over the course of decades editors gradually imposed size restrictions on comic strips to save on the cost of newsprint—and content restrictions to avoid offending the most sensitive readers or scaring away national brand advertisers. Moreover, unbalanced artist–syndicate rights were constructed to ensure that the business of comics always came before the art (syndicates wanted unlimited license to shape a strip for maximum appeal and to merchandise it for the quickest, largest payoff). However, each of these practices has proved to be either shortsighted or ultimately counterproductive in its drive to make the medium more efficient or profitable. Smaller sizes, less interesting content, and overmerchandising have effectively drained the medium of those qualities that might have allowed it to continue to be a big draw for new generations of newspaper readers, or that could make it a vital cultural site that would rival television or film in the variety of its creative and artistic content. In sum, Trudeau is not a slash-and-burn radical but rather a thoughtful auteur and advocate, not only of artists' rights but of the comic strip industry as a whole.

Trudeau and artists' rights

The following pages will explore the variety of battles Trudeau has taken on as an auteur interested in artists' rights, the vitality of popular satire, and the cultural health of his medium. To begin, he has long seen syndicates as shortsighted and unfair in their relations with cartoonists. The following statement, delivered in 1984 to an audience of newspaper editors, displays Trudeau's general appraisal of the syndicate business:

> ... realistically speaking, everyone here knows that there is only one syndicate in the business [his syndicate—UPS] that would support a concept as radical as artists' rights [this was before the rise of Creators

Syndicate, a company that was founded with the idea of remedying
many of the problems Trudeau highlights] . . . The role of the tra-
ditional syndicate has been that of a clearinghouse for product, and
they measure their success purely in terms of units of product moved.
(Trudeau, "APME" 6)

This statement is perhaps a bit of an exaggeration; there have been,
after all, a handful of syndicate editors over the years who have been espe-
cially good at finding and nurturing talented, iconoclastic cartoonists
such as Walt Kelly, Al Capp, and Bill Griffiths. Nevertheless, the balance
of power in negotiations between syndicates and artists in the business
has largely been in the hands of the syndicates, and thus productive, art-
ist-friendly collaboration has been the exception rather than the norm.
A bit of history on artist–syndicate relations will help set the stage for
understanding Trudeau's iconoclastic approach to this issue.

Because syndicates have been primarily interested in maximizing
their profits over the history of the medium, there is a legacy of bullying
cartoonists into diluting the content of their strips, catering to the lowest
common denominator, and overmerchandising characters. I say bullying
because the bulk of the power in these negotiations—until recent years—
was in the hands of the syndicates. This is a result, primarily, of the tradi-
tional syndicate–cartoonist contract. The norm from the early days of the
medium has been for syndicates to offer a cartoonist the slim chance of
becoming a cartooning celebrity in exchange for signing away the control
and ownership of their creation. These contracts could be dropped by the
syndicates at any time but locked a cartoonist into a binding obligation
for up to twenty years, essentially putting the cartoonist in the position of
indentured (albeit well-paid) servant to the syndicate. A handful of car-
toonists over the decades, such as Trudeau, Walt Kelly (*Pogo*), Bud Fisher
(*Mutt and Jeff*), and Richard Outcault (*Hogan's Alley*), were able to protest
these conventions and either begin with a more equitable agreement or
renegotiate a better contract after becoming widely popular. Other car-
toonists, however, such as Milton Caniff, who chafed under these oppres-
sive conditions, essentially lost their creation. For example, Caniff's *Terry
and the Pirates* was drawn by another artist when Caniff left his syndicate
in protest in the late 1940s and began a new strip, *Steve Canyon*.

These business arrangements have been slow to change, with some cartoonists insisting that the standard contract today—a ten-year agreement with the syndicate owning the strip—belongs in the 1920s. Mike Peters, the creator of *Mother Goose and Grimm* and a Pulitzer Prize–winning editorial cartoonist, sums up the view most cartoonists have of the industry contracts by arguing, "It's long overdue that syndicates realize that a new day is here. Indentured servitude went out in the 1500s" (Astor, "Strong Opinions" 44). Other established cartoonists such as Bill Keane of *Family Circus* fame concur; Keane, in fact, has good reason to protest industry practices since he has firsthand knowledge of the nightmare of laboring away on a strip for most of his working career without owning it. When he wanted ownership of his work after his contract came up for renewal in 1978 (after having cranked it out week after week since 1960), the old Register and Tribune Syndicate threatened to hire another cartoonist in his place to produce the feature. He described it as a "point-a-gun-to-the-head approach" to contract negotiations that is a still common, if more subtle, norm in the industry today (Astor, "Strong Opinions" 44).

Comparing the contract-copyright practices in the French comics system to those in the United States reveals that there are more progressive methods that the industry could adopt. As Roger Sabin points out in his book *Adult Comics*, since French law "enshrined 'the inalienable rights of the creator' and forbade companies [syndicates or comic book publishers] to own characters," artists automatically had more autonomy and clout in the creative process (Sabin 186). This basic advantage, joined with the higher status of cartoonists in French culture and the more accessible routes to financial success in the profession (cartoonists can collect two substantial royalty checks, one from the initial syndication or publication and another from the handsome hardback collections printed under their names), makes for a system superior to American practices.

Syndicates in the United States that still practice under the old system argue that the longer contracts are required in order to show that the syndicate is truly interested in helping a cartoonist to succeed over the long term. John McMeel, the president of Universal—Trudeau's syndicate—suggested in an interview in 1987 that "longer contracts . . . can

give creators the security of knowing they won't be dropped quickly if they don't sell at first" (Astor, "Strong Opinions" 46). The problem with this claim, however, is that syndicates are not necessarily committed, let alone required, to keep promoting a cartoonist according to the terms in these agreements. The contracts are written so that the cartoonist is stuck with his situation, but the syndicate can decide at any time to discontinue promoting or representing the artist and his or her work. A more feasible argument in favor of the longer contracts is that the syndicate does make a considerable investment in promoting strips that will not make a lot of money unless they succeed in the long haul, and their interest is to see the cartoonist stay with the syndicate so that the company can enjoy that return on its initial investment. If shorter contracts were the norm, the argument goes, then cartoonists might be tempted— as soon as they became big shots—to sign a more lucrative contract elsewhere, and the syndicate that did all the hard, initial legwork would lose out (Rees 60).

The issue of ownership rights is more cut and dried. There is no ethically sound argument that can be made for a syndicate owning at the outset, or in perpetuity, a cartoonist's work. Artists interviewed by Stuart Rees, in his study of artist–syndicate relations, considered the issue of copyright ownership as the "single most important part" of their contracts (33). And the pendulum has shifted in the last decade in artists' favor; with more cartoonists like Watterson publicly advocating ownership, syndicates have generally ceded this point, making it more common to either give the artist ownership upfront, or to create contracts that transfer rights automatically at a later date. Tribune Media Services and Creators Syndicate were pioneers in introducing this artist-friendly copyright policy: In the late 1980s, Tribune changed their policies and made it common practice to cede rights to the cartoonist at the end of the first contract; and Creators Syndicate, founded in 1987 by Rick Newcombe, was the first to give rights to the creator upfront, at the date the contract is signed.

In addition to Newcombe, other editors are concerned about industry practices and intent on being helpful and true to talent and peculiar satiric visions. Jay Kennedy at King Features, for example, was an interesting figure in the industry since he was relatively young for a syndicate

editor, was a fan of the underground comix movement, and had a colorful career including work in animation, magazines, and alternative comics (he died in 2007 at the age of fifty) (Stewart 22). He was outspoken at conferences on topics such as censorship and the shrinking size of cartoons, and championed satiric strips such as Griffiths's *Zippy the Pinhead*.

Another example is Lee Salem, the editor with whom Trudeau works at Universal; he has a reputation for innovation and artist-friendly practices. The pursuit of a masters degree in English from Park College in Kansas gave him some empathy, perhaps, for the cartoonist's creative process (Hurd 38). Unlike Newcombe, he is not a crusader looking to give rights and powers back to the artist—indeed, he has clashed with Bill Watterson and Lynn Johnston over these issues—but he has long worked courageously as a "human firewall" for Garry Trudeau, defending him from critics and giving him space to create his highly provocative work. So to provide an accurate frame for understanding Trudeau's syndicate battles, we could say that he has worked for a company that is traditional in insisting on long contracts and generally wanting to own its artists' works, but which also has a reputation for being progressive—willing to find and nurture talent such as Watterson, Johnston, and Trudeau. Nevertheless, the fact that Watterson was never happy with his contracts at Universal—that he had to fight continually to protect his work from overmerchandising—suggests that it is ultimately the artist rather than a syndicate (even in the case with Universal) that has to establish the proper balance between art and commerce in the execution of a strip.

Because Trudeau owns the rights to his work he has never been in danger of being fired by Universal and seeing them assign *Doonesbury* to another artist. And because he achieved such immense popularity and cultural clout in the first decade of his strip's run, he effectively established his auteur credentials and created the bargaining power he needed to wage friendly battles with Universal in the ensuing years over issues such as sabbaticals, merchandising, and political content. Trudeau's clout with his syndicate has been so solid, in fact, that they have generally supported him through a myriad of battles with newspaper editors over controversial content. Nevertheless, relations have not always been smooth, and Trudeau has had to fight hard for a variety of artists' rights.

Sabbaticals

Sabbaticals, for example, was an issue that pushed Trudeau into conten-
tion with his syndicate as well as the industry in general. This issue came
to a head when Trudeau chose to take a twenty-month sabbatical from
his strip in 1983. In his eyes, this was a hard-won and necessary break after
twelve years of meeting grueling daily deadlines; he felt that in order to
restore his energy and interest, he needed the chance to temporarily pur-
sue other creative interests such as two theater projects. He also cited it as
an opportunity to "rescue his characters from their twelve-year captivity as
undergraduates and 'move them out into the larger world of adult grown-
up concerns'"("Trudeau, by a Jury of His Peers" 137). However, from his
syndicate's point of view, this would be an awkward cessation of a lucra-
tive strip, and for many newspaper editors it represented an arrogant and
selfish affront by an "intermittent cartoonist" who did not take his obliga-
tions seriously. Even fellow cartoonists such as Charles Schulz were critical
of Trudeau's insistence on this right. As evident in this excerpt from an
interview, Schulz was frustrated enough to criticize Trudeau indirectly:

> Schulz sees drawing a syndicated strip as a rare and anointed privilege,
> not something to be taken lightly or ignored for a year or so while
> working on other projects. He could no more take a professional sab-
> batical and drop Charlie Brown for a year than he could abandon his
> own children. To him, the whole idea of such professional nonchalance
> is repugnant. [He stated,] "That's some way to repay editors and read-
> ers." (Johnson 213)

Trudeau had the following to say about these intolerant reactions to
his decision to take a sabbatical:

> The message was that I wasn't entitled to conduct my life as I pleased;
> that to exhibit a need to explore other creative outlets was self-indul-
> gent and an abdication of some implied covenant with newspapers and
> the public. Similarly, when I requested a two-week vacation to work on
> an outside project some summers ago, thunderstruck editors phoned

in their indignation from Martha's Vineyard. When a columnist takes
a month off and leaves "favorite columns" behind, it is considered
perfectly acceptable. When a cartoonist asks for comparable consider-
ation, it's considered an unconscionable disruption of a public service.
(Trudeau, "APME" 9)

As a side note, it is interesting to identify both a generational shift in
attitudes, and differing conceptions of what it means to be a popular art-
ist, between Schulz and Trudeau. Schulz embodied the journeyman car-
toonist who humbly served his syndicate and audience; he described this
desire to please syndicates, editors, and sensitive readers at all costs: "I bet
I lean further over backwards to keep from offending anyone than any
other cartoonist" (Johnson 238). From one perspective this attitude can
be seen merely as being professional in his business relations and devoted
in his service to fans; on the other hand, perhaps Schulz damaged his own
strip by allowing syndicates to always have their way, and never failing to
deliver a strip year after year. Schulz's pliability resulted in his strip receiv-
ing a name—*Peanuts*—that he resented throughout his career, and his
eagerness to become syndicated led him to create a strip of reduced size
that could be used as a space-filler on the comics page. He admirably made
the most of the minimalist aesthetic that matched his strip's size, creat-
ing emotionally rich and psychologically realistic comedies in which the
brevity of words and images served to amplify the internal complexities
of his cartoon world and characters—but he may have also inadvertently
helped usher in the gradual reduction of all strips down to that smaller
configuration. Fans additionally may have suffered in the end because of
Schulz's refusal to take any creative breaks. It was generally felt among
critics and longtime readers that the strip began to lose energy in its later
years, even repeating old jokes verbatim from the early years of the strip
in new installments.

It should be noted that, other than a few disagreements over pro-
fessional issues, Trudeau greatly admired Schulz's work. Trudeau praised
Peanuts as the "first (and still best) postmodern comic strip." He also cited
it as a major influence, highlighting Schulz's "graphically austere and
beautifully nuanced" drawings, "complicated, neurotic characters," and
"haiku-perfect dialogue. The stories were interwoven with allusions from

religion, classical music, psychiatry and philosophy." He concluded that Schulz "revolutionized the art form, deepening it, filling it with possibility, giving permission to all who followed to write from the heart and the intellect . . . [It is] an irreplaceable source of purpose and pride, our gold standard for work that is both illuminating and aesthetically sublime" (Trudeau, "An Appreciation" 270–72). From Schulz's direction there was the occasional note of appreciation—after he received the Pulitzer, for example—but there was also a stubborn disrespect for Trudeau and his work; it was indicative, perhaps, of one of Schulz's few flaws—a tendency toward melancholy bitterness or resentment if he felt slighted or challenged by the work or actions of other cartoonists. For example, here is an excerpt from an interview in *The Comics Journal* where Schulz was asked by Gary Groth and Richard Marschall, to react to Trudeau's insistence that his strip be run at the larger, pre-sabbatical size when he returned from his break:

> **Groth:** How do you feel about [Garry] Trudeau's demanding more space for *Doonesbury*?
> **Schulz:** [pause] That he's not professional. He's never been professional.
> **Groth:** How do you mean that?
> **Schulz:** I don't think he conducts himself in a professional manner in the things that he does.
> **Marschall:** You're not just talking about the artistry of the strip?
> **Schulz:** It's his whole attitude toward the business.
> **Groth:** You don't admire the strip.
> **Schulz:** [shakes head].(Groth, Marschall 11-12)

So in the arena of "professional" relations, Trudeau embodied a radically different conception from Schulz: the cartoonist as independent artist, social critic, and creative auteur. He was willing to offend in the name of advancing artists' rights and promoting the quality and content of the art. Sabbaticals, though seemingly about the artist's own need for a better quality of life, could also achieve both of the following objectives: a longevity for the strip (guarding against the fatal burnout that knocked great cartoonists such as Watterson, Larson, and Breathed out of the field); and a renewal of creative energy (eliminating that common decline into for-

mulaic, repetitive installments). Trudeau's willingness to buck the system also introduced readers to the business practices and creative processes of the medium, possibly leading them to become less complacent about what they settled for in reading the comics. It also opened the door for some changes to be made in industry practices. For example, Trudeau's own syndicate, Universal Press Syndicate, has now made it company policy to offer cartoonists four weeks of vacation each year. Although other companies have been slow to follow suit, editors and readers have come to tolerate and perhaps understand the necessity of having these short lapses in the cartoon's continuity.

Comic strip size

Upon Trudeau's return from his sabbatical in 1984, he tackled another shortsighted practice of the industry: the continual shrinking of comic strip size by newspaper editors. During the first twelve years of his career, size reductions had occurred sporadically and with little uniformity, but during his sabbatical, all newspapers had agreed on a reduced size that would allow them to print two columns of comics on the same page. This was a full 30 percent smaller than *Doonesbury* had been when it was first introduced over a decade before. Trudeau decided to take a strong stand on this issue because he believed that this move threatened his own work in particular—which needed space, obviously, to engage in its complex, topical, verbal satire—and the industry in general, because it made the comics more difficult to read and forced creators to rely more heavily on a talking-head style of drawing, and simple, gag-oriented content. He understood that newspapers were trying to find ways to save costs as readership declined, but pointed out that these papers "want the readership of comics, but not the commitment to space," and this showed a lack of "respect for a medium that draws more than its fair share" of readers (Radolf 49).

Feeling that simply making a point through editorializing would not make a difference, he gave newspapers a sort of ultimatum: they could either buy and run his strip at a larger, 44 pica size (the size the strip had been when he started his sabbatical), or not buy the strip at all. The fact

that Trudeau's work was such a popular, national fixture, and that many readers eagerly anticipated his return, gave this requirement its force. Editors, even if they personally disliked Trudeau's politics, knew that his popular feature attracted a desirable demographic and felt compelled to deal with this ultimatum.

Although Trudeau meant to suggest that he had the right as an artist to protect the health of his work, and that comics in general were being undervalued through continual reductions, many editors took his move as a personal challenge to their authority. Their collective outcry was intense and often vicious. They labeled Trudeau variously as being selfish because his larger size would mean less space for introducing new cartoons; that he was trying to upstage other cartoonists or dominate the comics page; that he was dictating newspaper policy, effectively usurping "management authority"; or simply that he was an irksome bully who liked to intimidate his syndicate and annoy people who ran newspapers (Trudeau, "APME" 3–8; Radolf 49). Fellow cartoonists, sensing that perhaps he was their collective advocate but realizing that this protest benefited only Trudeau in the short run, reacted with a mix of admiration and resentment. For example, Jeff MacNelly, the creator of *Shoe*, said, "Garry Trudeau is a helluva guy and a gifted writer and cartoonist. I just wish everyone's comic strip was printed as big as his is" ("Trudeau, by a Jury" 137).

A few editors understood the point Trudeau was making and quietly honored his size requests without complaining (one editor at the *Atlanta Journal* even decided that all the comics should go back to this reader-friendly size), but the general consensus seemed to be that Trudeau needed to be publicly shamed and taught a lesson. This lesson-giving took the form of dropping the strip in a few cases, but on the most part it consisted of scathing editorials and angry, internal-industry grumblings. Many readers, who had been conditioned to see the comics as a public utility that magically appeared day after day saw—thanks to Trudeau's public battles over this issue—that this art form was produced within a cultural "industry" that had disputes and problems between creators and mediators. The editorials may have even inadvertently made readers sympathetic to *Doonesbury*'s cause since he came across as a principled (if a little prima-donnaish) crusading artist fighting an audience-unfriendly, corporate practice.

Overmerchandising

Another precedent Trudeau set in the industry was resisting the temptation to cash in on his creation by aggressively merchandising and licensing the characters from the strip. His feeling about merchandising was that the strip would be devalued and overexposed if allowed to appear on a myriad of knick-knacks and T-shirts. He explained early in his career that "I don't like celebrification" (of both his characters and himself, it would seem); "Everything I have to share I share in the strip" ("*Doonesbury*: Drawing and Quartering" 65).

His abstinence from this merchandising was read as a protest by most observers, and unlike some of his other high-profile battles, he was less openly critical of the practice as done by other artists. For example, he only ventured self-mocking and mild, backhanded criticisms such as the following about big cartoon merchandisers such as Schulz: "Well, Sparky Schulz simply takes the position that the spin-offs make people happy. I have no problem with that position, but with the exception of the books, I prefer to keep my characters on the reservation. Perhaps it's because there's no logical connection between my characters and a lunch box . . . unless, of course, you find the logic of the profit motive irresistible" (Trudeau, *The People's* 3).

The strong point made here, nevertheless, is that other artists, motivated primarily by the prospect of more money, allow their work to be used in ridiculous, inappropriate ways. It would be easy to cite *Peanuts* and *Garfield* as an example of this sin; and, indeed, *Peanuts* did seem to lose some of its richly dark, existentialist tones when the market became flooded with "happiness is a warm puppy"–style merchandise. But perhaps a more deserving target would be a strip such as *Dilbert* whose satire more explicitly suffered from commercial merchandising. Although the creator, Scott Adams, never made any claims to being more than a cartoonist-businessman, much of the appeal and identity of the strip was built upon the impression that his comic emerged as a grassroots protest against corporate abuses of the oppressed cubicle worker. Adams's own story of being one of these disgruntled workers, of being self-taught, and of building a fan base slowly through self-syndication, reinforced this notion of his satire being used in a righteous, David vs. Goliath cause. But

then Adams seemed to "sell out" in aggressively unapologetic ways. The strip was plastered on all kinds of knick-knacks and quickly suffered from overexposure; cute Dogbert dolls, for example, ran counter to the acerbic ruthlessness of the strip character. More egregiously, Adams agreed to speak at corporate conventions, earning ten to twenty thousand dollars per appearance. At these events he was often introduced by the very upper-level executives who were ostensibly the principal targets of his strip. Companies may have thus effectively co-opted the subversive cubicle-workers movement rallying around his strip by giving rank and file employees at these conventions the impression that the company's bosses were in on the joke—or exempt from its barbs.

In the early 1990s Trudeau "sold out" by doing some limited merchandising of his characters on T-shirts and mugs; he did it in a typically iconoclastic way that differed radically from Adams's incorporation into the system. Indeed, the manner in which Trudeau undertook this venture successfully acted as a critique or commentary on the practices of purely business-minded cartoonists. Trudeau made it known that he would not make any profits from the licensing—it would all go to four charity foundations: Trees for the Future, Asia Watch, The Coalition for the Homeless, and The Center for Plant Conservation. Additionally, the types of products he chose to sell acted as satirical pieces that echoed themes in his strip and reflected on the gaudy silliness of merchandising in general. The following items, for example, were made available through a mail-order catalog: "$7.95 plastic swizzle sticks adorned with 'America's cutest death monger,' Mr. Butts," fake press credentials, and a baby-blue polo shirt emblazoned with a feather icon over the breast (the symbol for Dan Quayle). Uncle Duke, the resident opportunist in the strip, appropriately served as the guide and principal salesman in the catalog. The charitable angle and satirical tone of this "sell-out" effectively allowed Trudeau to remain true to his principles while still benefiting from some charity-directed profits and added exposure—exposure, importantly, that was an extension or amplification of the strip's satiric tone.

It should be noted, however, that there is always the danger of facetious satiric points—like those in Trudeau's mock-merchandising campaign—losing their way as they travel from creator to reader. This successful transmission of a layered satiric point is especially tricky when

commercial mediations like those in a merchandising campaign are involved. For example, putting Duke on caps and T-shirts, spouting his amoral, opportunistic maxims, runs the risk of making him into a heroic celebrity. Divorced from the sophisticated narrative framing of the strip, he can potentially become merely a funny antihero, a roguish icon of libertarian chutzpah. This problem is similar to what occurs with Schulz's *Peanuts* characters as they get plastered on towels and T-shirts: Snoopy's irreverence and intelligence gets diluted into that "Happiness is a warm puppy" sentimentality.

Despite these complications that occur when satire loses its bearings in the commercial realm, Trudeau's overall consistency and integrity as a principled satirist helps guide his core readers in interpreting these merchandising moves accurately. Working as a reliable brand name that people recognize, Trudeau's satire, characters, and humor are inextricably linked to what people know about him as a maverick cartoonist and iconoclastic social critic. As with Kelly's core audience, the avid readers of Trudeau's work read his satire in the context of what they know about his position on sabbaticals, size restrictions, and the appropriateness of political/social commentary on the comics page. Knowing from experience that Trudeau is not opportunistic, or driven by lowest-common-denominator marketing, they can rely on his strip to be an independent, alternative take on the concept of product merchandising.

Trudeau and the National Cartoonists Society

In most of the battles over artists' rights and industry practices, Trudeau has inevitably run into conflict with colleagues who are unwilling to create waves with newspaper editors and syndicates. It is understandable that many fledgling cartoonists who could exercise little clout in these battles might remain silent. Their desire to build greater syndication numbers— to effectively survive in a highly competitive business—might convince them to stay out of the fray. But older, superstar cartoonists had different reasons for either remaining silent or openly criticizing Trudeau as he challenged industry practices. On the most understandable or forgivable

side, this reticence had to do with a generational difference: older cartoonists such as Walt Kelly and Schulz were continually worried about behaving "professionally"—about the effect that airing dirty laundry would have on public perceptions on their craft. They were still struggling to legitimize their profession and to change readers' and cultural critics' perception that the medium was lowbrow, immature, or ephemeral. Many of these older cartoonists had also emerged from cartooning bullpens which were the equivalent of working-class sweatshops for artists; to break into the big money and higher prestige of comic stripping was a professional coup that one would not want to take for granted or jeopardize by creating controversy. (Schulz paid his professional dues by working as an instructor in the "Learn to Draw" correspondence-course company and by doing gag cartoons for magazines. Kelly labored as a junior animator at Disney, as a comic book artist for children, and as a spot cartoonist at a New York newspaper before making a big break with *Pogo*.)

A less admirable reason that this older generation resisted challenging the status quo was that they were satisfied with the wealth and professional security one could enjoy by simply going along with traditional industry practices. To question or challenge the business side of their profession could potentially disrupt this comfortable prosperity. Even the profession's official organization, The National Cartoonists Society, until recent years, seemed to exist primarily to help members enjoy professional prestige and clubby privileges. At times it could advocate the rights of artists and interests of the art form, but a perusal of programs and debates from the organization's archive gives the impression that it was primarily a sort of fraternal, male-dominated social club.

In order to better understand how Trudeau has clashed with this organization and the mindset of the older generation of wealthy cartoonists, a brief contrast with Walt Kelly's approach to the business side of comic strip satire is helpful. Kelly was an important and admirable precursor to Trudeau in many respects: he persuasively advocated for the inclusion of satire in comic strips; his left-leaning politics were coherently constructed and communicated through *Pogo*; and he established his own auteur-like independence through a renegotiation of his syndicate contract. But unlike Trudeau, he was eager to please editors in order to dodge contro-

versy or avoid giving the impression of being unprofessional. For example, he spent a great deal of time writing personal notes to editors, giving out signed cartoons, and offering other personal favors. In addition, he enjoyed the privileges of celebrity, embracing opportunities to rub shoulders with movie stars and politicians. Finally, he was also perhaps a bit too willing to make concessions to sensitive editors; for example, in the 1960s he offered an alternative, "bunny rabbit" strip to editors who did not want to see politics on the comics page. (As a side note, none of this diluted the general excellence of his strip and the unusual courage he displayed in taking on McCarthy and other targets in the 1950s.)

As a leading figure in the profession, and president of the NCS in the mid-1950s, Kelly exhibited a playful leadership style that his fellow superstar cartoonists loved, but that tended, at times to be more about clubbiness, and the fun and privileges of old-boy networks than advancing artists' rights. For example, when one young cartoonist complained in a meeting that the NCS was not doing enough to help young, struggling professionals, Kelly made it clear that he saw the organization's primary purpose as being a vehicle for privileged networking and partying. A newsletter emphasized this point with a quote from Kelly: "We're not here to help every lousy cartoonist to make a buck here. Get rid of illusions and high expectations; this is nothing more than a chowder and drinking club for we cartoonists who have made it to the top" (National Cartoonist Society newsletter, 1953). Ironically, Al Capp, another satiric cartoonist with a less coherent political philosophy in his work, envisioned a more progressive purpose for the society:

> Sooner or later, the Society must justify its existence by being something more than it now is, by using its members and strength to do something affirmative for the cartoonist in the way that all associations of creative men, screenwriters, newspapermen, dramatists, and authors have made better and sounder the relationship between the artist and his business management. . . . We can horse around with meetings and banquets and little stunts, add up to nothing constructive and quietly fall apart—or we can become a useful Society that devotes its numbers and its wisdom and its strength to clear up the muddiness in the artist-management relationships that keeps our profession the one important

creative profession left in America with no standards, no dignity, no honest American basis. (Harvey, "Tales of the Founding" 68)

Returning to Kelly, as president of this organization he hushed up controversies within the industry (some of them, admittedly, sordid enough to justify the silence) in order to promote a placid façade to editor–artist relations; denounced comic books on the Senate floor while highlighting the safe, family-friendly tone and content of comic strips (Report of Senate hearing on indecency in comic books); and participated in organizing outings and events that had a closer resemblance to fraternity parties for middle-aged men than they did to professional meetings. To be fair to Kelly, he inherited leadership of an organization that had long been entrenched in these practices. Most early-twentieth-century cartoonists were from working-class backgrounds and had struggled through cartooning bullpens to achieve their unlikely success. They were not interested, for the most part, in expanding the ranks of the profession or agitating for rights; they had achieved a sort of American dream through a uniquely democratic route and wanted to enjoy it.

The overwhelmingly male composition was reflected in sexist rhetoric and practices of the organization: they organized bathing suit contests in which their wives and girlfriends would participate; each year they passed out a booklet containing drawings of their female cartoon characters in the buff; they did not allow a woman into the organization until 1950; and many of the cartoonists were notorious carousers and drinkers. The National Cartoonists Society remained entrenched in many of these rowdy practices in the ensuing decades, and in 1985 Trudeau resigned from the organization in protest. Mort Walker (the creator of *Beetle Bailey*) and Johnny Hart (*B.C.*) triggered the reaction by including in the annual program magazine drawings of their characters, Miss Buxley and "Fat Broad," respectively, in the nude. Trudeau described the actions of Walker and Hart as "a travesty of condescension and sexism" and "deeply offensive" ("Controversy Over Sexism" 49). Ironically, this was the same year in which Walker and the other leaders of the organization had decided to honor female cartoonists in the industry—a "salute" that was highlighted prominently in the programs and annuals of that meeting. Trudeau added in his letter of resignation that he could "no longer remain a member of

an organization which consistently condones this kind of puerile, patronizing attitude towards 'gals.' While publishing naked cartoon characters may be the Society's idea of a 'salute' to women, it certainly isn't mine" (Ibid. 50).

Walker, interestingly, was also embroiled in the mid-1970s in a similar controversy: while attempting to put together a show of comic art, he stated that "women have no sense of humor" because he could not find any women cartoonists to represent in the show. This frustrated many female cartoonists working in the field; Trina Robbins, an underground cartoonist of the 1960s and comics historian, responded by writing an elaborate history of the complex roles that female artists played in the history of the medium. She highlighted their work both as unrecognized assistants working in cartooning bullpens, and as underappreciated creators of some of the most popular kid and "girl" strips from earlier decades (Robbins, "Women & the Comics" 24–26).

The National Cartoonists Society no longer resembles the old boy's club of Kelly's or even Walker's time, and Trudeau has recently resumed participation in its yearly meetings. Nevertheless, because of the hybrid nature of his strip and his private, personal nature, he remains a loner in the field, an aloof figure who seems to care little for the social side of the profession. Moreover, in contrast to Kelly, he has been interested in exposing rather than hiding negative industry practices, professional controversies, and the bad behavior of his peers. Not surprisingly, he is not as widely loved by some colleagues and editors as was the creator of *Pogo*.

Trudeau's proud, reclusive nature can also offend editors, making him appear to be arrogant and unfriendly. But another way of looking at his cold professional demeanor is that it is a facet of his effectiveness as an auteur and maverick in the field; by remaining detached from professional organizations, he retains the freedom to criticize insular clubbiness, self-satisfied exclusivity, and a drift toward professional courtesy that can lead to artistic or ethical compromise. One gets the sense, too, that Trudeau's ability to strike at folly wherever it arises in his satire is also derived in part from this independence. With few professional obligations and no chummy connections with his targets, he is able to attack without reserve. In the end, professional principles seem to matter more to him than the social niceties of fraternal organizations, and he seems determined to

apply the satiric maxim to "give comfort to the afflicted and to afflict the comfortable" in all aspects of his profession.

Even though Trudeau is reclusive, his principled, professional behavior over the years established a progressive model that has been followed by a handful of significant comic strip artists. Indeed, his influence in this area of the industry has been significant. Cartoonists such as Berke Breathed, Lynn Johnston, and Bill Watterson, for example, have followed his lead in taking greater control over the issues of sabbaticals, ownership of the strip, and merchandising. Watterson even matched Trudeau in his willingness to detach himself from professional organizations and to openly criticize industry practices that disadvantage artists or conspire against the health of the medium. His introductory essay to his tenth anniversary of *Calvin and Hobbes* book was especially trenchant in dealing with some of the same problems addressed by Trudeau: size reductions, artists' rights, contracts, heavy editorial mediation, etc.

Trudeau's influence on Berke Breathed's work is slightly more complicated. Breathed followed in Trudeau's footsteps in a variety of ways: a maverick orientation toward the industry and other cartoonists; a consistent inclusion of topical political satire in his strip (like Trudeau, he won a Pulitzer in 1987 for his work); a resistance to regressive industry practices; and the creation of comedy and satire that was highly verbal and complex. From Trudeau's perspective, however, Breathed's emulation bordered on plagiarism because of similarities in aesthetics, lettering, character construction, and the lifting of specific gags. As a result, when Breathed made his big splash on the comics page in the mid-1980s, Trudeau looked on with irritation; he was so bothered, in fact, that he sent Breathed a letter, chastising him for what he perceived as opportunistic borrowings from *Doonesbury* in *Bloom County*. Perhaps because Breathed's initial reaction was flippant and defensive (by Breathed's own admission in later years), Trudeau has never softened in his view of this peer. Evidence of this persistently harsh and perhaps unfair judgment (considering Trudeau's own emulation of many aspects of Jules Feiffer's work) appears in Trudeau's current FAQ at the *Slate* website; it reads,

> A critic for *The Comics Journal* once wrote that to call *Bloom County* funny is like complimenting a shoplifter on being a snappy dresser.

Breathed borrowed from a variety of his colleagues—even as he scorned their work. He once wrote a series of strips about two characters looking at clouds that was so clearly lifted from a legendary *Peanuts* strip that the *Washington Post* called him on it. His reply: It was an "homage"—never mind that the *Peanuts* strip had appeared 20 years earlier and was not referenced. The line between emulation and theft is a fairly subjective one, but Breathed developed a poor reputation among his peers because of the specificity of his lifts—and his arrogance when confronted with them. (Trudeau, *Doonesbury* FAQ)

It is true that Breathed's initial reactions were defensive and arrogant; he lashed back, saying that Trudeau's work was conventional and out of touch. But in recent years Breathed has mellowed and reflects with admirable good will and self-criticism on the clash:

He wouldn't meet with me many years ago when we were at a conference together. Painful at the time. But I can't blame him. I built heavily on his style, inadvertently lifted a handful of his specific gags the first year (very embarrassing) and then won the Pulitzer Prize. He has license to be fairly unimpressed with my rather glib response to his initial objections. He is, by the way, the best social satirist of the second half of this century. (Kurtz 3)

In closing, it could be argued that Trudeau is only making reasonable demands on the industry—that he is devoted to promoting artists' rights and the health of the medium. Moreover, although Trudeau may have a combative personal style, the controversies surrounding his criticisms have as much to do with the conservative intractability of the industry—its complacent, shortsighted stubbornness—as it does with his approach to the debates. At first glance it would seem that Trudeau's battles for size increases, sabbaticals, and other various protections of artists' rights did not translate directly into dramatic, industrywide changes. For example, while most other cartoonists admired Trudeau's courage or quietly steamed about his audacity, few were actually willing to risk their own precarious level of syndication, or reserve of good will with editors, by following suit. But his criticisms of the industry and his colleagues set precedents for

other iconoclastic cartoonists such as Berke Breathed and Bill Watterson to follow and perhaps alerted many engaged readers about negative industry practices. In addition, thanks to Trudeau's auteur-like independence, he was able to act as a critic of mechanisms within the newspaper and entertainment industries that conspired against the health of satire and the rights of artists. It would be difficult to measure all of the repercussions of such a sustained revolt against oppressive commercial and institutional practices. While he may not be able single-handedly to change these industry conventions, the collective rebellion of all those reached by his criticisms may indeed have a huge, progressive impact on how popular satire will be created, distributed, and received in the coming years.

Chapter 4

A Heavy-Lidded Eye

The Aesthetics of *Doonesbury*

Because Trudeau is celebrated primarily for the verbal aspects of his satire—and because his drawing skills are not as impressive as other celebrated cartoonists in the history of the medium—it is easy to undervalue the role that aesthetics play in his work. Additionally, because satire has traditionally been studied as a *literary* form in academia, there is a tendency in any discussion of cartoon satire to examine only the functions and content of the *written* text. In order to avoid these errors—to give full consideration to Trudeau's cartooning and to avoid undervaluing the relationship between visual art and satire in comic strips—I will consider in this chapter how the following aesthetic aspects of cartooning in general unfold in Trudeau's work in particular: the relationship between words and images in comic strips; theories related to the way readers read and identify with cartoon characters in comic imagery; how the differences between single-frame political cartooning and the multiple-frame continuity of comic strips affect the construction and reception of satire; and the cinematic effects and qualities of cartoon paneling. I will also discuss Trudeau's drawing style, evaluating its strengths and weaknesses, and consider the relative merits of Trudeau's practice of using symbolic icons—in place of traditional caricatures—as devices for lampooning public figures.

In recent years, comic strip scholars have worked to establish methodologies that can be profitably applied to the peculiar qualities of this medium. This is an essential project because existing methods—borrowed from traditional disciplines such as art history or literary studies—either

give no consideration to the complexities of the cartooning art form (writing it off as hopelessly commercial or crude) or simply cannot enlighten the relationship between words and text in this sort of hybrid medium. Indeed, it would be a mistake to treat comic strips either as only a type of popular literature or only a form of lowbrow art. Traditional tools of art history are not adequate for addressing the narrative thrust of strips and their open-ended cinematic structure; and most purely literary analyses would not do justice to the synergistic relationship between images and words in comics.

In Trudeau's case, one could easily conclude that the images are less important than the text because, in contrast to other strips, *Doonesbury* is highly verbal, often filling each frame with a great deal of text. But this impression has much to do with the fact that comics have decreased radically in size over the decades; indeed, if one were to compare Trudeau's work to many earlier strips such as *Pogo* or *Li'l Abner,* the amount of dialogue is only about average. Moreover, in ways less obvious than other more visually dynamic strips, there is an important interplay between images and text in *Doonesbury* that deserves close attention. Trudeau concurs, admitting to some deficiencies as an artist but recognizing that there is a synergistic energy in the combination of his minimalist drawings and verbal wit: "I have always felt that I'm not much of a writer and I'm not much of an artist but I reside at the intersection of those two disciplines and that's where I make my contribution, such as it is" (qtd. in Grove D1). Throughout this chapter I will elaborate on ways that Trudeau achieves this "contribution" to the medium of visual/verbal comic strips through his use of a variety of comedic tools such as exaggeration, irony, caricature, wordplay, and understatement. But before getting to the strip itself, a bit more discussion is in order on the synthesis of image and word in comic strips.

The visual combined with the verbal in studying comic strips

At the core of many of the discussions over the need for new theoretical paradigms to understand cartoons is the debate over whether comics are a hybrid of the verbal and visual arts, or a unique, integrated form that

transcends both the verbal and visual elements (Varnum and Gibbons xiv). For the purposes of this study, it is enough to argue that comic strips such as *Doonesbury*, whether hybrid or unique, must be understood as a verbal/visual medium, rather than a lesser form of literature or a cousin to popular illustration. There is a complementary relationship between words and images in the best comic strips, and any attempt to study the medium by isolating one element from the other will fall short of appreciating its complexity and richness. For example, approaching the medium as a hybrid form allows one to consider how the shape or format of strips (the literal size and flow of the frames) influences the content and uses of the satire; the way in which words and images are used in counterpoint, contrasting or reinforcing a satiric point; the way that seemingly simplistic (even punishing) visual comedic tools such as caricature are made more complex when used in tandem with open-ended storylines and complex dialogue; and how comics can amplify verbal messages or reader identification through iconic simplification of the art.

R. C. Harvey, a comics historian, is one of the key figures in this effort to do justice to the complexity of comic strips by examining verbal and visual elements in tandem. In his book *The Art of the Funnies*, he first establishes the most obvious point about Trudeau's aesthetics: they are largely static and sedate in comparison to most of the visual craziness one encounters on the comics page. He then observes that although Trudeau's work is seemingly static in its use of visual elements, there are subtle interplays between the drawings and the text(s) worthy of study for their comic-satiric functions.

Harvey highlights two significant verbal/visual interplays. There are the small but significant departures from the strip's static construction:

> Without much physical activity, the tone of the strip is rigorously
> restrained. And in those strips in which the last panel incorporates
> some minor visual change, that change—however slight—gains greatly
> in dramatic import. Since the fourth-panel alteration is the only thing
> "happening" in the strip, it draws attention to itself way out of propor-
> tion to the intensity of the action itself . . . Under these circumstances,
> even a lifted eyebrow can tell us how we are to interpret the verbal

message: ironically, seriously, mockingly, whatever. (Harvey, *Art of the Funnies* 227–29)

I would add to Harvey's description that Trudeau may have learned this rhythm from one of his satiric idols, Jules Feiffer. Both use this visual panel construction—three frames (or more, in Feiffer's case) building an idea through static (or frenetic, again with Feiffer) repetition, and then a final panel alteration—to make a core satiric method: the deflation of pretension or delusion through irony, logic, or witty banter. Whether thinking to themselves or talking to a friend, the characters in *Doonesbury* or *Feiffer* are typically allowed to hang themselves over the course of the strip on their own flawed logic, convoluted rationalizations, or foolish self-promotion. They build a flimsy argument or venture into ignorant commentary for three or more frames and then, in the fourth frame, some of them (those who are somewhat self-aware, such as Michael) self-deflate, acknowledging with the shift in expression that they are being foolish; in other cases, the speaker is so oblivious or self-delusional (Zonker or Duke, for example), that the other character in the strip is given the chance to raise an eyebrow or make a sarcastic wisecrack in ironic commentary shared with the reader.

Harvey also nicely describes the workings of strips in which no changes occur through four static panels:

A reverse effect is achieved in those strips in which the fourth panel presents no variation, in which all four panels are visually identical . . . Nothing changes. Thus, there seems to be no relationship between words and pictures. And because we expect a relationship, its absence constitutes the message of the strip . . . it is as if the strip is presenting us with two worldviews. The visuals portray "our" world . . . the words, however, suggest another world—the absurd extremity that results if we extend the logic of our politics or social customs or merchandising practices. These worlds run parallel to each other, but neither seems to have any real effect upon the other. And that, in fact, is the existential message of the medium as practiced by Trudeau: the world we seem to create out of custom and mores has no bearing upon or relationship

to the real world of concrete details in which we all dwell. The ideal to which our customs aspire has become absurdly out of touch. (229–39)

This second device also seems to work as a verbal/visual articulation of the hiply ironic flavor of anti-establishment, postmodern comedy and satire. For example, in contrast to the pie-in-your-face gags of earlier comedians like Red Skelton, the late 1960s introduced the dryly ironic shtick of comedians such as Bob Newhart and the Smothers Brothers. Like these comedians, Trudeau's deadpan, unemotional visuals flatter the intelligent reader—acknowledging that he or she does not need a lot of bells and whistles to spot and enjoy an ironic or quietly absurd joke. Indeed, elaborately slick or dynamic visuals may have even come to represent, in the minds of late 1960s youth, a sort of corporate artificiality or overeagerness on the artist's part to distract viewers from the lack of depth or integrity in the comedy.

This deadpan delivery in *Doonesbury,* seen in commentary from characters that were visually static and expressionless, further reflected the social spirit of the early years of the strip in that politically engaged readers wanted direct, unadorned commentary that stood apart from the flashy qualities of mainstream entertainment. Earlier "political" strips such as *Li'l Abner* and *Pogo* used highly animated, appealing animals or stereotypical, hillbilly hijinks as a means, in part, of camouflaging commentary—of flying under the radar of sensitive cultural guardians; Trudeau, like his role model Feiffer, was expected by his core readers to be more direct, confrontational, and unapologetic. By stripping away visual flourishes, rarely indulging in slapstick humor, and grounding his main characters in a setting that resembled everyday reality, Trudeau infused his satire with a no-nonsense authenticity and directness.

I add a third variation to Harvey's discussion of the interplay of image, word, and changes in aesthetic tone in Trudeau's strip: the exaggerated shift in the fourth panel to a scene of extreme emotion or physical agitation. Granted, because the strip is so sedate in its tone and aesthetic flavor, it does not take much action to qualify as a significant shift in tone. At times even an italicized or bolded word with an exclamation point is sufficient to communicate that intense emotions are at play. In approxi-

Figure 4.1. Garry Trudeau, "Transfer of Power," *Doonesbury*, Sept. 14, 1986. *Doonesbury* ©
1986 G. B. Trudeau. Reprinted with permission of UNIVERSAL PRESS SYNDICATE. All rights
reserved.

Figure 4.2. Garry Trudeau, "Flawed!" *Doonesbury,* May 9, 1994. *Doonesbury* © 1994 G. B. Trudeau. Reprinted with permission of UNIVERSAL PRESS SYNDICATE. All rights reserved.

mately one in every twenty strips, however, there is an even more dramatic contrast between the sobriety of the preceding three panels. This scene of agitation is either a character essentially "freaking out" (most often Duke or Zonker), or a cinematic cut to a public scene of protest or debate. The agitated lines and sweat drops in the freaking-out frames are funny in part because Trudeau is so reserved in his use of slapstick imagery; the reader is made to laugh in part for the sheer surprise of seeing the strip's imagery break free from its static tethers. Humor is also evoked because of the outburst's social implications: it suggests a society in which people are either stoic or severely repressed, and only the most extreme frustration or chemically induced hysteria can break through the pervasive numbness. Figure 4.1 reproduces a Sunday strip that allots several frames to the freak-out session, illustrating this contrast nicely.

At times this contrast is achieved through the cinematic cut to the final frame, a visual shift to an entirely different scene with a contrasting tone (static sameness and calmness in the first three panels, agitated action in the fourth—or vice versa). This device is most often used as an ironic commentary on some sort of naiveté or inaccurate perception in the first three panels. The chaos in the fourth frame effectively undercuts the worldviews at work in the preceding scenes. In an example from 1994 (see fig. 4.2), Trudeau accomplishes this ironic effect while using the sedate quality of the preceding panels to reinforce an additional satiric point: that comic strips are forced to excise any offensive political content—to maintain, in other words, a calm, static demeanor.

Comic strip frames

When discussing the visual elements of the medium, it is also important to move beyond the conventional practice of only considering the contents within the frames—the drawings, in other words. Indeed, understanding the workings of the *frames* themselves is critical. Early in the medium's history, framing conventions were relatively fluid and untamed, allowing for the baroque art of Windsor McCay (*Little Nemo in Slumberland*) and the surrealistic flights of Herriman (*Krazy Kat*). At mid-century comic strips were still expansive in size, providing room for the rich wordplay of Kelly or the vaudevillian caricatures and slapstick of Capp. But by the 1960s, most comic strips were packed into small, standardized boxes. This allowed for the emergence, in some instances, of beautifully economical and deceptively simple art and satire (Schulz's *Peanuts*); but in other cases, it resulted in glorified gags more akin to single-frame cartoon art than to open-ended strips. As Trudeau has argued, the compact structure of comic strips today is perhaps the most serious impediment for satire thriving in this medium. Satirists oriented toward visual comedy and minimalist renderings can still thrive in this setting, but more verbally inclined satirists can do little more than deliver a visual gag with sparse dialogue, or be reduced to drawing talking heads if they want to engage in any complex development of characters or ideas.

On a more positive note, the open-endedness of the narrative—as aided by the physical structure of comic strips—has allowed satirists to engage in inventive work not achievable in other comic mediums like the magazine gag genre and political cartoons. Because comic strips use a continuing narrative, or at least use the same characters from day to day, the frames of the medium are limiting only in a physical sense: they corral the contents of an individual frame's words and images and the day's joke, but they are porous when it comes to the continuity of narrative and character development. Moreover, because these panels are figuratively open-ended, the satire they contain can be much more nuanced than what is found in comic mediums that use a single frame to contain caricatures, characters, and storylines in more restrictive ways. For example, *Krazy Kat*, as an open-ended strip, created a complex, meandering narrative about

existentialist longing and questioning, whereas most gag cartoons have one shot to communicate a visual gag, present essentialized comic types or caricatures, and make a closed, relatively unambiguous point.

There are, of course, exceptions to this rule: the stable of recurring weirdos and talking animals in *The Far Side* created a compelling sense of continuity, and Charles Addams's *Addams Family* series in the *New Yorker* worked more like an open-ended strip with its family of demented characters and comically gothic themes—and thus both avoided the limitations of the single-frame format. Many political cartoonists, too, have found ways to open up their medium to allow for greater complexity, dialogue, and continuity despite their limited framing. Tom Toles and Tom Tomorrow, for example, use a series of related images to develop nuanced treatments of topics, and Pat Oliphant has a recurring character (a penguin) who reflects ironically on the core messages of the cartoon and creates a sense of continuity from image to image.

Trudeau effectively uses the open-ended continuity of comic strips to move beyond the general limitations of one-frame political cartooning. Specifically, he is able to engage in character-driven storylines; create verbose and complex articulations of public figures' foibles; construct ironic layering as dialogue unfolds or overlaps; employ cinematic and dynamic comic effects as an idea develops through a course of panels; display self-reflexivity and self-deconstruction as the point of the cartoon is played out beyond a simplistic point or gag; and execute complex development of satiric themes or patterns. Finally, Trudeau has observed that the playing out of the comedy and dialogue in *Doonesbury* through these connected panels gives the strip a "fugue-like" quality; this suggests that the weaving and overlapping of dialogue in his character- and situation-driven comedy could only be achieved in an open-ended format that allowed for this type of dynamic, almost musical movement or development (Bates 62).

It should be noted that this continuity can also shape comic strip satire and comedy in conservative ways. Since the story in a strip never ends or reaches a resolution the way that it can in satiric films or novels, the identities, habits, even politics of the characters remain somewhat static. They are like sitcom characters that can never learn from their experiences; the same story, with minor variations, is told again and again. This cyclical continuity, nevertheless, does not necessarily make all comic strips

fundamentally conservative in a political sense. In many forms of episodic or continuity-driven mediums, popular characters remain perpetually naive or apolitical, never experiencing radical enlightenment or moving toward a "true consciousness" of their condition. There is good reason for this stasis: the longevity and power of the satire would be diminished if characters like Zonker, Krazy, Pogo, Li'l Abner, or Calvin did change radically: they would outgrow their comic universe and thus become alien and unappealing to us. But this does not mean that the satire or comedy itself cannot make a progressive point. While Chaplin's Little Tramp or Trudeau's Zonker persists from episode to episode as an unchanging, unintentionally wise fool—never abandoning delusions, obsessions, and a selfish engagement with the world—the reader can spot the lessons that need to be learned and thus can use the repetitive motifs as prompts to overcome their own delusions or political naiveté; in effect, we learn from their experiences because they cannot.

Unlike most of these other strips, Trudeau's universe does unfold in something that approximates real time, and there are occasionally significant changes in characters' lives (divorces, job changes, aging, etc.). However, like classic sitcom characters, Trudeau's characters do remain relatively predictable in their worldviews and dispositions. By introducing some time movement into an otherwise static comic world, perhaps Trudeau has the best of both worlds: he can create reliable jokes based on the relatively unchanging foibles of his comic characters, but the forward movement of time in the strip allows him to remain continually engaged and topical in his satire.

Turning back to the conventions of framing, it can be observed that up until Trudeau's sabbatical in 1984, the framing in *Doonesbury* had a comfortingly consistent but perhaps uninventive flavor. All of the strips were presented—in cinematic terms—at a mid-distance establishing shot. The reader, taking the position of the camera, was never allowed to venture closer than ten or fifteen feet from the characters and action. This framing convention gave the strip an unpretentious, workmanlike feel similar to the unshowy aesthetics of an early Woody Allen film or the tone of a sedate documentary. Emerging from his sabbatical, Trudeau felt "bored with the look of the strip. It was static." He continues that "this is when the cartoonist decided to wake up," and thus he began to experi-

Figure 4.3. Garry Trudeau, "White House Appraiser," *Doonesbury*, Jan. 7, 1974. *Doonesbury* © 1974 G. B. Trudeau. Reprinted with permission of UNIVERSAL PRESS SYNDICATE. All rights reserved.

Figure 4.4. Garry Trudeau, "Perfect Little Victory," *Doonesbury*, May 1, 1991. *Doonesbury* © 1991 G. B. Trudeau. Reprinted with permission of UNIVERSAL PRESS SYNDICATE. All rights reserved.

ment with inventive angles and varying degrees of distance in framing the action (Alter 66). Soon Trudeau's strips unfolded like a playful experiment conducted by Orson Welles in *Citizen Kane* mode: high and low angle shots, odd close-ups, cinematic zooms, etc.

While making the strip more dynamic and inventive, this new visual dynamism also becomes a bit distracting at times. Some of the angles take too much effort to decipher; the drawings are occasionally a bit off because of the odd angles; and too often the effects are used gratuitously (with none of the rigorous harnessing of the devices to thematic developments as you would have in a film such as *Citizen Kane*). The gradually more polished and varied qualities of the inking in recent decades has also delivered mixed results. The strip has become more interesting to look at because of the new line variations, bolder uses of blacks, and other visual flourishes; however, the strip has also lost some of the homey,

unpretentious quality that came with Trudeau's original, unvarying line work. For example, the characters felt less constructed in the earlier strips, less labored over; thus, the most important aspect of the strip—the satiric message—was not overshadowed (as it occasionally is in more recent work) by flashy aesthetics. To illustrate this general shift in style, we can compare the angles of perspective and line quality from two White House strips separated by twenty years (see figs. 4.3 and 4.4).

Lettering and typefaces

Another often overlooked element of a cartoonist's satire is the lettering or type used in the strip. This tool can be used in showy ways, often blurring the boundary between the characters and the text. Herriman's clawlike scratches, Kelly's elaborate gallery of character-driven typefaces, or Schulz's sparely blocked and gently curved letters are an integral and vivid part of each strip's satiric tone. In Trudeau's strip a uniform, uppercase regularity connotes the investigative, topical, rational quality of the satire. Moreover, unlike the rowdier, more carnivalesque strips of the medium's early years, there is a sobriety to the written text in *Doonesbury:* minimal flourishes, few sound effects, and no blurring of the line between the drawings and the text (see fig. 4.5). Indeed, only occasionally does Trudeau even resort to exclamation points or italicized lettering to emphasize a point or project a character's emotions. This conservative approach to constructing the strip's type may make the strip less visually interesting than earlier classics such as *Pogo*, but it is in line with the deadpan tone of *Doonesbury*. In sum, Trudeau's tone employs understatement and quiet irony; the use of agitated, or expressionistic type would simply drown out these subtler satiric devices.

Figure 4.5. Garry Trudeau, example of lettering style, *Doonesbury*, March 11, 1981. *Doonesbury* © 1981 G. B. Trudeau. Reprinted with permission of UNIVERSAL PRESS SYNDICATE. All rights reserved.

Trudeau as artist

As for Trudeau's drawing style, one must acknowledge that Trudeau does not have any of the flamboyant skills of the great visual cartoonists of the medium—the playfulness of Herriman, the dynamism of Kelly or Watterson, the effective use of value contrasts by Capp, etc. In fact, Trudeau has some serious deficiencies: a sketchy understanding of human anatomy (often giving his figures a lumpy, indistinct form); a carelessness when rendering details such as fingers (which often resemble tapered sausages); and a tendency to render objects as if they are not subject to the laws of gravity (giving them an artificial, flimsy sense of mass). Critics and fellow cartoonists have been quick to highlight these deficiencies in *Doonesbury*—in part, perhaps, because there is so little else to criticize in the work. Al Capp in his last years gave this exasperated tribute to Trudeau: "Anybody who can draw bad pictures of the White House four times in a row and succeed knows something I don't. His style defies all measurement" ("Doonesbury: Drawing and Quartering" 59). To his credit, Trudeau is quick to own up to these faults, as in this interview: "I've always thought my main contribution to the comics page was that I made it safe for bad drawing, that *Cathy* and *Bloom County* and particularly *Dilbert* would have been unthinkable had I not challenged the assumption that competent draftsmanship was prerequisite to a career in cartooning" (Astor, "Trudeau Is 'Amazed'" 31).

Perhaps more useful than comparing Trudeau to master draftsmen from the "golden age" of comics is to compare him to more contemporary peers who practice similar styles of minimalist drawing. His two most obvious peers in terms of style on the mainstream comics page were Schulz (*Peanuts*) and Johnny Hart (*B.C.*). While on one level these two artists were merely reacting in their simplified aesthetics to the limitations placed on the medium after radical size reductions in the 1950s and 1960s, they also achieved artistic and comedic complexity out of a seemingly reduced visual palette. Both of these artists used an economical style and deadpan visual tone to achieve, like Trudeau, an ironic, reflective genre of comedy. Hart infused his drawings with a spontaneity and dynamism that gave them some of the easy flair of earlier strips like *Pogo*. Schulz's characters retained an appealing solidity and physical fluidity within his

spare and shaky line work. The minimalist look of *Peanuts* did not result in a deficit of emotional or intellectual content; on the contrary, in the vein of McCloud's "amplification through simplification," Schulz's spare drawings gave entry into a rich and nuanced world of neuroses, anxieties, and hopes.

Jules Feiffer, an alternative cartoonist, was also one of Trudeau's predecessors in legitimizing a modern, minimalist look. Like Trudeau, he used a "sparsely sophisticated style" (spare backgrounds and simplified drawings) to amplify the verbal, satirical qualities of his work (Weingarten W14). Feiffer also may have helped highlight how reductive line work can give readers a more direct entry into the internal life or consciousness of cartoon characters. Feiffer's scratchy, unfinished drawings feel like free-form Rorschach sketches at times, inviting readers to skip over details and particularities to get to internal truths and essences. This is especially evident in Feiffer's strips that featured agitated characters giving interior monologues against blank backdrops. While Trudeau's backgrounds are slightly more cluttered than Feiffer's, some of this dynamic is at work in *Doonesbury:* it occasionally can be seen when Michael is struggling with an internal crisis or making ironic mental commentary on the news.

Perhaps the most significant difference between Trudeau and these other minimalist contemporaries is that, for good or ill, his line work is much more rigid and static. It lacks the quivering emotionalism of *Peanuts*, the playful movement of *B.C.*, and the fluid, calligraphic agitation of Feiffer's character-construction. The lack of movement in Trudeau's strip is surely one indicator of his limited drafting abilities, but as I will illustrate, it also feels appropriate for the tone of the strip. Beyond being a legitimate, card-carrying member of this movement of simplified cartoon aesthetics, Trudeau has a variety of underrated strengths as an artist. Some of these qualities are shared by other minimalist strips, but many are his own: a sedate and unsentimental sensibility that is a refreshing contrast to the overly cute drawing styles of some of his more traditional peers on the comics page; a flat, unvarying line quality (in the strip's early years, at least) that matched the deadpan, ironic tone of the strip perfectly; and a knack for coming up with stylized symbols for physical features that communicate just the right amount of personality and individuality about a

vivid character or social type. He has also found clever ways to occasionally translate his weaknesses as an artist into strengths as a satirist.

One way to defend Trudeau's rough drawing style is to characterize it as a punk, do-it-yourself aesthetic. Signaling that he was closer in his political intentions to the underground, countercultural comics of the 1960s than he was to the corporately produced fare in mainstream cartoons, he did not bother with cute cartooning devices, slickly finished images, or labored drawings. While mainstream readers, editors, and even historians of the art form might complain about the rough aesthetics of the strip, this self-taught awkwardness effectively communicated to the satiric work's youthful core audience that this artist was not a product of the mainstream system. In a 2004 interview Trudeau acknowledged that there could have been some of this thinking at work in the construction and reception of his early strip: "My style was so unprofessional—it was this kind of urgent scrawl that played into the marketing of the strip as something that was supposed to be dispatches from the front. It looked like it had been created in a frenzy, and that gave it a kind of authenticity" (Bates 62).

As we consider other ways to praise his drawing style—in particular, the sparely iconic construction of his strip's characters—some basic theory on the power embedded in seemingly simplistic cartoon images is helpful. Specifically, Scott McCloud's explanation of the concepts of "amplification through simplification," and reader identification with iconically simplified characters, are useful in explaining the deceptively basic uses of iconic visuals in minimalist works like *Krazy Kat*, *Peanuts*, and *Calvin and Hobbes*. In his book *Understanding Comics*, McCloud rebuts the argument that comics, because of the medium's iconic nature and distilled verbal and visual content, are necessarily simplistic. He concedes that the visual and verbal language of the medium is reductive but suggests that the seemingly simple elements of the genre can be used in infinitely complex arrangements, and that the ways in which we decode the information in comics is active and powerful. He does this by articulating a theory of amplification through simplification that suggests that comics focus details rather than eliminate them; and by "stripping down an image to its essential 'meaning,' an artist can amplify that meaning in a way that realistic art can't" (McCloud 30). The pared-down iconic imagery offers

the reader entry into the rich, imaginative world of the strip. Whereas realistic images exist outside of our internal world as an "objective" reality populated with "others," iconic comic strip imagery allows us to identify with the characters and more actively participate in the construction of meaning in the strip. The open-ended verbal and visual language of the medium is thus more participatory than other more detailed modes of representation since it requires active "closure" or dialectical engagement on the part of the reader.

It is easy enough to see how amplification through simplification and reader identification applies to the minimalist mask of an everyman character like Charlie Brown: we are given very few details in his visage, but this does not prevent us from projecting onto him a rich personality and internal life. Moreover, the lack of details allows us to enter the *Peanuts* cartoon world, projecting ourselves through his blank slate of a face. The same principle generally applies to Trudeau's characters: they are all minimalist distillations of adult faces with enough detail to set apart each one's identity, but simple enough to invite imaginative completion—and in some cases, identification—by the reader. But because *Doonesbury* enters into a greater variety of subject matter and engages in more pointed satire than strips like *Peanuts*, Trudeau uses a larger variety of abbreviated symbols to construct and vary his characters.

Trudeau's characters

The main characters in *Doonesbury*—those with whom we are generally meant to identify (Mike, Mark Slackmeyer, Zonker, B.D., Joanie, etc.) —have varied markers of identity (such as mustaches, slightly different noses, or glasses), but share one visual marker in common: a heavy-lidded eye, with a dark shadow beneath (see fig. 4.6). This signature symbol of the strip does not invite the universal identification of an innocent dot (as with Charlie Brown) but does communicate a range of attitudes with which many educated, adult readers can identify: a knowing irony, a world-weariness, skepticism, middle-aged fatigue. Moreover, because it is such a distinctive, recognizable symbol of the strip, it may also represent the distillation of the worldview of an entire generation of baby boomers

Figure 4.6. Garry Trudeau, example of the heavy-lidded eye, *Doonesbury.* *Doonesbury* © 1971 G. B. Trudeau. Reprinted with permission of UNIVERSAL PRESS SYNDICATE. All rights reserved.

Figure 4.7. Boopsie's perpetually naive expression, *Doonesbury,* 1994. *Doonesbury* © 1994 G. B. Trudeau. Reprinted with permission of UNIVERSAL PRESS SYNDICATE. All rights reserved.

who participated in the countercultural revolution. Like the strip's core readers, these characters are too mature (and perhaps too disillusioned) to entertain wide-eyed, utopian ideals; but they can observe the world critically, knowingly, casting a skeptical eye on demagogues, passing trends, and hypocrisy. This connotation with the heavy-lidded eyes is confirmed and expanded by the satiric points made in the strip, week after week.

Two other significant symbols for eyes that Trudeau employs are the dot framed by parentheses, and opaque glasses. The parenthetical dot appears occasionally on main characters as a marker of momentary surprise, shock, or anger; but on some of the secondary characters, like Boopsie (see fig. 4.7) or Jimmy Thudpucker, it is the default expression. In these cases, it connotes a perpetual ignorance or naiveté—a counterpoint to the knowing world-weariness of the heavy-lidded eyes. Readers are alerted by this shorthand symbol that the words and ideas coming out of these characters' mouths are likely to be childlike or delusional.

Opaque glasses are used for secondary characters such as Duke and his assistant, Honey (see fig. 4.8). This device is used to great comic effect in features such as *The Far Side*, primarily because it does not give the reader too much information. The blank-slate quality of the eyes allows readers to project their own interpretation of underlying emotions and motives onto the inscrutable faces of the characters. Indeed, the reader perhaps finds greater humor in the effort of imagining a variety of emotions lurking behind the masklike spectacles of odd people than when given too much information about a character's singular, exaggerated mugging in the overdrawn cartoon faces of other strips.

Trudeau capitalizes on that same invitation to comic construction in

Figure 4.8. Garry Trudeau, Duke's and Honey's opaque glasses, *Doonesbury. Doonesbury* © 1984 G. B. Trudeau. Reprinted with permission of UNIVERSAL PRESS SYNDICATE. All rights reserved.

his use of blank glasses in his strip; more specifically, in Duke's case he uses them to suggest how hypocrisy, opportunism, and evil can take on banal expressions in today's world. This man is no deranged madman, groping for power with a manic cackle and crazed eyes. Instead, Duke looks like a bespectacled, mid-level bureaucrat who calmly uses a twisted rationality to commit his crimes. Perhaps the use of such a bland face with expressionless eyes helps force readers to imagine their own potential evil: the void in the glass frames prompts one to project his or her own face onto such a blank slate. As a result, perhaps they do not have the comfort of seeing Duke as some kind of hyper-specified, deranged other, existing outside themselves.

In Honey's case the blank glasses serve a slightly different function. She is the low-level bureaucrat who is forced to subsume her will to that of a boss or institution. Her expressionless eyes suggest that she has no solid identity; she has gone straight from being a subservient, communist party drone to Duke's lackey. Moreover, the placid glasses and expressionless face comically and ironically suggest two things: first, that she suffers

from no angst or double consciousness, but is simply content to negotiate the moral subjectivities of a postmodern global world with either an oblivious opportunism, or a savvy, survival-focused flexibility; and second, that she is a knowing observer who uses her marginalized, wise-fool position to watch with critical detachment the absurdities of her boss's world.

In Trudeau's construction of other general features in his characters' faces, he may have benefited from having limited skills as a draftsman of detailed reality. Instead of trying to draw features that approximate real noses, mouths, and chins, he borrows stylized, shorthand symbols from the history of cartooning. For example, he perhaps takes the square, stick-like noses from Herriman's *Krazy Kat,* and the minimalist chins and mouths from Jules Feiffer's work. These unrealistic, stylized symbols have a playful, figurative quality, reminding the reader of the constructedness of the strip. They also give each character a vivid identity marker. For example, Zonker's nose becomes a symbol of unapologetic hedonism and ego (see fig. 4.9), while Slackmeyer's hooked, hawk-like nose connotes his sharp, counter-cultural political convictions (see fig. 4.10).

Trudeau and caricature

Another successful, even innovative device that emerged from Trudeau's weaknesses as an artist was his use of floating, symbolic icons to stand in for the biggest targets in his strip—the major political leaders of the United States. In the early years of the strip he occasionally attempted to do semirealistic caricatures of public figures, but there was a generic quality to these interpretations of core physical traits that diluted the power of

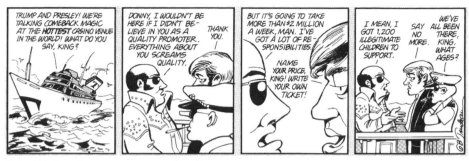

Figure 4.11. Garry Trudeau, "We've All Been There," *Doonesbury*, Sept. 2, 1988. *Doonesbury* © 1988 G. B. Trudeau. Reprinted with permission of UNIVERSAL PRESS SYNDICATE. All rights reserved.

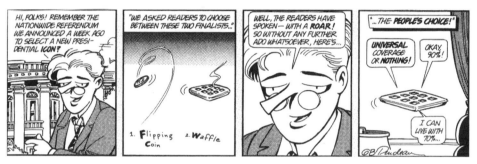

Figure 4.12. Garry Trudeau, "Waffle," *Doonesbury*, Aug. 22, 1994. *Doonesbury* © 1994 G. B. Trudeau. Reprinted with permission of UNIVERSAL PRESS SYNDICATE. All rights reserved.

the satire. They were neither vivid enough to stand in as easily recognizable caricatures (the features tended to be barely different from those of his other characters), nor were they cartoony enough to be funny on their own terms. Consider as an example, his awkward caricature of Donald Trump (see fig. 4.11). (Notice that Trudeau tries to deal with this problem by obscuring parts of Trump's face in two of the panels.)

Perhaps sensing this problem, Trudeau began to caricature these figures, starting with the first President Bush, in the most minimal fashion—by depicting each as an iconic, inanimate object that represented his or her core flaws as a public official. For Bush it was a cipher or point o' light (connoting a lack of moral backbone), for Quayle a feather (his lightweight qualities and daft intelligence), for Clinton a waffle (self-explanatory; see fig. 4.12), and the younger Bush a cowboy hat, and later, the helm of a Roman emperor (see fig. 4.13). There is a long tradition of better art-

Figure 4.13. Garry Trudeau, George Bush as Roman helmet, *Doonesbury,* 2004. *Doonesbury*
© 2004 G. B. Trudeau. Reprinted with permission of UNIVERSAL PRESS SYNDICATE. All
rights reserved.

ists using this device—Daumier rendering King Louis Phillipe as an obese
pear or Nast drawing Boss Tweed as a bag of money—but no artist has
taken the convention so far, creating a comic world in which all characters
but the principal target are depicted in more literal ways.

At first glance this practice may appear unfair or reductive as it seems
to reduce Trudeau's satiric commentary on the figure to a single criti-
cal point. One way to address the "fairness" of this practice is to look to
satire's privileged license to truthfully distort or exaggerate, further sup-
ported by Swift's rule that physical caricature can and should be based on
the target's core moral failing. The reasoning goes that if a politician is
both greedy and obese, then it is fair to use the physical shape of the man
as a metaphor for the abstract vice. And so reducing Quayle to the sym-
bol of a feather fairly communicates a distilled truth about his abilities
and inner character. As for the reductivity of this practice, this may be an
extreme case of McCloud's principle of "amplification through simplifica-
tion" at work. The figure's core failing is obviously amplified through the
power of this simple icon, but it also gives the strip a more potent aesthetic

punch. The eye reads the icon quickly, avoiding the labor of decoding an awkward caricature in the limited space of a small panel. And then, rather than the icon limiting Trudeau's satire to one idea, it can act as an easy entry into a host of related issues or failings. In addition, in the context of an elaborately verbal, ironic, and nuanced strip, it works as a nicely iconic and straightforward visual counterpoint to all of that wordy commentary. Finally, through repeated use, it is possible that it takes on the power of an archetypal symbol, attracting complex meanings and nuances as it lives on from strip to strip.

Recent aesthetic shifts

Because Trudeau was so roundly criticized for his limited drawing skills in the first decade of his career, he made a concerted effort to improve his draftsmanship after his sabbatical in 1984. Most observers found his newly ambitious approach to the aesthetics in the strip in the ensuing years a great improvement; for example, in a 2006 article a critic reported that Trudeau, after his hiatus, "seemed to learn the fundamentals of cartooning, and then some. The art in *Doonesbury* became far more professional, with inventive angles, cinematic shading, even intimations of an occasional foot" (Weingarten W14). It was as if, stung by early complaints about his drawing ability, Trudeau wanted to compensate for his lack of flair and skill in creating faces and figures by introducing a variety of visual flourishes related to angles, detail, and framing that enlivened the look of the strip. Occasionally these more ambitious methods work well. Some of his Sunday comics and full-page illustrations for book collections have an engaging complexity and sophisticated use of muted, tonal colors that are a welcome contrast to the garishness of most cartoon coloring. Trudeau's mimicking of cinematic techniques such as panning or slow zooming is also engaging and often enhances the satiric point he is trying to make.

However, many of Trudeau's efforts at amping up the look of the strip have been less successful. When he tries to use unusual angles or frontal views of characters that emphasize their three-dimensionality, these drawings often feel awkward and may even distract from the core point of the strip. Comic characters need to be based on basic laws of gravity, anatomy,

Figure 4.14. George Herriman, "I've got a date," *Krazy Kat.* KRAZY KAT © 1918 George Herriman. Reprinted with permission of KING FEATURES SYNDICATE.

OF COURSE, THEIR IN-
ACTIVE STATUS MEANS
THEY HAVE NO DEDI-
CATED DIALOGUE, SO
THE GREEN ROOM IS
A PRETTY QUIET PLACE.

Figure 4.15. Garry Trudeau, three-quarters view of Zonker's nose, *Doonesbury*. *Doonesbury* © 2004 G. B. Trudeau. Reprinted with permission of UNIVERSAL PRESS SYNDICATE. All rights reserved.

and the play of light and shadow as they work in the real world. At the same time, cartoons are two-dimensional constructions that operate according to a set of internal rules established over the decades—two-dimensional, shorthand symbols for emotions, movement, and form. The cartoonist must navigate between these two sets of laws, applying the rules of three-dimensional reality to provide substance and gravity to the characters, but then allowing the fanciful freedoms of cartoon logic and two-dimensionality to push in limited but playful ways against those constraints. At a certain point the cartoonist must let these two-dimensional constructions be just that. George Herriman's *Krazy Kat*, Walt Kelly's *Pogo*, and Bill Watterson's *Calvin and Hobbes* are the best examples of this dynamic at work. Herriman, in particular, was especially good at acknowledging those laws of temporal reality, but then capitalizing on the freedoms of minimalist, two-dimensional iconography—pushing the strip into the realm of comedic surrealism (see fig. 4.14).

Trudeau loses his grasp on the appropriate interplay of these two sets of rules when he occasionally tries to treat his characters—two-dimen-

sional, abbreviated icons of various human faces—as if they were real, three-dimensional people. Trudeau may be trying to prove his abilities as a draftsman or enliven the aesthetics of the strip when he does this, but it simply serves to distract the reader, highlighting the construction of the strip in an obtrusive way. A good example of this is when Trudeau tries to render Zonker's stylized nose from a three-quarter angle, giving it a square end (see fig. 4.15). In cases like this, Trudeau is forgetting that readers do not read comics as fully logical, accurate reflections of three-dimensional reality. They need the characters to look as if they are part of the natural world that we all know, that their anatomy is fundamentally sound, that they move in ways familiar to real experience, and that light creates shadows in the right place; but going beyond, with the addition of labored shading or hyperaccurate three-dimensionality only serves to dilute the iconic appeal and power of the images.

In sum, Trudeau's aesthetics—like his satire and business practices—work best when he insists on being the iconoclast. Rather than trying to please critics through gratuitous cinematic effects or flashy inking, he should revert to the homey, sedate drawing style that gives the strip its signature look. It is this seeming blandness, in the end, that works synergistically with the verbal satire in the strip in some of the following ways: by acting as a deceptively minimalist entry into the rich, ongoing narrative of the strip; by allowing the iconic construction of the main characters to amplify interior lives and emotions—and to invite active reader identification; by reflecting accurately the journalistic seriousness of Trudeau's satire; and by allowing his minimalism to contrast effectively against other cartoon entertainment on both television and the comics page that are visually manic and ultimately empty in their emphasis on flashy exteriors over satiric substance.

In closing, we can highlight how Trudeau's signature aesthetics remain satirically effective in our cultural climate by comparing them to emerging aesthetic trends in other cartoon-based satire such as *Life in Hell, The Simpsons, South Park,* Max Cannon's *Red Meat,* and Tom Tomorrow's *This Modern Life.* Trudeau helped create a minimalist, deadpan drawing style that gave rise, in part, to a barebones genre of cartooning and animation that can be seen in the comedic works listed above. As suggested earlier, this brand of cartooning did not originate solely from Trudeau's strip, of

course; it was developed and explored by Schulz, Hart and Feiffer, and even some low-budget Hanna-Barbera animated cartoons before Trudeau entered the field. A more current strip that also played a part in establishing contemporary minimalist trends was Scott Adams's *Dilbert*. Although the strip has lost much of its initial subversive qualities, its amateurish, stilted drawing style embodied a sort of punk, do-it-yourself ethic that can be seen in Trudeau's strip as well. Both strips seemed to eschew the slick look of professional cartooning that connoted collaboration with the mechanisms of Hollywood or the media industry. Gary Larson's *The Far Side*, though less overtly satiric than these other two strips, also stood apart from the mainstream comics page because of the quirky, self-taught look of Larson's drawings.

All of the strips discussed above, for good and ill, can be credited with establishing an aesthetic that is now prevalent in alternative weeklies, satiric animated sitcoms, and many comic strips. For example, Matt Groening's satiric alternative-weekly cartoon, *Life in Hell*, exhibits some of the intentionally amateurish qualities of *Dilbert* and the wordy, static look of *Doonesbury*. Moreover, *The Simpsons*, an outgrowth of *Life in Hell*, capitalizes on the powers of amplification through simplification that are associated with Schulz's *Peanuts*. *The Simpsons*, however, is far from the static, deadpan look of *Doonesbury* because it is a frenetically constructed and brightly colored animated television show. This dynamism, while making the program more broadly entertaining and accessible than Trudeau's work, may also undermine the strength or integrity of the show's satire. Viewers may be so wowed and distracted by all the movement and visual stimulation that the satirically substantive writing is drowned by the colorful spectacle. Moreover, many of the programs that have followed in *The Simpsons'* minimalist wake, such as *South Park* and *Family Guy*, have harnessed these aesthetics to largely juvenile comedy that is more about shock value and scattershot parody than coherent political or social satire.

Returning to alternative weeklies, another branch of the do-it-yourself aesthetic of recent years are the strips that appropriate imagery from other sources, creating satiric, postmodern collages. Meant to reveal their own constructedness, strips such as Tom Tomorrow's *This Modern World* and Max Cannon's *Red Meat* rely on détournement—redirection of an

image or idea produced by the dominant culture with new, subversive codings attached to it. These strips engage in détournement by borrowing earnest advertising and illustration images from the past to comment ironically on contemporary events and figures. The rough construction of the images alerts readers to the ironic intentions and also helps set them apart from the polished aesthetics of mainstream animation and comic stripping. Of the two strips, *Red Meat* suffers in comparison because it seems to advertise its constructedness merely to engage in humor that that has hip shock value; it might also qualify as the negative type of postmodern pastiche criticized by Frederic Jameson—the collaging of images from other time periods for mere surface attitude rather than a critical, satiric purpose. It also has some slick production values that diminish its credibility (at least in terms of appearance) as a sort of punk cartooning.

Tomorrow's work, on the other hand, shares some significant strengths with Trudeau's *Doonesbury*. For example, both satirists deemphasize traditional cartooning tropes in order to highlight or amplify satiric messages; both are unapologetic about amateurish drawing methods that give credibility to the pose of cultural critic first, cartoonist second; and each has a consistent, coherent political philosophy at the core of his work. If one were to weigh the two for cultural clout or effectiveness, however, Trudeau would have to come out on top because of his prominence on the mainstream comics page. The lack of postmodern embellishments and borrowings, too, may make Trudeau's work more accessible to older audiences untutored in the aesthetics of ironic, postmodern visual satire. Thus, while Trudeau may not be at the cutting edge of deconstructive cartooning methods, his minimalist aesthetic remains true to the expectations and interests of politically engaged readers. *Doonesbury* may also avoid the pitfalls of pastiche, frenetic overproduction, and misdirected subversion that plague some of the offspring of the less-is-more, do-it-yourself movement of recent decades. If Trudeau were willing to become even more aesthetically conservative, returning to the less showy style of his early years, one might even be able to praise his homely but wholly effective artistic methods without qualification.

Chapter 5

Zonker and the Zeitgeist

Doonesbury as a Cultural Chronicle

Trudeau is one of the only topical, political satirists to thrive on the comics page in the last several decades, and he will probably be remembered principally for his pointed treatment of big political scandals and the foibles of presidents. Equally impressive, however, is Trudeau's realistic and sympathetic documentation of the everyday lives of characters who represent a variety of social types. In fact, if one steps back to look at *Doonesbury*'s long, impressive run, it is this chronicling of lives, everyday realities, cultural trends, and the zeitgeist of each era that perhaps stands out as the most impressive achievement of the strip.

While many of the secondary characters who populate *Doonesbury* are meant to be reductive types and exaggerated comic props, the principal figures are much more. Like many stock characters in sitcoms or plays, they may have begun as comedic archetypes—the jock (B.D.), the everyman nerd (Michael), or the blonde bimbo (Boopsie)—but over time they developed into characters with backstories, complicated inner lives, and everyday dilemmas as complex as those of the best-developed figures in novels. Much of this rich character development is a simple outgrowth of the sheer accumulation of strips charting their lives over thirty years. As with any ongoing, empathetic narrative, the creator—and his readers, by extension—could not help but develop an interest and affection for even the most foolish of his characters through the years. Indeed, even the secondary characters that began life as two-dimensional props become multidimensional in a strip with *Doonesbury*'s contextual richness and long-running continuity.

The novelistic depth of the strip also has much to do with Trudeau's early choice to dispense with the traditional comic strip practice of employing static types that remain in a comic time warp—forever the same age, doing the same foolish things. Instead, Trudeau allowed his characters to change and mature over time. It should be noted that he was not the first to employ this device; Frank King in 1918 created *Gasoline Alley*, a gentle, middle-American family drama that effectively chronicled social history—albeit of an idealized, comic strip variety—for over eighty years. More recently Lynn Johnston, the creator of *For Better or Worse*, has used this practice to chart the comedies and traumas of a middle-class family's life; to her credit, she has pushed this realism to its logical conclusions, introducing unpleasant aspects of the passage of time (such as the passing of a favorite family dog) into the narrative.

Trudeau's use of real-time narrative progression seems to have served two purposes: first, to give his characters room to change as they engaged with politics, aging, family crises, and engagement in war. Whereas the characters in most sitcoms never gain enough insight from their experiences to change (they always start the next episode locked in the same habitual patterns of behavior or thinking), Trudeau's cast actually experience nervous breakdowns, midlife crises, depression, divorce, and ideological shifts. This allows for his comic strip to create a level of realism unusual in any medium with the exception of long-running television dramas or novels in a series such as the Harry Potter saga.

Trudeau also used real-time progression to more accurately record shifting cultural trends and values. This makes the strip an excellent chronicle of the last four decades of cultural history. In Trudeau's words, he is a sort of cultural "anthropologist," tracking trends and whatever is "causing a great deal of excitement" at a particular moment; and thus the strip acts as "a kind of Rorschach test for its readers. To the extent to which it is a diary for a certain generation, it becomes a way of mirroring both change in the culture and change in the individual who is reading the strip" (Grove D1). Beyond acting as a mere diary-like chronicling of cultural trends and the progression of individual lives, *Doonesbury* offers a satiric treatment of both individual and collective foibles.

In sum, the strip as a whole is like a massive, sprawling, comic-satiric, verbal/visual novel that chronicles and critically comments upon the

cultural experience of Americans for close to four decades. It is hard to imagine a more impressive literary/satiric achievement unless one links together the collective works of a writer such as Charles Dickens or Mark Twain. As Trudeau puts it, *Doonesbury* is like an open-ended, decades-long "journal" of our times, "put together on the fly, as running dispatches." It is our culture, and many of our lives, in much of their complexity, "fleetingly observed" by a great comic-satirist (Grant 8).

This final chapter will explore the significance of the strip as social satire and as a chronicle of cultural experience in the latter part of the twentieth century. I will begin broadly, discussing the development of Trudeau as a social chronicler and the merits and deficiencies of his strip in this area. Then I will narrow the focus, analyzing each of the major characters, considering their meanings as complex social types and highlighting significant episodes from their fictional lives—in particular, episodes that took on a resonance with readers as a collective rite of passage, or as an embodiment of a particular moment in our cultural history.

Bull Tales to Walden Pond Commune

Because Trudeau began his career as a college cartoonist, he was trained to take on the task of speaking for a collective group and for deciphering, and then transmitting, the interests and values of his community. To explain, college cartoonists are traditionally expected to do humor that is local—that people will be able to recognize as their particular experience at that institution. But these readers also want humor that is about the universal experience of going to college—comedy that affirms the significance of this period in their lives. As a result, typical college comic strips are a combination of broadly recognizable social types (the jock, the nerd, the beauty queen, the feminist, etc.), and specific references to the events and trends of that particular campus (the inside jokes that make everyone feel a part of a shared experience). Trudeau's college strip, *Bull Tales*, fit this description nicely: B.D., Zonker, and Michael filled the requisite stereotypical roles, and Trudeau's humor captured both the generalities of the cultural period (the campus protests, the drug culture, the feminist movement, etc.) and the specifics of Yale during those years.

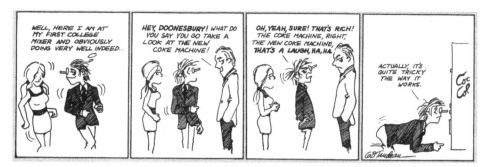

Figure 5.1. Garry Trudeau, "My First College Mixer," *Bull Tales*, 1969. *Bull Tales* © 1969 G. B. Trudeau. Used by permission. All rights reserved.

Bull Tales' weaknesses were what one might expect of a college comic strip: rough drawings, a too-heavy emphasis on the stereotypical in the construction of characters and dialogue, and the occasional reliance on shock value in Trudeau's choice of themes and gags. Nevertheless, taken as a whole the strip was much more sophisticated than most college cartoons. In particular, its verbal complexity, effective use of layered irony, and astute topicality set it apart from other college humor. Interestingly, the mature *Doonesbury* can be charged with both the same weaknesses and strengths; however, when used judiciously those same demerits can often enliven the strip, and its satiric-verbal sophistication has long overshadowed problems related to aesthetics or the occasional comedic missteps.

When Trudeau achieved national syndication with *Doonesbury*, he was able to successfully transfer to this new strip basic strategies he had learned from his college strip: combining comedic types, universal observations, and themes with specific cultural details and nuanced social commentary. In good comic tradition, the syndicated strip contained the same identifiable social types—slightly adjusted for life beyond Yale—and hit upon issues that resonated with a broad audience because they were common to most people's experience in their young-adult years. But there was also a refreshing specificity to the strip that was perhaps an outgrowth of its college origins. Rather than appearing to be a committee-created strip about generic, average middle-class Americans (the flavor of many domestic strips in recent decades), it was about a particular group of classmates moving beyond college and trying to make their way in the adult world in a specific place in the northeastern United States (the Walden

Pond Commune). The regional flavor of the strip, and the limited age and class identity of the characters, may have prevented the strip from quickly achieving a breadth of popularity that comes with more generic comedy, but it also contributed to its longevity. The details emerging from the strip's specific setting and quirky characters grounded the comedy, giving it a resonant authenticity unusual in comic strips. A cursory overview of some of the other great, quirkily specific comedy creations in recent decades, such as *Pogo*, *Seinfeld*, and *Napoleon Dynamite*, affirms the value of this particular convention.

Situating the strip at the fictional Walden Pond Commune was an inspired choice that performed several critical narrative functions. First, it provided a non-college setting that still evoked the sense of belonging and camaraderie that comes from participating in the undergraduate experience with a large group of peers. Although only a limited number of people, obviously, can belong to a collective social experiment like this, a reader could vicariously gain entry and membership in this chummy club as they read the strip. Secondly, on a narrative level the setting provided a convenient mechanism for bringing together characters of disparate backgrounds so that they could interact. Indeed, the comic possibilities of joining together a group of adults with such varying levels of maturity, divergent political opinions, and contrasting life goals was limitless. Finally, the connotations of *commune* fit the cultural moment nicely, advertising Trudeau's affiliation with a demographic emerging from college and holding on—in one degree or another—to the idealistic values of the countercultural movement.

Trudeau as poplorist

On a theoretical level, Trudeau also took on the role of a national poplorist in the way he configured his strip to resonate so richly with a particular audience—baby boomers emerging from college. Gene Bluestein, a folklore scholar, coined the term and concept of poplore, in part, as a way of legitimizing the art of pop culture creators who were unusually well connected to the audiences and the spirit of their times. In other words, much like the auteur concept, poplorists formed a new category of artists

that exists between the divide of supposedly pure and authentic high or folk cultures on the one side, and crass, factory-produced mass culture on the other. Criteria for classifying a creator as a poplorist include the following: their work should achieve a breadth of popularity through grassroots means; it can revive "stylistic elements and values from the matrix of traditional culture"; it should be created through a collaborative "call and response" between creator and engaged readers; and as a result, it should address the ideological interests and psychological needs of a core audience and articulate a brand of democratic, progressive politics often associated with folk forms (Bluestein 6, 8–9). Moreover, although contemporary poplorists, like Trudeau, are often highly independent creators or auteurs (perhaps even a precondition for creating this type of work), the work itself is often highly dialogical, containing voices that linger from the traditional forms that inspired the work, or that are included when the readers/collaborators lend a hand in the creative call and response (Bluestein 10). This profile works best with a singer-songwriter such as Bob Dylan, who self-consciously channels folk energies and traditions.

In the realm of comic strips the poplore concept nicely fits the career of someone like Walt Kelly, who mined African American folk culture in progressive ways. While *Doonesbury* does not pay tribute in theme or tone to traditional folk tales, it fulfills much of the other criteria. For example, the strip achieved popularity through grassroots means, starting out as a resonant college strip and then gradually building a large, niche audience through national syndication. The quirkiness of Trudeau's aesthetics, the fierce iconoclasm of his satiric modes, and his rule-breaking with the industry reinforce the reader's perception that this work did not achieve its success through some sort of committee-designed, lowest-common-denominator marketing campaign.

Trudeau also has long been highly conscious of the interests and needs of his core audience: he creates comedy that rewards devoted, careful readers familiar with his characters, Trudeau's worldview, and the history of the strip. As a result, there is an insider clubbiness to the strip that pleases longtime fans but that can alienate those casual readers looking for an easy, throwaway gag. Moreover, Trudeau has actively invited feedback and dialogue about *Doonesbury* and its contents. This has taken the form of incorporating criticisms in his book collections, writing editorials that

address controversial runs, and creating half-jokey installments in which Zonker and Michael read mail that has been sent to Trudeau. In recent years Trudeau has also harnessed Internet technology to engage in even more explicit forms of call and response. Doonesbury.com contains generous archives, historical information, and forums that allow readers to engage more actively with him and the strip. While it would be difficult to quantify how this back-and-forth with readers has affected Trudeau's satire, it is clear that he is the modern (or postmodern) equivalent of a politically and socially engaged folk storyteller: connected to his listeners; interested in meeting their social and psychological needs and interests with his tales and comedy; and engaged in collective construction of a progressive political philosophy.

Finally, this political engagement in Trudeau's strip also marks it as poplore. While much of the mass-produced entertainment of late-twentieth-century culture is marked with a benign but blatantly bourgeois ideology—a complacent celebration of a contented, middle-class, generic-American worldview—poplore is typically counterdiscursive in its tone and content. Think once more of Walt Kelly or Dylan as models of this folkie, vaguely leftist political orientation. Although Trudeau was born and raised in relative comfort and wealth, he has fashioned himself as a sort of Woody Guthrie of comic strips—insisting that a popular medium is a legitimate carrier of political commentary, adopting a populist persona, and using his art to engage in what he perceives as David and Goliath cultural battles. In Trudeau's case, his combative strips, rather than politicized folk songs, are the stones that he slings at public and political figures who are propped up by enormous public relations departments.

Trudeau as chronicler of the baby boom generation

Returning to a more general discussion of the strip as a chronicle of American culture, one problem emerging from Trudeau's intimate affiliation with a very particular niche audience—baby boomers emerging from the countercultural movement—is that he ran the risk of limiting his ability to speak for subsequent generations of readers or to reflect with any authenticity or resonance on a changing cultural zeitgeist. By following

one generation's experiences so closely, Trudeau also risked reinforcing a general baby boomer clubbiness and narcissism—the notion that they were center of the universe, the first generation to experience the joys and traumas of different life rites and passages. He was aware of this danger, as the following comment from an interview in *Newsweek* suggests: "The creators of *Thirtysomething* and a lot of baby boomers think that nobody ever parented a child before they did, that they're the first ones to really tap into this miracle. That whole phenomenon is so repellent to me" (Alter 65). Despite this distaste, it seems that Trudeau could not help but reinforce as much as satirize those attitudes in strips about Michael having his daughter, Alex. Even Trudeau himself at times fell into this trap, albeit in an admirably self-reflexive way; when interviewed while trick-or-treating with his small children in 1986, he both embodied *and* criticized this baby boomer tendency:

> It's just amazing [his excitement at seeing his children enjoy the evening's activities]—it's like nobody discovered parenthood before. Do you have children? . . . You see, it'll be a personal choice for you. It's something you and your wife will decide together and, God willing, if you decide to have it, everything will go well and you'll have this baby. And it will be the most important thing in your life. And you will discover things about yourself that are truly astonishing to you, especially if you have lived a fairly self-involved life up until that point. And it will seem truly remarkable. The fact is, it isn't. It's only remarkable to you, just as it's only remarkable to me. And people seem to have lost that perspective. There's just this sense among 'boomers' that they've discovered parenthood. We're such a self-conscious generation . . . I don't think we'll ever get tired of talking about ourselves. (Grove D1)

While Trudeau may have participated in inflating baby boomers' self-regard by chronicling their lives in such detail in *Doonesbury*, the actual satiric points of those strips were consistently critical. For example, in a strip from 1985 (see fig. 5.2) Trudeau effectively mocks some of the inconsistencies behind this complacent navel-gazing.

The broader, but related theme of the 1960s generation growing up and selling out is an ongoing target in *Doonesbury*. Trudeau charts a grad-

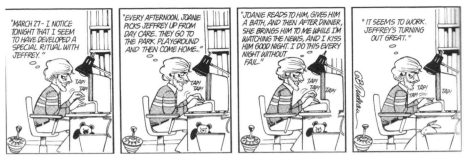

ual loss of countercultural energy in his characters—and occasionally
laments this slide into complacency, as when Mark Slackmeyer exclaims
after a cynical conversation with friends, "God, what's happened to us?"
("Doonesbury: Drawing and Quartering" 65). Michael's entire life, in par-
ticular, could be a drawn-out, sympathetic satire of high ideals gradually
getting flattened (and only occasionally being reconstructed) by the sheer
weight of adult life in a capitalist society. So there is an ambivalent or vari-
able quality to Trudeau's chronicling of baby boomer experience. Linda
Grant, a writer for the *Guardian,* describes the way this complex chroni-
cling can be interpreted from a baby boomer's perspective: "Perhaps it
flatters us. It reminds us of who we once were, of our values. I prefer to
think that it keeps us honest, because those values do not seem to have
abandoned Trudeau himself" (8). Grant may be right that Trudeau is ulti-
mately engaging in a sustained call to repentance to his generation, but he
is not so self-righteous to imply (as she does for him) that he is somehow
ideologically or morally superior. In his treatment of Michael (the clos-
est representation of himself in the strip) and in his few interviews, he
displays a consistent ability to judge himself honestly and to self-depre-
cate. At times he unconsciously strays into realms of self-satisfaction, as
suggested in the quote about his own children, but this ability to include
himself as a target in his generational satire is one of the saving merits to
his treatment of the baby boomer experience.

In Trudeau's defense, it is also significant that he sensed that his char-
acters, after ten years at Walden, were trapped in some sort of inbred, gen-
erational rut. To remedy the problem Trudeau took his twenty-month sab-

Figure 5.3. Garry Trudeau, "Owning an S.U.V.," *Doonesbury,* Jan. 10, 2003. *Doonesbury* ©
2003 G. B. Trudeau. Reprinted with permission of UNIVERSAL PRESS SYNDICATE. All rights
reserved.

batical in 1984, to "rescue his characters from their twelve-year captivity as
undergraduates and 'move them out into the larger world of adult grown-
up concerns'" ("Trudeau, by a Jury" 137). Away from Walden Commune
the characters could represent a wider variety of cultural experiences, but
there was still the sense that they represented only one generational per-
spective. To move beyond that baby boomer myopia Trudeau began intro-
ducing a new generation of characters in the 1980s, in some cases the chil-
dren of the main characters: Alex (the daughter of J.J. and Michael), Kim
Rosenthal (Mike's eventual second wife, after he divorced J.J.), and Zipper
Harris (Zonker's much younger half-brother). This allowed Trudeau to
give voice to the attitudes and concerns of Generation X readers, and
more recently, Generation Y readers.

Some of this effort to keep up with the changing times has been very
successful. For example, through these characters Trudeau has admirably
kept pace with emerging trends in academia, technology, and the business
world. At times, however, it has seemed as if Trudeau tries too hard to
make these characters ultrahip, or is too ambitious in constructing them
as elaborate social types. For example, Trudeau describes Kim Rosenthal
as a Vietnamese-Jewish-Southern-Californian and Gen X hacker, and
in storylines there is an unfunny hipness and goodness to her character
(see fig. 5.3) (Trudeau, "Character Biographies"). She comes across as a
flat, artificially constructed social type in contrast to the more nuanced,
three-dimensional qualities of Mike, her baby boomer senior. This prob-
lem suggests that Trudeau is perhaps making two missteps with younger
audiences: trying too hard to capture the zeitgeist—forcing a character to
scream her generational affiliation rather than letting it emerge organi-

cally from dialogue and complex character development; and being too eager to flatter younger audiences by representing them with unrealistically hip and wise figures.

Despite these latter-day stumbles, one has to acknowledge that, in the history of comic strips, no one has done a better job than Trudeau of creating characters that are complex, funny, and effective representatives of a variety of worldviews and cultural formations. Moreover, like the best comic figures in literature, his Generation Y characters are complex enough to alternately invite identification, sympathy, and satiric mockery from readers. While one might be tempted to add to this accolade that it is all the more impressive that Trudeau has accomplished this through the seemingly limited tools of cartooning, it may be, in fact, the medium itself that has allowed him to create such rich characters. Echoing McCloud's theories of iconic identification and amplification through simplification, an article in *Slate* about Pixar's animated films suggests that cartoon characters may even surpass contemporary novelistic figures in their ability to engage an audience in complex ways.

> When we disparage a poorly developed character in a novel by calling him a "cartoon," we're saying that he's too general and abstract to be believable as a person. But the generality of a complicatedly scripted animated figure has the reverse effect. As the character deepens from type into a concrete figure, symbolic and specific meanings fuse. Novelists have become increasingly self-conscious about psychological categories. Cartoons, however, offer an evocative externality. The viewer supplies the interiority himself—out of his own. (Siegel 2)

While this passage best helps explain the richness of a Pixar film such as *Toy Story* or *The Incredibles*, it can also be easily applied to a strip like *Doonesbury* because, like animated films, continuity strips are complex and open-ended in scripting and minimalist in their construction of the facial features of characters. Like the vivid characters in these films, a comic strip character eventually transcends simple types, becoming an accessible, iconic entry into a rich interior life and history.

Trudeau's construction of his characters as sympathetic participants in a satiric dramedy also adds a complexity missing from many strips or films that are purely Juvenalian in their satire. In straight satires or

farcical burlesques, characters tend to serve merely as two-dimensional props for the satirist, standing in for a laughable social position or value. One can identify with the satirist, but there is little impulse to emotionally or intellectually identify with the characters. In the hands of a great satirist, creating a stand-alone work of satire, this is not necessarily a serious deficiency. But in a continuity strip where the characters are always the two-dimensional butts of jokes, when they only invite condescending mockery—as seems to be the case in a farcical work like Al Capp's *Li'l Abner*—the potential for the work to prod readers to be self-critical is severely limited. In Trudeau's case, there is a dramatic-satiric complexity to his characters that make them multivalent—simultaneously the object of ridicule *and* empathy. Moreover, Trudeau's satiric voice or persona is consistently self-critical or self-reflexive. These dynamic qualities allow Trudeau to "preach to the choir" in one strip, congratulating readers for sharing a character's enlightened worldview, and then turn the sights of the attack back on readers in another strip, using the same character as the carrier of the satiric point. To illustrate these dynamics at work, and to highlight the ways the lives of the characters act as social chronicles, I will profile the major characters, analyzing significant episodes from their lives for their satiric and social significance.

The major characters in *Doonesbury*

Michael Doonesbury, observed from a distance, may seem to be the least vivid character in the cast—and thus perhaps the least obvious reflector of social practices or cultural attitudes. Closer inspection, however, reveals that Michael is merely more subtly nuanced than the other characters and is actually a complex representation of the shifting baby boomer psyche and experience. Moreover, as the character with whom Trudeau most closely identifies (he has admitted that, "Yes, dammit. I'm the model for Michael") he is the best entry into understanding Trudeau's personality and worldview (Trudeau, *Flashbacks* 9).

As a college student, Michael was a bit of a delusional nerd, believing (incorrectly) that he was "God's gift to women," but behaving in goofy ways that limited his romantic possibilities. As the founder of Walden

Commune, he set himself up as a sort of steady straight man for the more exaggerated social types in the cast. Acting as a representative of Trudeau in the strip, he also played the role of ironic observer in many episodes, commenting wryly on the foibles of others or just looking on with heavy-lidded worldweariness. This steadiness and detachment has not meant that he is idealized or immune to the foibles that throw the other characters into myriad crises; indeed, Michael's life has been tumultuous in the everyday sense common to most people's experience: a difficult marriage, the challenges of child-rearing, divorce, great success and dramatic failure in his career.

One critical difference between Michael and the other characters is his passive, everyman quality. While having a few personality quirks, he does not have an outrageously goofy worldview (as with Zonker), exceptionally delusional view of himself (B.D.), or dangerous psychoses (Duke); instead, the universe seems to conspire against him much as it did against Charlie Brown. Bad things happen to him because there are bad people and bad things in the world—and sometimes because he is continually *reacting* rather than acting in his life and career crises. If Michael has any culpability in his misfortunes, it is simply that he is cowardly at times when he should have more backbone or integrity. In most cases he means well, but there is weakness to his resolve or a fluidity to his standards as he simply tries to ride the forces of the culture, relationships, or his job. The most vivid example of this weakness is Michael's ambivalence toward his work as an advertising executive—in particular, his creation of Mr. Butts, a cartoon spokesperson for the tobacco industry (see fig. 5.4).

Michael's creation of Mr. Butts becomes the perfect metaphor for the dilemma faced by many aging baby boomers (and Gen Xers and Gen Yers, for that matter): how to remain true to one's youthful, countercultural idealism while getting on with the demands of life and a career. Probably working from firsthand experience in the challenge of remaining an auteur, Trudeau gently satirizes the life choices his generation makes, condemning the blatant sellouts and sympathizing with those who make a few, small-scale compromises. Michael, of course, belongs to both camps at different times in his life; readers are inclined to give him the benefit of the doubt—to forgive his missteps and root for a bumbling but well-meaning protagonist in each life predicament that comes his way.

Figure 5.4. Garry Trudeau, "Nobody Sez 'No' to Mr. Butts!" *Doonesbury,* April 22, 1989. *Doonesbury* © 1989 G. B. Trudeau. Reprinted with permission of UNIVERSAL PRESS SYNDICATE. All rights reserved.

J.J., Michael's first wife—and the daughter of Joanie Caucus—also stands in for some common baby boomer foibles. She might represent what David Brooks dubbed the "Bobo," or bourgeois-bohemian, because she so enthusiastically pursues countercultural trends that have lost their political bearing or degenerated into inward-looking philosophies: wacky new age culture; goofy, self-indulgent avant-garde art (see fig. 5.5); and self-help trends that exploit or delude their adherents. In an interview, Trudeau explained his reasons for lampooning the world of avant-garde art through J.J.:

> What's happening in the fine arts right now is something anathema to me. When it comes to art, I am at heart a cultural conservative. I believe in anachronistic concepts like discipline and craft and drafts-manship. There is a kind of careerism at work, a repudiation of any sense of synthesizing and creating a body of work over a period of time. There's more of an emphasis on making it immediately than letting the work evolve. So in a way, it was the perfect marriage of per-sonality with milieu when J.J. moved to New York and became a part of that scene. She was someone in a hurry, as so many young people are. (qtd. in Grove D15)

J.J. also represents a type of bohemian, laissez-faire parent that can give a child (Alex) interesting strengths and weaknesses: a great sense of confidence and independence on the one hand, a flimsy moral worldview on the other. While her free-spirited approach to life served as a nice foil

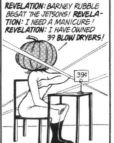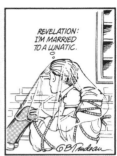

Figure 5.5. Garry Trudeau, "I'm Married to a Lunatic," *Doonesbury*, Sept. 11, 1986. *Doonesbury* © 1986 G. B. Trudeau. Reprinted with permission of UNIVERSAL PRESS SYNDICATE. All rights reserved.

to Michael's cringing passivity through much of their marriage, she has fallen to second-character status after their divorce. The fact that she left Michael after having an affair with a two-dimensional cowboy-bohemian, Zeke Brenner, cemented her status as a hopelessly wayward Bobo.

Readers may not be prompted to identify with Zonker in the same way they are with Michael, but he is equally sympathetic and tends to act as a goofy comic fool to Michael's straight man. Trudeau has suggested, in fact, that Zonker—his favorite character—is his (and, by extension, Michael's) untethered alter ego (Astor, "Trudeau Is 'Amazed'" 31). He is an innocent id, a perpetual man-child that is disconnected enough from society and reality to enjoy a delusional, optimistic bliss.

In the earliest college strips Zonker most obviously represented the extreme aspects of the countercultural movement: recreational drug use, bohemian hipness, and an unapologetic rejection of the bourgeois lifestyle. College, for him, was "the best nine years of my life." But showing that he understood the contradictions and inanities inherent to the idealism of the late 1960s, Trudeau gave Zonker telling foibles: a childlike naiveté; a selfish, hedonistic philosophy; and a quirky waywardness to his political passions. The naiveté worked on one level to satirize the dangers of easy idealism—countercultural attitudes or practices that fell apart when tested by real experience or the complexities of day-to-day life. On another level, it allowed Zonker to play the role of the wise fool, a comic type with deep roots in the satiric tradition. Zonker performed the narrative functions of many of Shakespeare's fools: commenting "innocently," but with satiric bite, on the behavior and attitudes of more mature or

powerful characters; using language incorrectly (malapropisms, unintentional wordplay) to make a satiric point; and operating outside of the normal rules of society—and thus being free to create comedy by flirting with taboos or playing out the id-like fantasies of other characters or readers.

Zonker's unapologetic hedonism also served more complex functions. For example, it was an opportunity for Trudeau to engage in ongoing satire of progressive political ideals gone wrong. Here Zonker represented a hippie ethic that had lost sight of its political motivations and justifications and was left with only a selfish pursuit of the next high. Zonker's daffy love of marijuana at the expense of all other life passions (other than tanning, perhaps) made him a comically pathetic figure—a perpetual teenager incapable of real work or a significant relationship. His second passion—tanning—represented, at times, the way political passions can be misdirected, or hijacked altogether, by the distractions of a hedonistic, consumerist society. On the broadest scale it was a commentary on the communal baby boomer ideals of the late 1960s giving way in the 1970s and 1980s to the ethics of a me-focused culture. On a more immediate level the tanning story lines also gave Trudeau the opportunity to satirize superficial aspects of our culture such as celebrity worship, shortsighted vanity, and beauty pageants.

Interestingly, through all of the comic-pathetic episodes of Zonker's life he has remained an endearing figure. This is partially a result of him being a lead character in the strip; we are asked to see him sympathetically despite his foolishness, to assume that he is fundamentally good because he (along with Michael) often guides us through the narrative of the strip, commenting upon the injustices of society and the inanities of more evil characters. Like Chaplin's Little Tramp or George Herriman's *Krazy Kat*, this perpetual, blissful ignorance gives him a special status: separated from society, untainted by the complexities of adult life, and forever able to take pleasure in simple things. While having Zonker for a friend in reality would probably drive one crazy, as a fictional figure with whom one can occasionally, vicariously identify, these qualities make him endearing.

Perhaps the most sympathetic female character in the strip is Joanie Caucus, the middle-aged mother of J.J., whose dramatic character arc allowed her to represent a shifting zeitgeist over the last thirty years. She began as a depressed housewife; became energized by the feminist move-

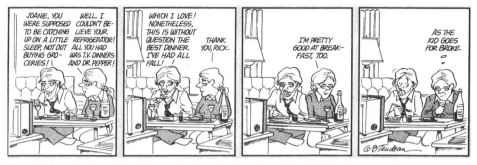

Figure 5.6. Garry Trudeau, "The Kid Goes for Broke," *Doonesbury,* Nov. 9, 1976. *Doonesbury* © 1976 G. B. Trudeau. Reprinted with permission of UNIVERSAL PRESS SYNDICATE. All rights reserved.

ment in the 70s; struggled to be an effective single parent; went to law school years later than most students; had a series of hapless romances; and eventually found a partner in the reporter Rick Redfern. Because of her daring midlife choices, she became an icon of the feminist movement and received exposure and fame far beyond the strip itself. In the mid-1970s Trudeau jokingly complained that "I've received so much mail addressed to Joanie that my mother thinks I'm living with her" (*"Doonesbury: Drawing and Quartering"* 60). Nora Ephron, the screenwriter, describes the impact Joanie had on her and other female readers:

> I have no idea why she's so funny. I just know she kills me. And I think
> about her all the time. It's not just that I know women like her and that
> I'm a little like her myself . . . It's also that there is something about
> what she looks like and the way she behaves—so downtrodden and yet
> plucky, so saggy and yet upright, so droopy-eyed and yet wide awake,
> so pessimistic and yet deep-down sure that she's on the right track.
> (Ephron 94)

Trudeau made Joanie an obvious representative of a particular social movement, but he also succeeded in making her a complexly sympathetic three-dimensional character. Indeed, in the end it seems that Joanie would not have resonated so well with readers if she were less riddled with doubts, contradictions, and funny foibles. The fact that she radicalized herself and became a success in the world of law while still being self-deprecating and insecure, made her seem less strident in her feminism. Readers could thus

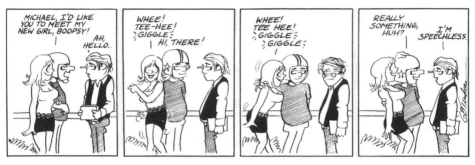

Figure 5.7. Garry Trudeau, "My New Girl, Boopsy," *Bull Tales*, Sept. 15, 1971. *Bull Tales* © 1971 G. B. Trudeau. Used by permission. All rights reserved.

Figure 5.8. Garry Trudeau, "Malibu Mud Slide Victims," *Doonesbury*, Dec. 14, 1984. *Doonesbury* © 1984 G. B. Trudeau. Reprinted with permission of UNIVERSAL PRESS SYNDICATE. All rights reserved.

identify with her struggles and see her as an individual first, and an icon of a movement second. Some of her best comic moments that gave her these sympathetic, flawed qualities included the following: her haphazard attempts at disciplining a willful daughter; her naive crush on a man who was obviously gay to everyone but her; her tendency to descend into crippling self-doubt while in law school; and her imperfect but well-meaning efforts to be romantic with Rick during their courtship (see fig. 5.6).

B.D. and Boopsie started out in the early days of *Bull Tales* (see fig. 5.7) and *Doonesbury* as laughable secondary characters, representing particular social types: B.D. was the athletic star who womanized and carried a sense of macho entitlement everywhere he went. He was a bit of an idiot and bigoted lout, however, and the target audiences of Trudeau's strip probably saw him as a representation of all things squarely, wrongly middle American. Boopsie was his two-dimensional counterpart, a dumb-blonde

bimbo who relied on her physical charms while continually exposing a social cluelessness and political naiveté. It seemed appropriate that they should become a couple, and in the early days of their relationship B.D. coasted on the glories of his college football career (the helmet fused to his head as symbol of how central those exploits were to his core identity), while Boopsie tried to make it as a B-list movie actress (see fig. 5.8). They represented the vulgar side of American culture: commercialism, superficiality, selfishness, exaggerated gender roles.

But as with any character that develops over the course of a long, novelistic narrative, B.D. and Boopsie gradually became more complex and sympathetic. The first truly humanizing plot twist for B.D. occurred while he was still in college: in order to get out of writing a term paper, he enlisted in the army and was sent to fight in Vietnam. There, on the frontlines, some of his narrow-mindedness was challenged and he even befriended a soldier from the Vietcong, Phred. While B.D.'s core weaknesses remained the same after returning from Vietnam, readers perhaps gave him some credit for having more depth and worldly wisdom after having experienced real trauma and having seen life from another cultural perspective. As B.D. aged, there was also a poignant desperation to his inability to do anything that could recapture some of the glory of his college football days. For much of his early years with Boopsie he was simply unemployed, watching a lot of television and living vicariously through Boopsie's Hollywood adventures. He eventually found an appropriate career, however, as a high school football coach, leading the "Swooshes" through some up and down seasons.

By the 1990s B.D. had developed a middle-aged gravitas that further deepened his character. In addition, Boopsie gained a depth of character that comes with time and experience. The culmination of this movement toward sympathetic depth occurred during B.D.'s service in the two Iraq wars. In these episodes Trudeau downplayed the comedy in order to explore some of the darker realities of combat. He even visited troops during the two conflicts to give his strips a verisimilitude that could not be accomplished from a distant drawing table. While Trudeau was opposed to the Iraq war in particular, he was a devoted supporter of the troops, and used B.D.'s war experiences as a means for highlighting soldiers' challenges and celebrating their sacrifices.

Figure 5.9. Garry Trudeau, "Meg the Old Girlfriend,"
Doonesbury, May 24, 2004. *Doonesbury* © 2004 G. B.
Trudeau. Reprinted with permission of UNIVERSAL PRESS
SYNDICATE. All rights reserved.

The most starkly poignant segment from these war installments was
the injury B.D. received during the Iraq war, a shattered leg that had to be
amputated (see fig. 5.9). Trudeau charted in a months-long story arc each
aspect of B.D.'s long recovery, dealing with such dark subjects as depres-
sion, chemical abuse, alienation from family, diminished job prospects,
post-traumatic stress syndrome, etc. This does not sound like promising
material for a comic strip, but Trudeau also infused the strips with his
trademark irony and a grim humor that is apparently an accurate reflec-
tion of the attitude many soldiers adopt in an effort to ease the heaviness
of their burdens. Critics praised the complexity and compassion of these
war documents, and many readers found it to be cathartic in its treatment
of such harrowing subject matter. Indeed, illustrating the power of comic
strips to invite complex sympathy and identification, Trudeau reported

that he was "overwhelmed by some of the letters that came in about B.D. It was so emotional. People wrote that it made them feel they had a personal stake in the war—like someone they knew had been harmed" (Bates 62).

A small detail in these war strips signaled Trudeau's more serious intentions, as well as B.D.'s maturation into a fully formed, novelistic character: the removal of B.D.'s helmet during the recovery process (see fig. 5.9). That may seem like an inconsequential and logical choice, since any recovering soldier would not wear a helmet, but this was an artificial world in which B.D. was wont to wear his helmet—whether it be football or military—in hot tubs, at the kitchen table, or in bed. So Trudeau's choice to finally remove this character-defining gear was significant, signaling a shift away from constructed comedy into poignant naturalism. Trudeau described people's reaction to this alteration of B.D.'s essential identity and look: they were "astonished when B.D.'s helmet came off. It signified his vulnerability and made it [his loss of a leg] all the more difficult for them to accept" (Bates 62).

Because Trudeau was an open critic of the war, it would have been understandable had he chosen to use B.D. and his conservatism to mock the middle-American (red state) politics and attitudes in relation to their support of the Bush administration and the conflict in general. And while he did get in his jabs at Bush and the flimsy justifications for the war in these strips, he never mocked in cruel ways the actual soldiers on ground that were sacrificing their health or lives. In fact, because of his sympathetic treatment of their challenges, Trudeau was honored by the armed services and received many thanks from individual soldiers. Ultimately this more nuanced treatment of the war worked as a better critique of the conflict than would have a flippant, cynical denouncement from afar. Trudeau's particularization of the trauma through B.D.'s trials simultaneously honored those who served and condemned those who may have pursued an illegitimate war.

A less sympathetic comic duo in the strip is Duke and Honey. Duke is based roughly on the "gonzo journalist" Hunter S. Thompson, who was, by the way, incensed by the caricature. Thompson said of Trudeau, "If I ever catch that little bastard, I'll tear his lungs out" ("Doonesbury: Drawing and Quartering" 59). Over the course of his many careers and exploits Duke has come to represent a great range of corrupt political and

Figure 5.10. Garry Trudeau, "You Can't Say That Word," *Doonesbury*, Jan. 21, 1995. *Doonesbury* © 1995 G. B. Trudeau. Reprinted with permission of UNIVERSAL PRESS SYNDICATE. All rights reserved.

corporate figures. Trudeau has suggested that "because he [Duke] started life as a parody, he is the least complicated of all the characters. He suffers no ambiguity. He's very binary: This is either good for me, or it's not good for me [laughs]. In that sense, he's the shallowest character in the strip" (Bates 62). On a basic level, Duke simply represents human nature in its most selfish, id-like state: unaffected by ethical considerations, the needs of others, or abstract notions of community, fairness, or loyalty. But he is also smart and educated, and thus not an uncivilized monster; instead, he is a sophisticated opportunist who uses reason, existing political and financial systems, and the gullibility of others to create devious scams and engage in "civilized" forms of evil. The fact that he appears so blandly normal with his balding head, functional glasses, and unimposing figure underscores this point; he is the classic little man or corporate drone who has discovered that physical strength and outrageous charisma are no longer necessary to make it to the top of government or corporate America. Instead, all one needs is the amoral knowledge of how to work systems through cronyism, bribery, legal loopholes, and sheer, selfish chutzpah (see fig. 5.10).

Observing Duke's Machiavellian machinations, one cannot help but think that Trudeau is echoing Swift's critique of humanity in *A Modest Proposal* and *Gulliver's Travels*: some people can even be worse than the animalistic yahoos Gulliver encounters because they justify their base appetites and evil actions with the civilized trappings of law, government, or high commerce (as with the government bureaucrat speaking of the Irish in *Proposal*). A more recent literary example that puts a face on this evil

is Milo Minderbinder in Joseph Heller's *Catch-22*. Duke, like Milo—who cheerfully undermined the safety of his fellow soldiers in order to make money for the "syndicate" to which everyone supposedly belonged—gets inside corporate and governmental systems and either twists their laws and logic to serve his own ends or takes advantage of existing practices and exploits loopholes. Because Duke has a long track record of capitalizing on systemic flaws, it is easy for Trudeau to send him into adventures that satirize the seemingly perennial governmental scandals that plague the United States, such as the lucrative Halliburton contracts in wartime Iraq.

With Duke's penchant for seeking out political appointments overseas—like the most recent one in Iraq—he has come to stand for a type of grasping, yet blandly bureaucratic American imperialism. He is unapologetic about his pursuit of power and spoils, but willing to work within existing discourses of spreading democracy or "helping the natives." Aiding him in these exploits is his longtime assistant/lover, Honey, a former member of the Chinese communist party. Like her country, Honey is forever in a transitional state between communism and capitalism; as a result, she is often conflicted or confused about the ethics of her involvement in Duke's crimes. She has a lingering, childlike fear and respect for authority figures and thus is easily manipulated by Duke; but she is also smart enough to spot his hypocrisies and ethical lapses. However, because she has not established a fully independent consciousness or conscience (she exists in a sort of perpetual ideological vacuum), she is never able to challenge or reject completely Duke's twisted logic and convoluted manipulations. Moreover, as a representation of the complexities of postcolonial identity, she continually struggles to overcome a double consciousness—by constructing an independent identity—while forever trapped in her comfortingly familiar communist garb and her need for Duke's approval. The best she can do in this psychodrama is act as the wise fool, a part often played by servants and slaves in traditional comedy: lacking power, she cannot affect the flow of the narrative, but she can comment in funny ways upon the foibles of her "master," highlighting ironies and inconsistencies. In sum, the strange relationship between Duke and Honey works as a satiric microcosm of America's relationship with other developing countries during an era of Americanization of the globe: a twisted mix of paternalism, cooperation, and exploitation.

Figure 5.11. Garry Trudeau, "Rake the Leaves!" *Doonesbury,* Oct. 29, 1973. *Doonesbury* © 1973 G. B. Trudeau. Reprinted with permission of UNIVERSAL PRESS SYNDICATE. All rights reserved.

A final major character that Trudeau used effectively, as both a social type and a complex and sympathetic figure, was Mark Slackmeyer, the gay radio talk show host. In his earliest days Mark embodied what his surname suggested—a young adult in continual rebellion against his square, suburban upbringing. He was politically radical, unkempt, sporadic in his employment, and alternative in his lifestyle. Mark's constant battles and misunderstandings with his obliviously conservative father were especially funny and effective in the early and middle years of *Doonesbury.* The basic premise of this generational struggle may sound contrived, but the fact that Trudeau allowed readers to see the world in these exchanges from both the son's and the father's perspective—to effectively recognize both of their blind spots—allowed the strips to be richly layered, comic dialogues (see fig. 5.11).

Mark was also useful through much of the strip's run as a spokesperson for political points of view that may have been even more leftist than those of Trudeau. His work as a radio talk show host was a handy device for allowing him to give a running commentary, week after week, of national political events. Because Trudeau occasionally mocked Mark's strident goofiness over the radio, it was clear that he meant to distance himself from these extreme politics; but it is also possible that Mark served as an effective buffering persona when Trudeau really did want to vent his most liberal opinions. He could express radical ideas while still being able to retreat behind the defensive layers of persona and irony—as in the "Guilty, guilty, guilty!" episode. In recent years Trudeau has paired Mark with a conservative pundit in the radio discussions; this feels a bit contrived, and

Mark is perhaps too often on the winning end of the ironic point Trudeau wants to make, but it is nevertheless a functional comic device. Mark's homosexuality has also been handled by Trudeau with typical complexity. Mark has not behaved in stereotypical ways, and the humor in the strips that deal with the topic can just as often be at Mark's expense as they are at the expense of those who might be bigoted about his lifestyle.

Secondary characters

Trudeau also works with a huge cast of secondary characters that allow him to satirize a wide range of social types and cultural sectors. For example, the teenage offspring of many of the main characters, such as Alex Doonesbury and Jeff Redfern (the son of Joanie and Rick Redfern) give Trudeau the chance to chart Generation Y attitudes and experiences. Alex has led her dad into the dot-com world, and her schooling experiences have allowed Trudeau to revisit his classic college territory. In recent years Jeff has worked for the CIA during the Iraq war, easily (and disturbingly) applying his video gaming skills to the deployment of high-tech weapons systems. As I suggested earlier, while Trudeau's enthusiastic coverage of the zeitgeist of younger generations is generally effective, his construction of these youthful figures lacks the organic authenticity of his first generation of characters. They tend to be more flat and predictable as social types, and Trudeau seems too eager to give them prematurely wise hipster worldviews.

Trudeau's character construction occasionally rings false as well when he creates some figures from minority cultures. For example, his early attempts at introducing black characters into the strip initially felt awkward—as if he were self-consciously avoiding old stereotypes in making these black people especially hip and wise. He succeeded only in creating new types that used exaggerated hipster dialect of the 1970s (one calls Michael a "honkey") and that stand apart from the main action of the strip. Trudeau's troubles with minority characters may have had something do with negotiating the racist baggage comics accumulated through the early parts of the twentieth century. Because the medium was so adept at constructing and reinforcing visual ethnic stereotypes with all

their racist baggage, liberal-minded cartoonists working today may feel a need to overcompensate in the opposite direction, creating unrealistically noble types. Trudeau recognized this tendency in himself when he tried to counter negative typing of gay people in society with a more heroic, but equally two-dimensional type in Andy Lippincott, the character who died from AIDS. An interviewer noted that "Trudeau was never entirely satisfied with that sequence, because Andy was two-dimensional—literally and figuratively. He became a bravely noble funny man dying with bravely noble humor. [Trudeau said,] 'Andy handled it with more grace and humility than any human would'" (Weingarten W14).

Even in the 1980s Trudeau seemed still to be incapable of finding a handle on race issues. Much of this confusion may also be chalked up to the nature of Trudeau's upbringing and homogenous social circles as an adult; without direct experience with minority cultural experiences, it is hard to speak from that worldview or feel confident in giving a black character a complex personality (Alter 66). Nevertheless, in more recent years Trudeau has fared better in this endeavor, giving one of his principal black characters, B.D.'s army buddy Ray, an interesting personality with both admirable qualities and funny foibles. He has also been effective in his treatment of Asian characters, giving folks like Honey and Phred (the former Vietcong turned diplomat) quirky personas and failings that could either be traced to their individual worldviews—or the particular cultural formations from being raised in communist China or Vietnam—than it could be to an essentialized ethnic identity.

There are also a range of exaggerated social types in the strip that seem appropriately flat. As with secondary characters in works by literary satirists such as Twain or Dickens (think of Twain's Duke and Dauphin), their roles simply stand for an easily identifiable social vice, a warped worldview, or a questionable profession. For example, Roland Hedley, the reporter, is never given a fully fleshed-out, sympathetic identity; instead, he always predictably behaves according to the opportunistic rules of the muckraking reporter. His role, thus, is to stand in as a representative of all the quirks and failings of reporters in general, and the media companies for which they work. Sid Kibbitz, the Hollywood agent, similarly functions as a representation of all that is venal, shallow, and materialistic in the world of entertainment. An especially funny member of these second-

ary ranks is the dean of Walden college. He has been a handy tool over the years for periodically dealing with the latest trends and embarrassments in academia. Because of the sheer number of years that have passed in the strip, Trudeau has gradually given this figure nuanced layers of self-awareness and irony that add rich, melancholy tone to the strips in which he appears.

Taking the long view of *Doonesbury,* one could conclude that most of Trudeau's characters essentially begin as these secondary types—relatively simplistic comic constructions that are used for a limited range of jokes and tend to act within a narrow range of predictable behaviors. One only has to think of the early jock B.D. or the bimboesque Boopsie to get this point. But because of the rich continuity of the cartoon, and the sheer bulk of strips that build the story line week after week, these secondary characters eventually evolve into primary figures that retain their foibles but acquire sympathetic layers and nuances to their personalities and story lines. In addition, Trudeau, despite his combative tendencies and contempt for the jerks of society, is ultimately a sympathetic chronicler of American social and political life in all its rich complexity. While many satirists seem to grow increasingly more misanthropic with age, Trudeau seems to have gone the other direction—developing a stern but Horatian worldview that can condemn social evils and political stupidity without resorting to simplistic scapegoating, condescending caricature, or flippant mockery. Most comic strip artists lapse into a stale complacency after they gain tenure on the comics page; Trudeau has remained alert and engaged, determined to keep his work relevant and resonant. *Doonesbury* is a remarkably rich chronicle of American cultural history over the last forty years, and a complexly sympathetic portrait of a variety of individual lives within that culture.

Works Cited

Alter, Jonathan. "Real Life with Garry Trudeau." *Newsweek*, 15 Oct. 1990: 60–64.

Andersen, Kurt. "Doonesbury at War." *New York Times*, 19 June 2005: 1–3.

Aristotle. "Poetics." In *Art and Its Significance*, ed. Stephen David Ross. Albany: State University of New York Press, 1994. 65–74.

Astor, David. "About 25 Clients Pull *Doonesbury* Strips." *Editor & Publisher*, 16 Nov. 1991: 36.

———. "Strong Opinions about a New Syndicate." *Editor & Publisher*, 7 Mar. 1987: 44–46.

———. "The Wall Street Journal vs. 'Doonesbury." *Editor & Publisher*, 28 Dec. 1991: 28.

Bates, Eric. "Doonesbury Goes to War." *Rolling Stone*, 5 Aug. 2004: 62.

Begley, Sharon. "So Long, Snoopy." *Newsweek*, 1 Jan. 2000: 18–25.

Berry, Boyd M. "A Perusal of Pogo Possum's Politics." *The Best of Pogo*, ed. Bill Crouch Jr. New York: Simon & Schuster, 1982. 196.

Bluestein, Gene. *Poplore: Folk and Pop in American Culture*. Amherst: Massachusetts University Press, 1994.

"Controversy over Sexism Flares in the Cartoon World." *Editor & Publisher*, 16 June 1984: 49–50.

"Doonesbury's 900." *Washington Journalism Review*, Nov. 1987: 4.

"Doonesbury: Drawing and Quartering for Fun and Profit." *Time*, 9 Feb. 1976: 57–66.

Ephron, Nora. Afterword. *Joanie*. New York: Sheed and Ward, 1974.

Ford, Gerald. "Garry Trudeau." *Time*, 9 Feb. 1976: 58.

Francesca. Letter. "The B.D. Strips." *Posting Time*, 14 Dec. 2005.

Grant, Linda. "Welcome Back, B.D." *Guardian*, 19 Sept. 2005: F8.

"Great Doonesbury Sellout." *Associated Press*, Oct. 1991: 1.

Groth, Gary, and Richard Marschall. "Charles Schulz Interview." *Comics Journal* 31 (Jan. 1992): 5–24.

Grove, Lloyd. "Trudeau Speaks." *Washington Post*, 12 Nov. 1986: D1, D15.

Harvey, R. C. *The Art of the Funnies: An Aesthetic History*. Jackson: University Press of Mississippi, 1994.

———. "Tales of the Founding of the National Cartoonists Society." *Cartoonist Profiles* 109 (Mar. 1996): 48–68.

Hoffman, David. "Reading Bush's Lips." *Washington Post*, 4 Dec. 1988: L1.

Hurd, Jud. "Editorial Director of a Major Syndicate." *Cartoonist Profiles* 53 (Mar. 1982): 38.

Johnson, Rheta Grimsley. *Good Grief! The Story of Charles M. Schulz*. New York: Pharos Books, 1989.

Kelly, Walt. National Cartoonist Society newsletter, 1953. NCS Dossier, Ohio State University Cartoon Archives.

Kurtz, Scott. "Interview with Berke Breathed." *A Piece of My Mind*, http://www.pvponline.com/rants_breathed.php3. 2 Feb. 2001: 3.

Lamb, Chris. "*Doonesbury* and the Limits of Satire." Address to the Visual Communications Division. Association for Education in Journalism and Mass Communications Convention. Portland, Oregon, July 1988.

Lears, T. Jackson, "The Concept of Cultural Hegemony: Problems and Possibilities," *American Historical Review* 90.3 (June 1985), 567–93.

McCloud, Scott. *Understanding Comics*. New York: Harper Perennial, 1993.

Moritz, Charles, ed. *Current Biography Yearbook*. New York: W. H. Wilson, 1975.

O'Sullivan, Judith. *The Great American Comic Strip: One Hundred Years of Cartoon Art*. Boston: Little, Brown, 1990.

Pells, Richard H. *The Liberal Mind in a Conservative Age*. New York: Harper & Row, 1985.

Plato, "Republic II, III, X." In *Art and Its Significance*," ed. Stephen David Ross. Albany: State University of New York Press, 1994. 9–45.

Radolf, Andrew. "Don't Shrink the Comics." *Editor & Publisher*, 30 Apr. 1988: 49.

Rall, Ted. "The Death of Political Cartooning." Unpublished speech at Popular Culture Association Conference. San Antonio, Texas, 29 Mar. 1997.

Rees, Stuart. Thesis on Syndicate Contracts. Harvard Law School, 1997.

Report of Senate Hearing on Indecency in Comic Books, 21 Apr. 1952. Lino Regal—FF 45. Located in Walt Kelly Dossier. Ohio State University Cartoon Archives.

Robbins, Trina. "Women and the Comics." *Cartoonist Profiles*, Dec. 1983: 40–45.

———. *A Century of Women Cartoonists*. Northampton, MA: Kitchen Sink Press, 1993.

Rubien, David. "Brilliant Careers: Garry Trudeau." *Salon*, 15 Feb. 2007.

Sabin, Roger. *Adult Comics: An Introduction*. New York: Routledge, 1993.

"Satire Gap." *New Republic*, 1 Dec. 1985: 42.

Siegel, Lee. "The Incredibles: How Pixar's Animated Films Became the Best Literature Around." *Slate*, 28 Dec. 2005: 1–6.

Stewart, Bob. "King Features Went Back to the Future in Its 75th Anniversary." *Witty World* 11/12 (Summer/Autumn 1991): 20–24.

Test, George. *Satire: Spirit and Art*. Tampa: University of South Florida Press, 1991.

Tinsley, Doris H. "Mallard Fillmore." *Cartoonist Profiles* 105 (Mar. 1995): 10–17.

Trudeau, Garry. "Character Biographies." Doonesbury.com.

———. Doonesbury FAQ, doonesbury.com.

———. *Flashbacks: Twenty-Five Years of Doonesbury*. Kansas City: Andrews and McMeel, 1995.

———. "Speech before APME." 27 Nov. 1984.

———. "'I Hate Charlie Brown': An Appreciation." In *Charles M. Schulz: Conversations*. M. Thomas Inge, ed. Jackson: University Press of Mississippi, 2000. 270–72.

————. "Investigative Cartooning: Why Does the White House Quail at My *Doonesbury* Strip?" *Washington Post*, 15 Dec. 1991: C1.

————. "Still a Wimp." *Washington Post*, 4 Nov. 1988: A25.

————. *The People's Doonesbury*. New York: Holt, Rinehart and Winston, 1981.

"Trudeau, by a Jury of His Peers." *Esquire*, Dec. 1985: 137.

"Trudeau is 'Amazed' His Comic Endures." *Editor & Publisher* 133.43 (2000): 31–32.

Turner, Kathleen J. "This Is Serious." *Ohio State Magazine*, 1984: 42, 43.

"Update on Giving Creators a Break." *Editor & Publisher*, 14 July 2003.

Varnum, Robin, and Christian T. Gibbons. *The Language of Comics: Word and Image*. Jackson: University Press of Mississippi, 2001.

Weingarten, Gen. "Doonesbury's War." *Washington Post*, 22 Oct. 2006: W14.

Weisenberger, Steven. *Fables of Subversion: Satire and the American Novel, 1930–1980*. Athens: University of Georgia Press, 1995.

Woodson, Michelle. "Enter Mike Doonesbury." *Entertainment Weekly*, 28 Oct. 1994: 104.

Index

References to illustrations appear in *italics*.